PEARLS OF THE SOUTHERN SKIES

A Firefly Book

Published by Firefly Books Ltd. 2014

Copyright © 2012 Oculum-Verlag GmbH
English translation © 2014 Firefly Books

First printing

Publisher Cataloging-in-Publication Data (U.S.)

Willasch, Dieter.
 Pearls of the southern skies : a journey to exotic star clusters, nebulae & galaxies / Dieter Willasch ; text by Auke Slotegraaf.
[176] pages : col. photos., maps ; cm.
Includes index.
Summary: This comprehensive photographic volume covers the most prominent seventy-one deep-sky objects, from the String of Pearls Galaxy to the Helix Nebula.
ISBN-13: 978-1-77085-445-1
1. Southern sky (astronomy) – Photographs. I. Slotegraaf, Auke. II. Title.
523.1 dc 23 QB500.3.W444 2014

Library and Archives Canada Cataloguing in Publication

Willasch, Dieter, photographer
 Pearls of the southern skies : a journey to exotic star clusters, nebulae and galaxies / Dieter Willasch ; text by Auke Slotegraaf.
Includes index.
ISBN 978-1-77085-445-1 (bound)
 1. Southern sky (Astronomy)—Popular works. 2. Astronomical photography—Popular works. 3. Stars—Clusters—Pictorial works. 4. Nebulae—Pictorial works. 5. Galaxies—Pictorial works. I. Slotegraaf, Auke, author II. Title.
QB500.3.W34 2014 523.1 C2014-901338-8

Published in the United States by
Firefly Books (U.S.) Inc.
P.O. Box 1338, Ellicott Station
Buffalo, New York 14205

Published in Canada by
Firefly Books Ltd.
50 Staples Avenue, Unit 1
Richmond Hill, Ontario L4B 0A7

Printed in China

DIETER WILLASCH has a PhD in physics and worked as an industry manager until his retirement. Now he is pursuing his childhood dream of observing the skies with binoculars and telescopes, and to capture the sights with his camera. Since 2001, he alternatively lives in South Africa and Germany. His photographs can be seen on his website www.astro-cabinet.com.

AUKE SLOTEGRAAF is a passionate deep-sky observer. He is director of the deep-sky observing section of the Astronomical Society of Southern Africa, one of their honorary members, and editor of *Sky Guide*, the astronomical handbook for southern Africa. His website is www.docdb.net.

PEARLS OF THE SOUTHERN SKIES

a journey to exotic star clusters, nebulae and galaxies

PHOTOGRAPHS BY DIETER WILLASCH
TEXT BY AUKE SLOTEGRAAF

FIREFLY BOOKS

Contents

Gallery

Spring

Summer

Autumn

APPENDIX

FOREWORD

y own experience in the southern hemisphere is so far only a few weeks long. In 1978, while a post-graduate student at the University of Edinburgh in Scotland, I needed data for southern galaxies for my dissertation, so flew twice to South Africa to observe at Sutherland in the Karoo. June and September gave me splendid views of the winter and spring skies, and I was delightfully overwhelmed by celestial riches whenever I could take the time to simply look at the stars and Milky Way. Borrowed binoculars helped with the big globulars, the Magellanic Clouds, and the splendid clusters and nebulae along the Milky Way itself. We in the north should be so lucky with our sky!

I also worked on the southern extension of the rich galaxy cluster catalogue with George Abell, the Southern Galaxy Catalogue with Gerard and Antoinette de Vaucouleurs, its extension to the equator with Brian Skiff, and the ongoing NGC/IC Project (what did our astronomical ancestors actually see?) — all of these projects gave me the opportunity to become intimately familiar with the wonderful details of the southern sky.

So, it is with more than a little satisfaction that I page slowly through "Pearls of the Southern Sky" and admire the skillfully combined efforts of its authors. They have collected from among their own observations dozens of the greatest wonders that the southern sky has to offer. Trying to choose favorites from among them is like being asked to choose favorite moments of our lives — there are far too many contenders!

Gorgeous full-color portraits of the objects are followed with a page of text giving the history and significance of each. Why does *this* galaxy or *that* cluster or *this* nebula deserve to be in such splendid company? What is its relationship to neighboring objects that might or might not appear in the book with it? What astrophysics stands behind the stunning images that we see in the book? What are our own chances as 21st century observers to actually collect photons from the objects? Dieter Willasch and Auke Slotegraaf give us the answers, sometimes light-heartedly, sometimes with a gravitas suitable to an up-to-date astrophysical text — always, however, with appropriate details so that those of you in the south can go outside to observe all of these special objects for yourselves, and to understand them. We in the north fortunately have a few of them winging just above our southern horizon; for the rest, we can only sigh, read, and admire the images in the book.

And that is exactly what this book is for. Read, learn, contemplate, and enjoy the best that the southern sky has to offer.

August 2014
Harold G. Corwin, Jr.

INTRODUCTION

On a clear, dark winter's night in the southern hemisphere, the mere act of looking skyward is likely to result in a deeply moving and unforgettable experience. Standing under the arch of the Milky Way, which spans from horizon to horizon, and looking directly into the heart of our galaxy feels like being in the center of the cosmos. This silent awe is at once expansive and all-inclusive; while at the same time introspective, a speck of dust in an infinite universe.

Gazing at this southern panorama with the naked eye quickly leads to observing with binoculars, and then to using a telescope to explore the wonders of the southern sky. This is the path we followed.

Along this path runs a trail, along which the traveler feels compelled to grasp these impressions in pictures and share them with those who rarely, or never, have the opportunity to walk beneath the southern skies. This book is a scenic viewing point along that trail.

We wished to present the most beautiful and interesting objects of the southern sky in pictures, the selections of which are, of course, very personal and subjective. We also wanted to share with the reader some facts worth knowing about these objects: How can they be found with the naked eye? How do they look when seen through binoculars and telescopes? Who discovered them? What are these objects really?

This book is dedicated to all who carry the longing for the stars in their hearts, and we wish them an exciting journey through the southern sky

August 2014
Dieter Willasch
Auke Slotegraaf

How to use this book

Pearls of the Southern Skies presents the most beautiful and fascinating deep-sky objects south of the celestial equator.

In preparation for the series of objects shown, a wide-field photograph of the southern Milky Way, from Sagittarius to Canis Major, is given. This serves as a general orientation to this richest part of the southern sky, and it identifies selected constellations and asterisms that are referred to in the pages ahead.

The 71 objects that follow are presented in order of their Right Ascension, which makes it easy to determine the approximate time of their best visibility. A rough guide to the season in which an object can be observed is indicated in the Table of Contents.

Each object is illustrated on a left-hand page by a photograph, and on the right-hand page a brief description is given of how to find it in the sky, its appearance as seen through binoculars and a telescope, the history of its discovery, and selected astrophysical details.

The astronomical convention of image orientation (north up, east to the left) was not strictly followed; instead, aesthetics was the primary consideration in orienting each image. Several objects are illustrated by two images, a small scale, detailed, image on the left-hand page, and a large scale, wide-field, image on the right. All images have their orientation and scale indicated by a direction compass and a scale bar.

Many sources were consulted in the compilation of the text accompanying each image. Visual descriptions and historical references were taken mostly from the publically available *Deep-Sky Observer's Companion database* (http://www.docdb.net), *Biographical Encyclopedia of Astronomers* (Thomas Hockey, Ed., 2007) and *Observing and Cataloguing Nebulae and Star Clusters* (Wolfgang Steinicke, 2010). To access the latest research findings for each object, extensive use was made of the SIMBAD database (operated at CDS, Strasbourg, France) and NASA's Astrophysics Data System.

At the bottom of each right-hand page, basic data are given for the object illustrated: catalogue designations, object type, coordinates and constellation. Astrophotographers interested in the technical details of how each photograph was made should refer to the Photographic Details section in the Appendix (p. 170).

An astronomical object sometimes has a bewildering array of catalogue designations. A bright nebula, for example, may be included in the catalogues by Bernes, Lynds, Cederblad, Gum, Gaze & Shain, etc. Each inclusion results in an alternate designation for that object. The International Astronomical Union has, fairly recently, published sensible specifications for designating deep-sky objects. Such proper designations ensure that an object is uniquely identified. Similarly, one's passport number is also unique, yet it is unlikely that you'd be known by your passport number. Instead, a proper name, or a nickname, is commonly used. The authors feel that interesting deep-sky objects have the same "rights," and they have endeavoured to use nicknames for the objects illustrated. In some cases, the nicknames are familiar and well-established (such as the Coal Sack or Jewel Box). Yet surprisingly many southern deep-sky objects have to be satisfied with an ugly string of digits and letters to identify them. To help remedy the situation, where sensible, new or uncommon nicknames have been used in this book as the heading for each object's entry. In some cases, the names are taken from the scientific literature (e.g. the Cosmic Owl, for the galaxy pair NGC 2207 and IC 2163, taken from a 2000 paper published in the *ASP Conference Series*). Gerard

Bodifee and Michel Berger's creative *Catalogue of Named Galaxies* was also consulted. Attempts were made, via personal communication, to provide proper attribution to the sources of popular nicknames already in use, and the authors welcome any corrections and additions to the material published here. In other instances, the names were given by the authors, for instance, the Kobold (by DW) and the TIE Fighter Nebula (by AS, a *Star Wars* fan).

The appendices to the book include six short sections that will be particularly useful to readers who are unfamiliar with the various kinds of deep-sky objects illustrated. Each section is a brief, non-technical, overview that will help the beginner better enjoy the beautiful photographs, and understand the text accompanying each object.

Annotated identification charts are given on pp. 166 – 169 for particularly complex objects.

Finally, two indices list people mentioned and objects discussed. In addition to nicknames, objects are also cross-listed here by their (several) scientific designations.

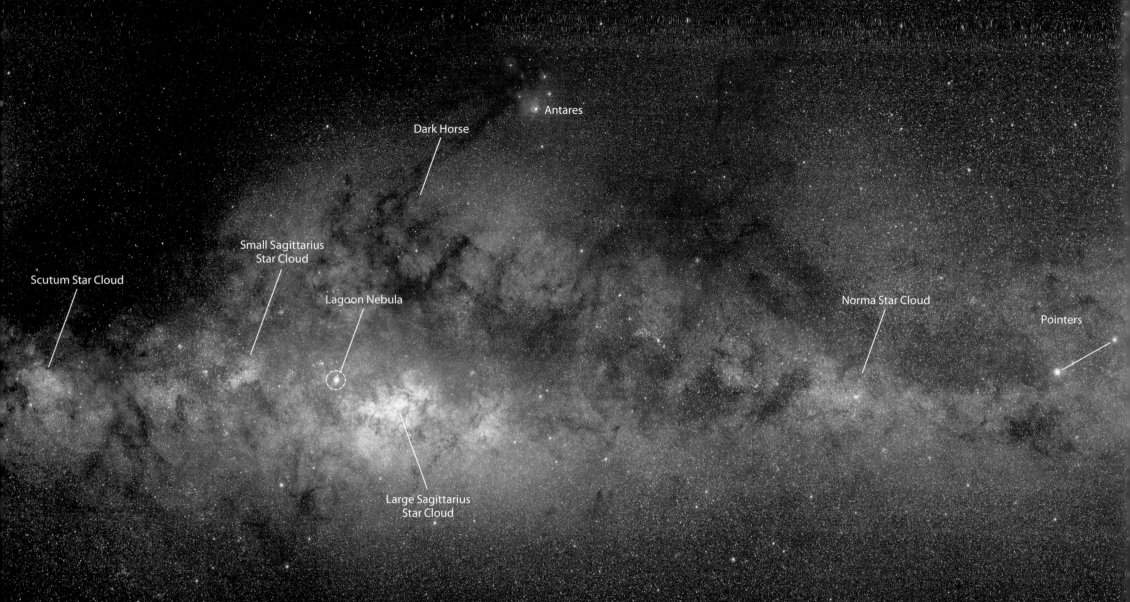

Antares

Dark Horse

Small Sagittarius
Star Cloud

Scutum Star Cloud

Lagoon Nebula

Norma Star Cloud

Pointers

Large Sagittarius
Star Cloud

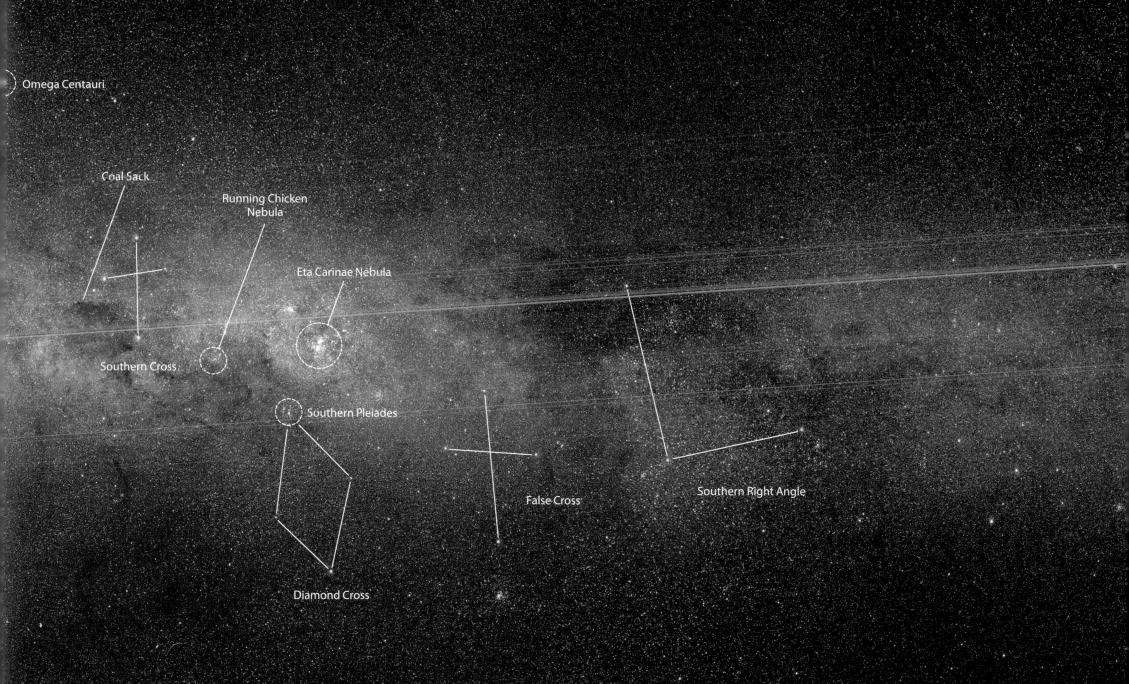

Omega Centauri

Coal Sack

Running Chicken
Nebula

Eta Carinae Nebula

Southern Cross

Southern Pleiades

Diamond Cross

False Cross

Southern Right Angle

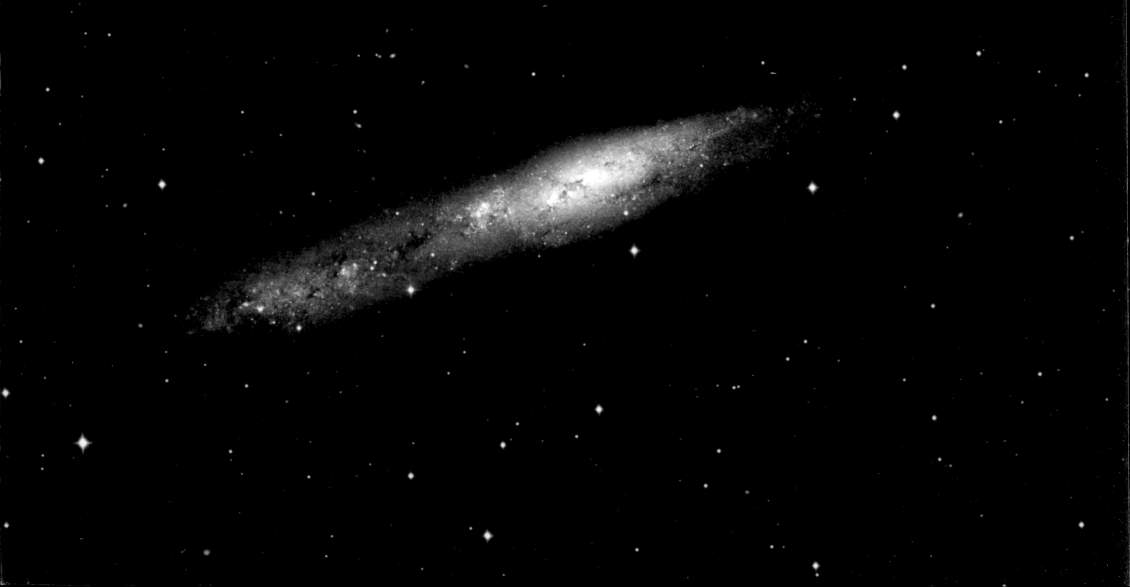

THE STRING OF PEARLS

Draw a line from Achernar to Fomalhaut and pause midway. The bright star a short distance north is Ankaa (α Phe), a pale orange ember that marks the head of the fiery Phoenix. Ankaa and NGC 55 lie in the same binocular field of view – place the star at the edge of the field while looking in the direction of Fomalhaut to find the galaxy.

Even under mediocre skies, binoculars show NGC 55 as a delicate ray, at least 15′ long, oriented in PA 110°. Three 7th-magnitude stars 2° due east point to the galaxy, and are useful for estimating its apparent size. Under dark skies the galaxy extends to almost 30′ and is a beautiful sight. Unlike any other binocular galaxy, it is curiously lopsided in appearance, with its brightest part offset to the west. This brighter portion extends for about a fifth of the galaxy's total length. Three 10th-magnitude stars southeast of the galaxy are useful for estimating the size of its minor axis.

It's almost certain NGC 55 would have been a Messier object had that gentleman visited the southern hemisphere. Indeed, NGC 55 is also catalogued as Bennett 1, the first object in South African comet hunter Jack Bennett's list of southern comet-like deep-sky objects.

Through a modest-sized telescope, the galaxy's remarkable structural details can be appreciated. The nuclear region is elongated and contains several brighter knots. Along its length are brighter and darker patches that give it a rich, curdled appearance. Overall, the western extent is brighter but smoother looking, whilst the eastern reaches of the galaxy show the most signs of subtle detail.

This exceptional galaxy was discovered in July 1826 by James Dunlop, observing from the garden of his home in Paramatta (now a suburb of Sydney), Australia. "I see several minute points or stars in it," he wrote, "as it were through the nebula."

John Herschel observed it in May 1834, soon after his arrival at the Cape, calling it "a strange object" and drawing attention to its "three nuclei." In October 1875, observers noted that with the Great Melbourne Telescope: "There are still three nuclei, the centre one of which is much the brightest."

In September 1897, the American astronomer Lewis Swift curiously reported a "new nebula," designated IC 1537, described as "partly overlapping" the eastern end of NGC 55. It is clear that Swift was seeing the fainter, eastern extent of the galaxy, but why he thought it was a separate object, unseen by Herschel, is a mystery.

NGC 55's off-center brightening has led some observers to liken it to a comet, with its tail trailing off to the east. Veteran observer Stephen James O'Meara compared NGC 55 to a "squashed comet," recalling that Carolyn Shoemaker once described the fragmented Comet Shoemaker-Levy 9 as a "string of pearls." This was the inspiration for the nickname he coined: "As I see it, NGC 55 is an extragalactic String of Pearls."

NGC 55 is an S-shaped barred spiral galaxy spanning some 40,000 light-years. We see it nearly edge-on, inclined just 7° from our line of sight. The brightest part of the galaxy is an end-on view of the bar, nearest us. The faint eastern part is an end-on view of the main spiral arm nearest us. The distant parts of this arm are obscured by dark clouds.

NGC 55 is a member of the Sculptor Group, which consists of 27 galaxies at an average distance of 13 million light-years. The group is, however, strongly elongated along a line pointing back to our Local Group, with NGC 55 located nearer to us. Together with NGC 300 and two dwarf companions they form a loose quartet about 6 million light-years away. In the sky, the galaxies of the Sculptor Group lie within a 33° circle centered on RA $00^h35.4^{min}$, Dec −34° 31′.

N

E

2′

NGC 55, Dunlop 507, Bennett 1, Caldwell 72

Galaxy in Sculptor, $0^h 14.9^{min}$, −39° 12′, Size 31.2′ × 5.9′

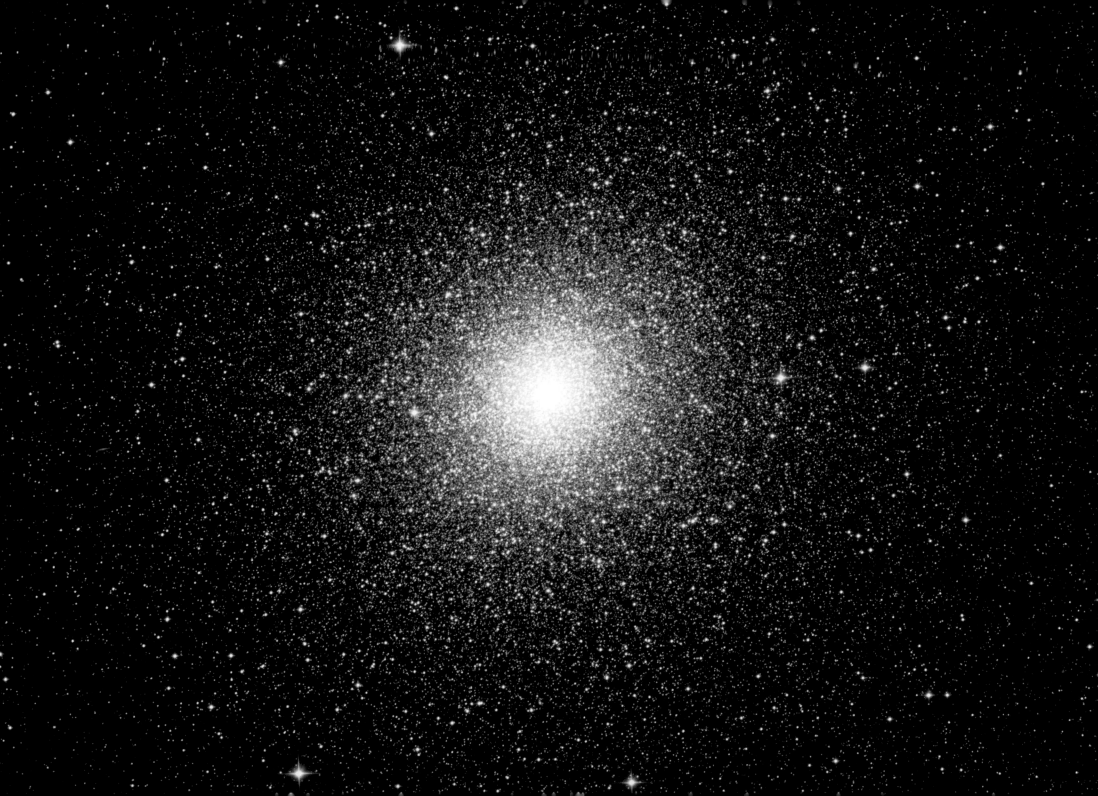

47 Tucanae

Visible to the naked eye as a cometary glow just west of the Small Magellanic Cloud (SMC), 47 Tucanae (or 47 Tuc for short) is possibly the most impressive of all globular clusters.

Binoculars reveal a perfectly round bright nucleus, about 1.5′ across, and set within a round soft halo at least 15′ wide. A telescope shows the heart of the cluster as a sudden blaze of pale-yellow light, an eye-catching bright button of unresolved stars. Under certain viewing conditions, the nucleus appears to have a dark lesion on its eastern side, looking like a hungry Pac Man about to gobble up the other stars. Conspicuous streamers of stars meander from the intense nucleus into the outlying regions. Under dark skies, the cluster swells out to at least 30′ in diameter. These outer regions play delightful havoc with the brain's pattern-seeking proclivity, revealing "wedges of ill-defined blank areas and arms of stars," as American astronomer Brian Skiff aptly describes it.

The cluster was first recorded by Nicholas Louis de Lacaille during his stay at the Cape. He described it as being similar to "the nucleus of a fairly bright comet." James Dunlop noted that its stars had "a dusky colour," which John Herschel (who called it "a stupendous object") later commented on by noting the "rose-coloured light of the interior and the white of the exterior portions."

American astronomer Solon I. Bailey wrote: "The only close rival to this cluster is Omega Centauri... but 47 Tucanae is much more condensed in the centre." This blazing nucleus of compact starlight makes 47 Tuc a more rewarding sight than the larger, brighter, Omega Centauri, at least in modest-sized instruments.

NGC 104 is one of the most massive and nearest globular clusters. It weighs in at 600,000 solar masses, and in its densely populated core there are about 50,000 stars per cubic parsec. In the stellar hub, the stars are on average about 5 light weeks apart. An observer on a planet in the core of 47 Tuc would see hundreds of stars as bright as Venus dotting the night sky.

NGC 104 lies 15,000 light-years away. At that distance, our sun would be a terribly feeble 18th-magnitude star.

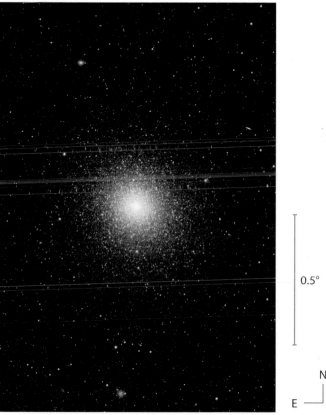

0.5°

N

E

The immediate environs of 47 Tuc, including the globular cluster NGC 121 to the north and the star cluster ESO 28–19 (Kron 30) to the south (both belonging to the SMC).

N

E

3′

NGC 104, Lacaille I.1, Dunlop 18, Bennett 2, Caldwell 106

Globular cluster in Tucana, $0^h 24,1^{min}$, −72° 5′, Size 50′

THE BLACK-BOTTOMED GALAXY

More or less midway between brilliant Achernar and the Great Square of Pegasus lies a lone bright star, Diphda, the brightest star of Cetus the Whale. In the same binocular field, just 3° to the south, lies NGC 247, the northernmost bright member of the Sculptor Galaxy Cloud.

From suburban skies NGC 247 is a challenging blur in binoculars, appearing as a delicate smudge trailing northwards from a 9.5-mag. star. Under good skies, binoculars show it readily as a very elongated glow that can be traced for almost 15′.

Through a telescope this low surface brightness object requires a generous field of view to be appreciated. Unless conditions are good, a modest-sized telescope shows essentially a featureless glow without a central brightening, elongated in proportion 4:1. Dark skies allow subtle detail to be discerned. There is a hint of a very slightly brighter nucleus, set within a spindle-shaped body. The southern half of the galaxy is brighter, while the northern half is dimmer but also broader. The dark oval in the north, obvious on photographs, is difficult to detect visually. A noticeable feature is the 9.5-mag. star embedded just inside the southern extent of the galaxy. Small telescopes (or poor conditions) put this star just outside the reach of the galaxy. Larger telescopes show a surface mottled with several almost-stellar knots, particularly to the south and west of the center. The extra light-gathering power also renders the dark oval more prominent.

William Herschel discovered this galaxy from his home in Datchet near Windsor, England, in October 1784, where it never rose more than about 18° above the horizon. Curiously, he reported this "streak of light" as being 26′ long. Some 40 years later John Herschel observed it with the same telescope, noting a more realistic 10′ major axis. Oddly, the younger Herschel never observed NGC 247 while he was at the Cape of Good Hope.

In their systematic review of the objects observed by the Herschels (1848–1854), the Earl of Rosse and his assistants, using the massive 6-foot (2 m) "Leviathan of Parsonstown," on one occasion failed to confirm the existence of NGC 247.

NGC 247 has been dubbed the "Black-Bottomed Galaxy" by Gerard Bodifee and Michel Berger in their creative *Catalogue of Named Galaxies*. They call attention to the dark oval feature, which "brings to mind an odd feature of the classical hero Hercules, who in Greek was sometimes called after his 'black bottom,' considered a mark of manhood." Stephen James O'Meara calls NGC 247 the "Milkweed Seed Galaxy," beautifully capturing the galaxy's gentle appearance and relation to the embedded 9.5-mag star. The pair, he writes, "look like a silken fiber attached to a milkweed seed adrift in the cool winter wind."

NGC 247 is classified as a member of the SAB morphological family, having characteristics of both ordinary spiral and barred spiral galaxies. It is inclined just 18° to our line of sight, and its very wide spiral arms trace an almost circular outer loop, spanning some 67,000 light-years. The dark oval feature is likely enclosed by the galaxy's northern arm.

NGC 247 and NGC 253, together with several dwarf companions, form a clump of galaxies in the Sculptor Filament, some 12.9 million light-years distant.

Near the top-right corner of the photograph opposite, about 16′ northeast of the center of NGC 247, lies the Burbidge Chain, a quartet of faint galaxies consisting of (north to south) ESO 540–23 (LEDA 2791), LEDA 2798, ESO 540–24 (LEDA 2794) and ESO 540–25 (LEDA 2796). The chain was discovered by chance during an examination of a sky survey photograph of NGC 247.

E
N
2′

NGC 247, Bennett 3, Caldwell 62
Galaxy in Cetus, 0h 47.1min, −20° 46′, Size 19.2′ × 5.5′

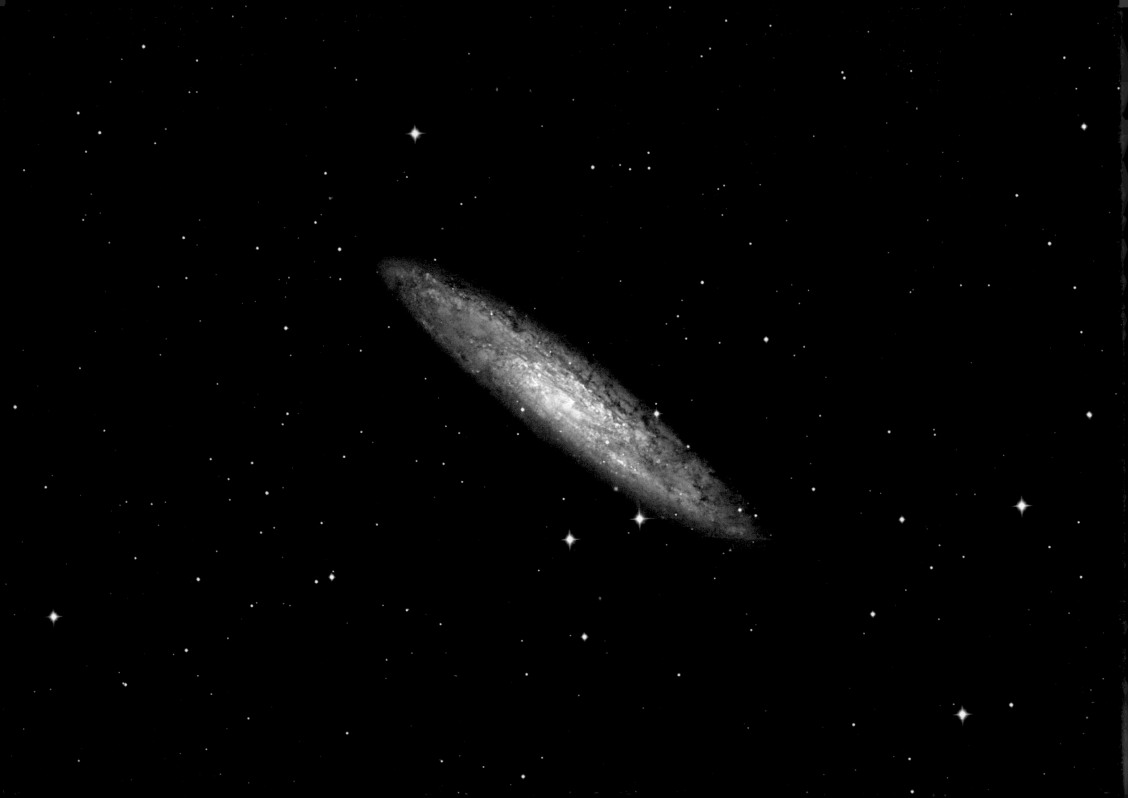

CAROLINE'S GALAXY

The constellation of Sculptor appears as just an empty patch of night to an observer trapped under suburban skies. The easiest way to find its general location is to start with bright Achernar and look 10° due north for a prominent 5° triangle of stars in Phoenix. Farther along lies Diphda (β Cet); the point midway lies not too far from α Scl.

Sweeping from α Scl to Diphda reveals three beautiful surprises: a globular cluster (NGC 288) and two galaxies (NGC 253 and NGC 247). Unlike NGC 247, NGC 253 is visible in binoculars without averted vision even under poor skies. It appears as a slash of gray light with a gently brighter center, oriented northeast to southwest and wedged between stars. The brightest part of the galaxy stretches out for about 11′, which lies off-center (to the northeast) within a larger 22′ × 3.5′ glow.

Through a telescope, NGC 253's spindle can be traced for at least 30′, offering a wealth of detail unrivalled by any other galaxy (excluding our Milky Way and the Magellanic Clouds). From its southwestern tip, it gradually brightens to a broad elongated central region and then abruptly fades away unevenly to the northeast. The surface, dotted by several stars, is strongly mottled, particu-

larly in the southwestern extent. The central region is rich in subtle detail; experienced observer Steve Coe likens it to a surrealistic painting. Several observers report a definite almost-stellar nucleus.

NGC 253 was discovered in September 1783 by Caroline Herschel using her "small sweeper," a 4.5-inch (11 cm) reflector, from Datchet in England. She described it as a "faint nebula," noting with satisfaction: "Messier has it not." The French observer Charles Messier had published an important list of nebulae three years earlier, and Caroline's brother, William Herschel, soon began observing them. William made his first discovery in September 1782 (NGC 7009) using a 12-inch (30 cm) reflector, the "small 20ft," but had no intention of undertaking a systematic search for new nebulae. It was Caroline's success at discovery (her first find was NGC 2360, in February 1783) with her small telescope that made William realize that undiscovered nebulae and clusters must exist in abundance, prompting him to embark on his own epic explorations. In addition to her work on nebulae, Caroline held the women's record for comet discovery for almost 200 years. When William later observed NGC 253 he referred to it as "Nebula Lina."

NGC 253 was not observed by James Dunlop during his remarkably productive seven months at Paramatta, Australia (1826/1827) because it fell outside of his northern declination limit of −28°.

John Herschel first observed NGC 253 in September 1830, from Slough in England, but he got his best views from Cape Town five years later. He called it "a superb object... gradually much brighter toward the middle to a centre elongated like the nebula itself. The nebula is somewhat streaky and knotty in its constitution and may perhaps be resolvable."

Harvard astronomer Solon I. Bailey remarked, in the early 1900s, that NGC 253 "somewhat [resembled] the Great Nebula in Andromeda, but without a central nucleus. It resembles more closely, however, NGC 6618," the Swan Nebula (Messier 17).

NGC 253 is a spiral galaxy, inclined just 11° to our line of sight, with a weak, broad bar, from which two wide arms emerge. It measures about 75,000 light-years across. It is classified as a Seyfert galaxy and is the third-most luminous galaxy in the Local Volume, after the Sombrero (NGC 4594) and the Andromeda Galaxy (M 31). NGC 253 and NGC 247, together with several dwarf companions, form a clump of galaxies in the Sculptor Filament, some 12.9 million light-years distant.

N
E ⌐ 2′

NGC 253, Bennett 4, Caldwell 65
Galaxy in Sculptor, $0^h 47.5^{min}$, −25° 17′, Size 29.0′ × 6.8′

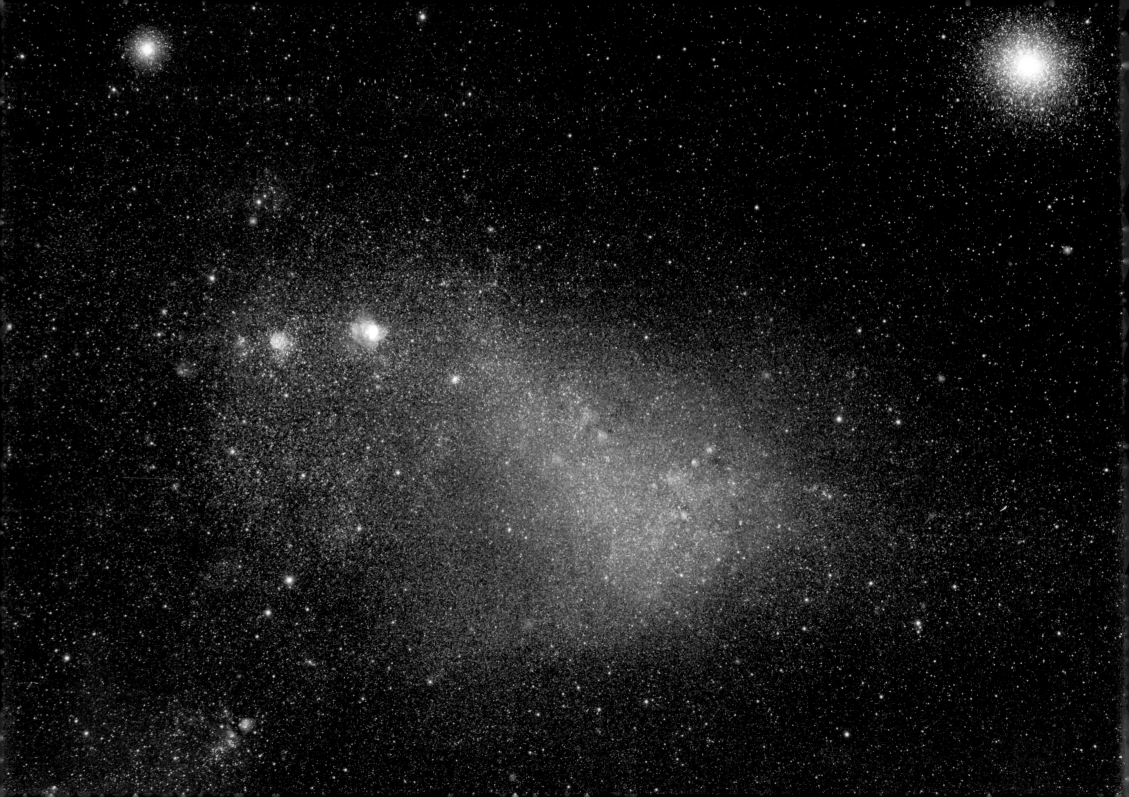

THE SMALL MAGELLANIC CLOUD

Identification chart
p. 167

The most singular aspect of the southern sky is undoubtedly the two Magellanic Clouds, companion galaxies of our Milky Way. At least 17 other galaxies are gravitationally locked to our galaxy, but all of them are dim at best and almost invisible at worst. The Large and Small Magellanic Clouds, in contrast, are prominent visual anchors, lying between the arc of the Milky Way and the south celestial pole.

On a dark summer evening, when the Milky Way rises gently in the south and highlights the eastern horizon before dipping away in the north, the Cape Clouds stand high in the south.

The Small Magellanic Cloud (SMC) lies in southern Tucana, and to the naked eye it appears as an essentially uniformly bright white (or perhaps bluish) teardrop-shaped cloud, some three degrees across. It contains ten or so bright deep-sky objects and many more, fainter, ones, including nearly 2,000 star clusters and 2 billion stars.

The SMC lies 190,000 light-years away and, like the Large Magellanic Cloud (LMC), is a satellite galaxy of our Milky Way. The Clouds are thought to orbit our galaxy once every few billion years, locked into a decaying orbit by the Milky Way's gravity. One result of our galaxy's gravitational effect on the SMC has been to stretch it out into an elongated cylinder, 60,000 light-years long and 15,000 light-years wide, with its long axis directed toward us. The SMC is further split along the line of sight into two fragments, probably as a result of a collision with the LMC some 300 million years ago. Such close encounters are thought to account for the presence of young star clusters and hot, young stars found within the SMC. Calculations suggest that the Clouds will only survive for another 10 billion years before their orbits decay and they are assimilated into our galaxy.

In 1913, Danish astronomer Ejnar Hertzsprung determined the distance to the Small Magellanic Cloud as 10,000 parsecs. He used observations of Cepheids in the Cloud, and Leavitt's law (relating their period and luminosity) calibrated with parallax observations of Galactic Cepheids, to derive this distance. It is currently accepted that the SMC is some six times farther. Despite this error, it was some time before it was challenged, because his value was larger than any distance determined in the universe at the time.

In the accompanying photograph, the magnificent globular cluster 47 Tuc can be seen at top-right, and the bright globular cluster NGC 362 at top-left. Both clusters can be seen with the naked eye. Despite appearing near the SMC in the sky, these globulars belong to our galaxy. NGC 362 lies 30,000 light-years from us, while 47 Tuc is half that distance.

Had NGC 362 been elsewhere in the sky, it would certainly be more appreciated. James Dunlop called it a "beautiful globe of white light," noting its similarity to Messier 2 in Aquarius.

The brightest feature within the SMC is NGC 346, well shown in the accompanying photograph in the upper left of the Cloud. Binoculars show it as essentially globular, like a dim version of NGC 362. A telescope reveals a complex mix of stardust and elongated nebulosity. NGC 346 is the largest starburst region in the SMC, containing many young massive stars within compact H II regions. Some 60 times more energetic than the Great Orion Nebula, it is considered a scaled-down version of NGC 2070, the Tarantula Nebula, in the LMC.

N
E
10'

NGC 292, ESO 29-21

Galaxy in Tucana, 0h 53min, −72° 48', Size 5.3° × 3.4°

THE SCULPTOR PINWHEEL

In a barren patch of sky in the southern reaches of the dim constellation Sculptor lies the intriguing NGC 300. Sweeping with binoculars helps with locating the galaxy, which has a moderately low surface brightness. It appears as a large (10′) oval smudge, elongated roughly east-west in a 10:7 proportion, with no brighter center A 9.5-magnitude star is immersed near the southwestern edge.

A small telescope at low magnification shows the galaxy readily as a large ethereal glow, with several small stars involved. Its gentle light brings to mind the naked-eye view of the Small Magellanic Cloud. Despite the wealth of detail revealed on the accompanying photograph, NGC 300 does not offer up its riches easily. The beautiful spiral arms and the giant star forming regions are difficult to see. The most visible feature in the arms is a bright knot 4′ due east of the galaxy's center. Veteran observer Stephen James O'Meara reports glimpsing traces of the two major spiral arms using a 4-inch (10 cm) refractor at 23x magnification.

NGC 300 was discovered by James Dunlop from Paramatta (Australia) in August 1826. Dunlop noted seeing four or five stars within the nebula, and suspected that it could be resolved. John Herschel saw it from his home, Feldhausen, in Cape Town (South Africa) in September 1834, noting its knotted appearance and specifically mentioning the prominent 1.5′ patch visible on the northwestern edge in the accompanying photograph.

NGC 300 was one of the galaxies studied with the Great Melbourne Telescope (GMT), the first large telescope at a state observatory anywhere in the world. Prior to its erection in 1869, all large telescopes were owned and operated by amateur astronomers. The GMT, with its 48-inch, 1-ton speculum primary mirror, was also the first large telescope to be designed and built by a professional engineer (Thomas Grubb), as well as the last large telescope to have a speculum mirror. The GMT's intended function was to review the observations made by Herschel some 30 years earlier. Work commenced in August 1869, with Robert Ellery as director.

An 1873 sketch of NGC 300 by GMT observer Joseph Turner shows the bright knot 4′ east of the galaxy's center. In 1884, observer Pietro Baracchi noted: "Searched for [NGC 300] on two nights in September; could not see it. Observed it on 7th October 1884.... I have examined it for hours." Baracchi suspected that the nebula had changed since Herschel's time, stating "the patch [to the east] does not exist at present, or it must be very much fainter than all the rest."

Regardless of whether this presumed change in the nebula is attributed to adverse weather, poor condition of the mirror, or differences in the observer's abilities, the Great Melbourne Telescope never performed satisfactorily. It was moved to Mount Stromlo Observatory near Canberra in 1944 and a new 50-inch mirror was installed in it. In the early 1990s, it was rebuilt a second time only to be badly damaged in the disastrous bushfire of 2003 that raged through the Mount Stromlo grounds. Work is currently in progress to restore the telescope and observatory buildings for eventual use in public outreach and education.

Morphologically, NGC 300 is a classic spiral galaxy, inclined 45° to our line of sight, spanning some 42,000 light-years across. Together with NGC 55 and two dwarf companions (ESO 410–5 and ESO 294–10), NGC 300 forms a loose quartet of galaxies about 6.4 million light-years away, within the Sculptor Filament.

Because of its visual similarity to Messier 33, NGC 300 is sometimes referred to as the Southern Pinwheel Galaxy.

N
E
2′

NGC 300, Bennett 6, Caldwell 70
Galaxy in Sculptor, 0ʰ 54.9ᵐⁱⁿ, −37° 41′, Size 19.0′ × 12.9′

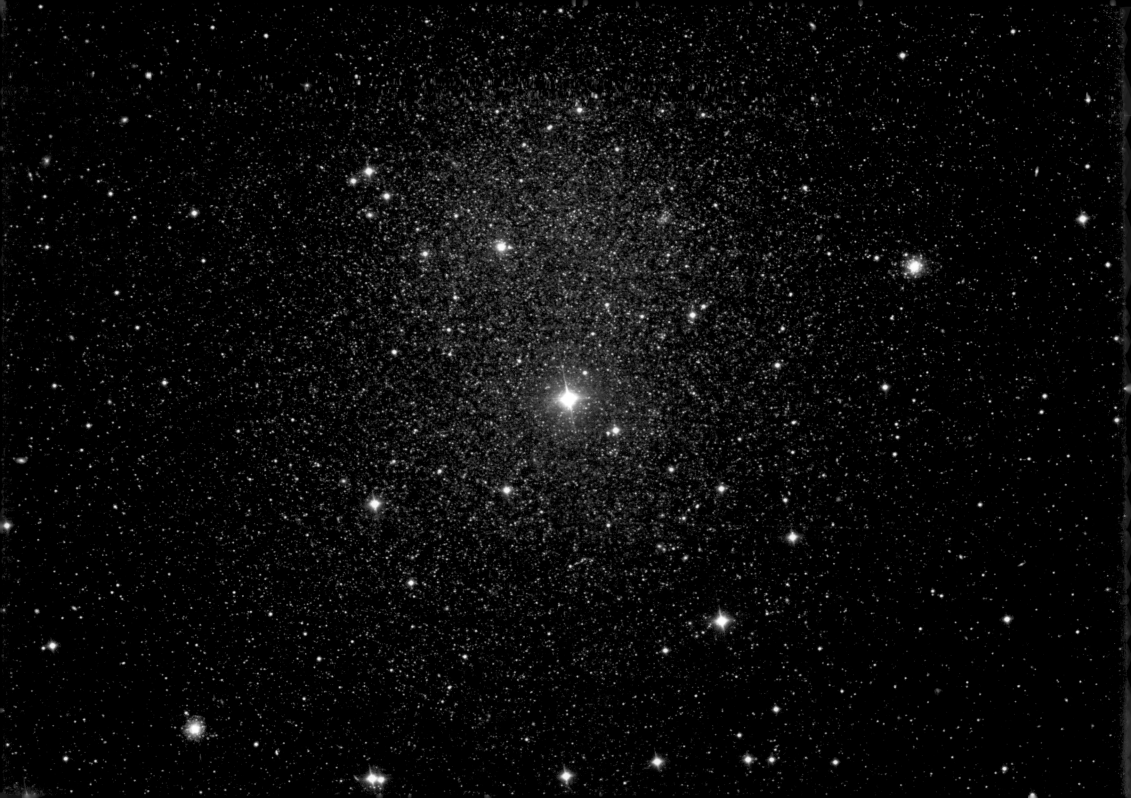

THE FORNAX DWARF

Identification chart
p. 166

Fornax lies on the banks of the river Eridanus, within the southernmost of two great meanders the majestic river takes as it trends northeast toward Orion. The brightest star inside this loop is α For (3.9 mag.), an interesting double star with a 7.2-mag. companion 5″ distant. Sweep 9° southwest to the orange-tinted 8.3-mag. star HD 16690. The Fornax Dwarf Galaxy envelopes this star.

Although easy to locate, the Fornax Dwarf can only be seen under the most favorable conditions. In fact, dark skies are more important than aperture to catch a glimpse of it, as it has a very low surface brightness. Binoculars show a very faint, irregularly-round glow, perhaps 15′ across, just to the northeast of HD 16690. Even with a sizeable telescope, not much more than a hazy patch is shown. The extra aperture lets the galaxy swell to about 20′, and it takes on an uncertain elongated shape.

The Fornax Dwarf was discovered in 1938, on a 3-hour photographic plate taken with the 24-inch Bruce telescope at Harvard's Boyden Station (Bloemfontein, South Africa). Despite its southerly position, it was photographed the following year by Walter Baade and Edwin Hubble with the 100-inch Hooker Telescope at Mount Wilson, revealing a diffuse elliptical object 50′ long and oriented northeast-southwest. The best modern values are 71′ × 14′ in PA 48°. Its integrated apparent visual magnitude is 7.6, giving a central surface brightness of just 23.4 magnitudes per arcsec2.

It is classified as a dwarf spheroidal (dSph) galaxy, a class of low-luminosity galaxy usually found as a companion to a much larger spiral galaxy. Initially it was thought that dSph galaxies are related to elliptical galaxies, but recent evidence suggests that spheroidals are formed when highly irregular spiral galaxies are subjected to destructive processes. These processes include supernova-driven gas loss and tidal stripping by the larger parent galaxy. Dwarf galaxies are the most common type of galaxy known, making up 90% of the population of the Local Group, and 80% of the galaxies in the Virgo Cluster.

The Fornax Dwarf is a satellite galaxy of our Milky Way, locked in an orbit that carries it once around in 3.2 Gyr. It is currently on approach to our galaxy and is located about 450,000 light-years away.

Fornax is one of the giants of its class, measuring 3,800 light-years across with a total luminosity of 14 million suns.

Several bursts of star formation occurred throughout its history: the majority of the stars formed about 5 Gyr ago, but it also contains a young (few 100 Myr old) and ancient (older than 10 Gyr) stellar population.

Unlike other dwarf galaxies, Fornax has a significant population of globular clusters. The finder chart on page 166 identifies three of its five known globular clusters, four of which can be seen in the accompanying photograph. The feature labeled "C" on the finder chart was first noticed by Harlow Shapley in 1939 and described as a "very faint cluster of unidentified character ... probably a part of the Fornax system." Paul Hodge, in 1961, showed it to be merely a group of faint stars.

Curiously, the globular cluster designated H3 was first seen in 1835, almost a century before its host galaxy was discovered. John Herschel, during his stay at the Cape, recorded it as "a curious little object and easily mistaken for a star," and it was catalogued as NGC 1049.

It has been suggested that the globular cluster H4 is, in fact, the nucleus of the Fornax Dwarf, based on its age, chemical composition, and location. This is analogous to the idea that Messier 54 is the remnant nucleus of "the Sagittarius (Sgr dSph) galaxy".

E
N
2′

ESO 356-4, MCG-6-7-1
Dwarf galaxy in Fornax, 2h 39.9min, −34° 27′, Size 71′ × 41′

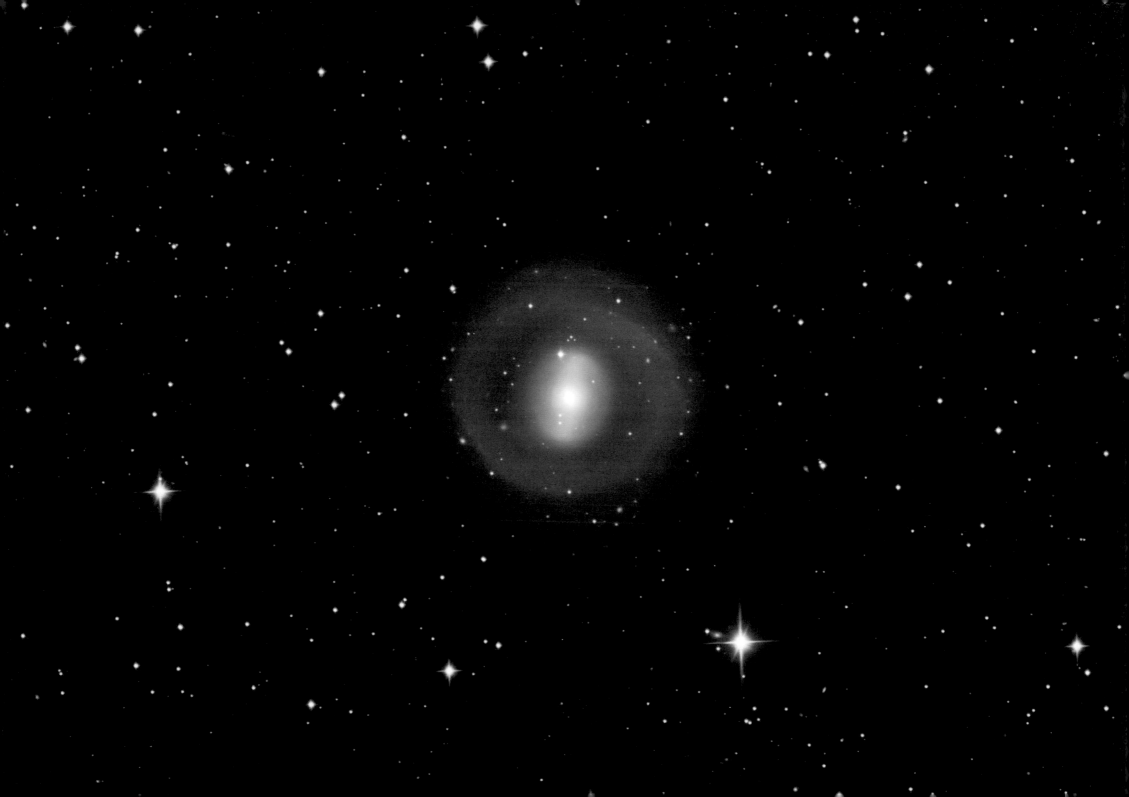

THE GOLDEN EYE

Follow the course of Eridanus the River upstream from Achernar (α Eri, 0.5 mag.) to Acamar (θ Eri, 3.2 mag.) and continue for a farther 3.5° to find NGC 1291, at the eastern tip of a zigzag of three 7.5-mag. stars.

Binoculars will show this galaxy from a suburban site as a fuzzy star and from a dark site as a bloated star embedded in a much fainter halo. A telescope reveals a large but dim outer halo about 8' across, within which lies a much brighter core (which some observers report as oval) about 3' across, containing a striking almost stellar nucleus.

NGC 1291 was discovered by James Dunlop in September 1826. Ten years later, John Herschel observed it from Cape Town, South Africa. Due to (presumably) a clerical error, he logged it twice, as NGC 1269 and NGC 1291. In December 1901, when Robert Innes failed to find NGC 1269 with the 7-inch Merz refractor at the Royal Observatory in Cape Town, he suggested that the two entries refer to the same object. Interestingly, that telescope was sent to the Observatory on the recommendation of Herschel, so that a suitable instrument would be available to re-observe the double stars he discovered during his stay at the Cape. It was during the course of his double star work with this telescope that Innes searched for NGC 1269.

Herschel's initial classification of NGC 1291 as a globular cluster stood until it was convincingly shown to be nebulous, on photographs taken between 1914 and 1916 with the 30-inch (76 cm) Reynolds reflector at Helwan Observatory, Egypt. The primary role of this telescope was to systematically image southern galaxies, a task which occupied the astronomers from 1909 to 1931.

The remarkable outer ring of NGC 1291 was discovered in the early 1920s by Charles Perrine, on photographs taken with the 30-inch reflector of the Argentine National Observatory at Cordoba. The reflector was designed and built in the workshops at Cordoba, and it served as a technology demonstrator to the Argentine government. It was the largest in the southern hemisphere, and Perrine, a skilled astrophotographer, produced noteworthy results with it. In the case of NGC 1291, it revealed "a spiral … surrounded by a large apparently disconnected ring," a combination Perrine noted as being unique.

Subsequently, many galaxies with ring-like structures have been discovered. Some rings are formed when a smaller companion galaxy collides head-on with a larger spiral. Such collisional ring galaxies typically have an off-center nucleus and an asymmetrical ring. A ring can also form as a resonance phenomena in a spiral galaxy having a bar. The rotating bar channels the movement of gas clouds in the disk into a prominent ring about the galaxy's center. Resonance rings are generally symmetric and due to the enhanced gas density, they are often sites of active star formation.

Morphologically, NGC 1291 is classified as an S-shaped barred spiral with a high surface brightness bulge, a diffuse bar, low surface brightness outer arms, and an almost complete outer ring.

It is isolated, having no known galactic companions, suggesting that it is a resonance ring system. Furthermore, recent X-ray studies have confirmed that its ring is the main site of star formation, hosting younger stars than are found in its bulge.

NGC 1291 is one of the nearest ringed systems, located 30 million light-years away, in the foreground of the Fornax I cluster.

Stephen James O'Meara has nicknamed NGC 1291 the "Snow Collar Galaxy," while Gerard Bodifee and Michel Berger dubbed it *Chrysopis Eridani*, (the golden-eyed)—a beautiful name for a beautiful galaxy.

N
E — |
2'

NGC 1291, NGC 1269, Dunlop 487, Bennett 12

Galaxy in Eridanus, 3h 17.3min, −41° 6', Size 11.0' × 9.5'

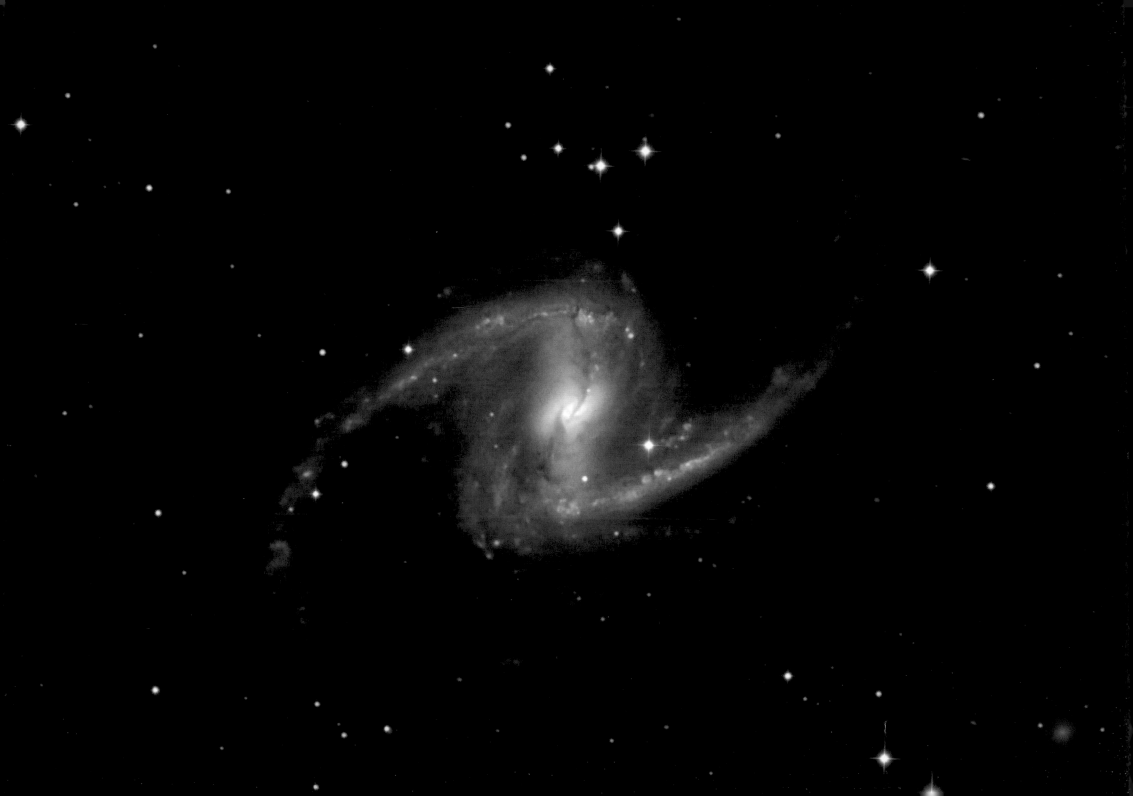

THE FORNAX PROPELLER

Follow the course of Eridanus the River from Achernar to Acamar (θ Eri), where the river makes a sharp eastward bend. Journey on for 10° to a triangle of 4th-magnitude stars (HD 24160, 23319 & 24072). Just 3° due west of the brightest star in the triangle lies the magnificent barred spiral galaxy NGC 1365.

Australian deep-sky doyen Ernst Johannes Hartung, author of *Astronomical Objects for Southern Telescopes*, called NGC 1365 "the best object of its type for the southern observer," and the photograph opposite shows why. It is one of only a handful of galaxies that clearly shows spiral structure in modest-sized telescopes.

In binoculars it is readily visible as a delicate round glow 3′ across, which becomes slightly brighter toward the center. It shares the field with two other prominent galaxies: NGC 1316 2.5° southwest and NGC 1399 just over a degree northeast.

A small telescope shows a large glow, elongated in PA 30°, with a bright core. Larger telescopes reveal its iconic Z-shape: a brighter bar with two fainter curved arms. Overall, the galaxy presents as a 8′ × 4′ soft hazy envelope. In the center is a brighter, narrow 3′ ellipse oriented east-west, the bar of the galaxy. In the center of the bar is a small, much brighter core, triangular in shape, about 10″ across, pointing westward.

From opposite ends of the bar the two graceful arms can be traced. One arm curves southward for 4.5′ from the eastern end of the bar, the other curves northward for 3.5′ from the western end. The southeastern arm, the fainter of the two, is however broader at its point of origin. The northwestern arm has several subtle, dark notches visible at high magnification, and nestled within its curve is a 13th-magnitude star, one of several stars within the nebula. A narrow triangle of 14th-magnitude stars lies 3′ east of the core, just outside the dimmest extent of the galaxy's envelope. Faint patches can be glimpsed between the bar and the arms, particularly to the south.

Although John Herschel was credited as the discoverer of NGC 1365 in Dreyer's *New General Catalogue*, it was James Dunlop who was first to see it, on September 2, 1826, noting only a "pretty large, faint, round nebula." Herschel called it "a very remarkable nebula. A decided link between the nebulae M 51 and M 27." His sketch shows the two arms as disconnected arcs, and he noted: "the preceding Arc is the brighter."

NGC 1365 is a barred spiral galaxy of gigantic proportions, spanning some 200,000 light-years, making it about twice the size of our Milky Way. Located 60 million light-years away, it is the most luminous spiral in the nearby Fornax I galaxy cluster.

It is inclined 40° to our line of sight, with the northwestern part closest to us. In addition to the two main spiral arms, secondary arms can also be seen, most prominently on the outside of the northwestern arm. As may be expected from the very bright nucleus, it is classified as a Seyfert galaxy with an active nucleus that presumably hosts a super-massive black hole.

Three star-forming regions near the nucleus of NGC 1365 were discovered in 2005. Some seven million years old, these are the most massive star clusters known, containing 10 million solar masses each. These young massive star clusters (YMCs) are thought to be proto-globular clusters, and are also referred to as super star clusters (SSCs).

The nickname for NGC 1365 is taken from Gerard Bodifee and Michel Berger's compilation, who note the similarity of the graceful spiral arms to the blades of an aeroplane propeller.

E
N
1′

NGC 1365, Dunlop 562, Bennett 16
Galaxy in Fornax, 3h 33.7min, −36° 8′, Size 11.0′ × 6.2′

FORNAX I

Identification chart
p. 166

The Fornax Cluster of galaxies lies on the northern bank of the river Eridanus, more or less midway between Acamar (θ Eri) and Theemin (υ^2 Eri).

Binoculars will show at least half a dozen of its members, with the three brightest—NGC 1316 (Fornax A), NGC 1365 (Fornax Propeller) and NGC 1399—sharing the same field of view.

Six of the brightest cluster members (NGC 1316, NGC 1317, NGC 1350, NGC 1365, NGC 1380 & NGC 1399) were discovered by James Dunlop, 12 by John Herschel, and 7 by Julius Schmidt in Athens. Schmidt (famous for his highly detailed lunar maps) used the 6-inch Plössl refractor at Athens Observatory for his discoveries, all of which were made on one remarkably productive evening: January 18, 1865.

The accompanying photograph shows the eastern portion of the Fornax Cluster. The prominent barred spiral near the bottom-left edge is NGC 1365. The brightest cluster member, NGC 1316 (not shown), lies 2.5° southwest of NGC 1365. An identification chart of the other bright galaxies in the photograph is given on page 166.

Some 16,000 clusters of galaxies are currently known, with the northern sky being richer in clusters than the southern. The closest rich galaxy aggregation is the Virgo Cluster, located 54 million light-years away and containing 1,170 galaxies. Fornax is the next closest at 65 million light-years and consists of 235 galaxies. The Fornax Cluster is considerably smaller (about half as large and with one-tenth the mass) than the Virgo Cluster, but the density of galaxies at the center (about 500 galaxies per cubic megaparsec) is twice as high.

This conspicuous concentration of galaxies was first recognized as a cluster by Harvard astronomer Harlow Shapley in 1943, who noted that it would be very unlikely that so many bright objects were close together in the sky purely by chance. "They appear to constitute a real colony of galaxies," he wrote.

The majority of the cluster's galaxies are centered around NGC 1399, a luminous elliptical galaxy with an extended halo and a large population of globular clusters. A sub-cluster of some 16 galaxies, dominated by NGC 1316, lies to the southwest. This sub-cluster is rich in star-forming galaxies, which are falling in on the main Fornax cluster.

Dwarf galaxies were discovered in the cluster in 1959, and globular clusters around the brighter galaxies in 1976. In 1996, astronomers using the 100-inch (2.5 m) Du Pont telescope at the Las Campanas Observatory (Chile) discovered a new class of object within the Fornax Cluster—the so-called ultra-compact dwarf galaxies (UCDs). They were soon found in other clusters, too, including Virgo, Centaurus, and Hydra. Larger than typical globular clusters, but smaller than dwarf galaxies, UCDs are thought to be the remains of dwarf galaxies, gravitationally stripped of their outer material by a close approach to a more massive galaxy. UCDs appear to be very rare outside of galaxy clusters.

The Fornax Cluster is also known as Fornax I to distinguish it from Fornax II, which is more commonly called the Eridanus Group. The Eridanus Group lies some 12° to the north, and is a large irregular structure. Its brightest galaxy is NGC 1395.

E

N 5'

Fornax I

Cluster of galaxies in Fornax, 3h 38min, −35°, Size 3.5° × 3.5°

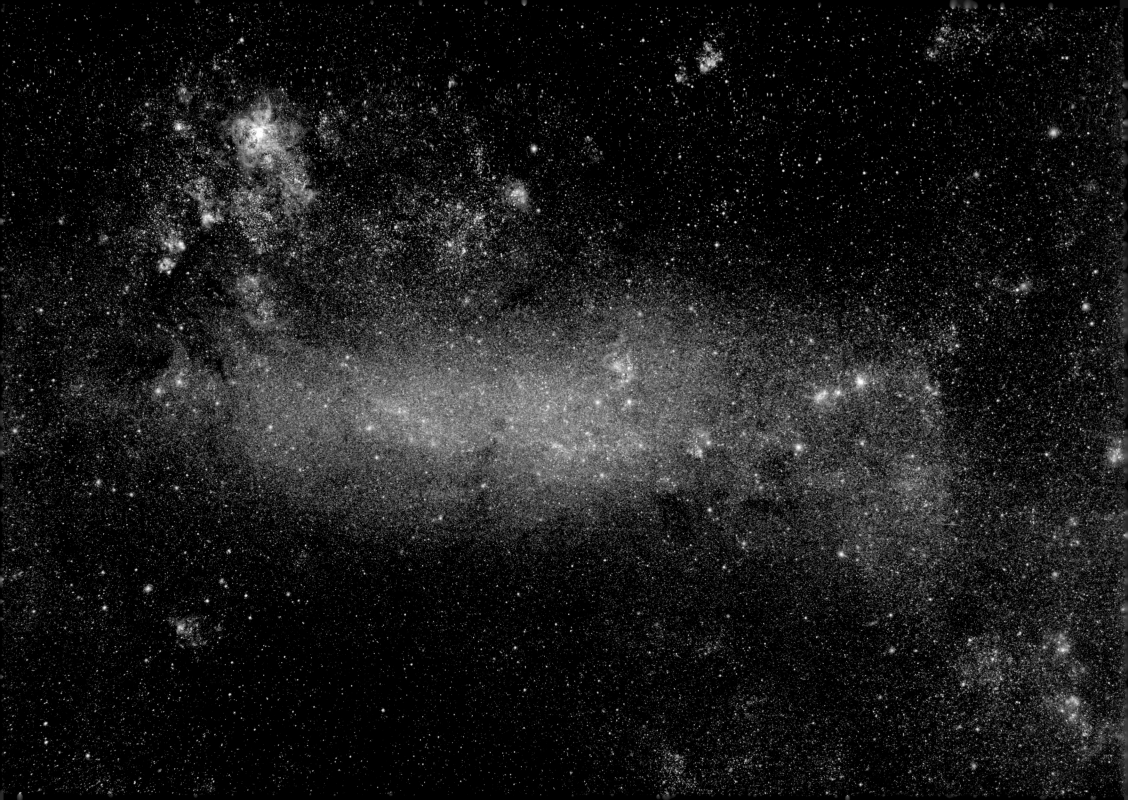

THE LARGE MAGELLANIC CLOUD

Identification chart
p. 167

The Large Magellanic Cloud (LMC) is surely the most outstanding southern deep-sky object. It is visible to the naked eye even in strong moonlight as an 8° elongated glow about 20° from the south celestial pole. As a prominent feature of the night sky, the Magellanic Clouds are recorded in the ethnoastronomy of the southern African peoples. The Ju/Wasi and !Kung Bushmen said that the larger cloud was a part of the sky where soft thornless grass grows, like the kind they used for bedding, and it was there the Creator paused to rest one day. The traditional Sotho saw the clouds as the spoor of two celestial animals: the LMC was the spoor of Naka, the Horn Star (Canopus), while the SMC was the spoor of Senakane, the Little Horn Star (Achernar).

15th-century European sailors knew them as the "Cape Clouds," and found them a useful navigational aid on their journey around the Cape of Good Hope. It was Antonio Pigafetta, Ferdinand Magellan's chronicler, who suggested that the Cape Clouds be called the Clouds of Magellan, as a memorial to the navigator and the epochal 1518–1520 voyage.

To the naked eye, the LMC appears oriented more or less southeast to northwest, broad at the southeast and tapering to a curved hook in the northwest. Some observers see the brighter southeastern end as curved, too, giving it an overall S-shape.

Like the Small Magellanic Cloud, the LMC is a satellite galaxy of our Milky Way. It is the nearest bright galaxy to us, lying some 160,000 light-years away. It is an irregular barred spiral galaxy more or less 32,000 light-years across. An observer using binoculars can see about as much detail in the LMC, as can be seen in Messier 31 with a 32-inch (81 cm) telescope.

The LMC is home to some 6,500 star clusters, many of which are young and enshrouded in glowing H II. This major bout of star formation was probably triggered by the effects of a close encounter with the Milky Way. The brightest part of the LMC is the fantastic NGC 2070 region, visible at top-left in the left-hand photograph and shown in detail overleaf.

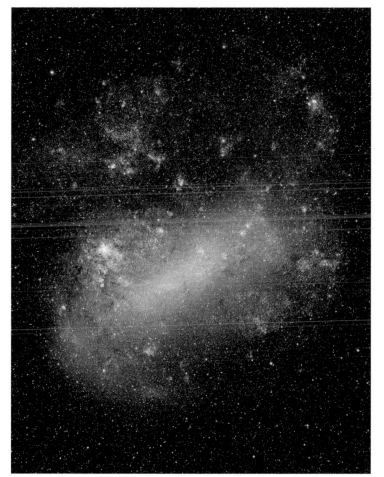

2°

N
E

A wide-field view of the Large Magellanic Cloud.

E N
15'

ESO 56–115
Galaxy in Dorado, 5ʰ 24ᵐⁱⁿ, −69° 45', Size 10.7° × 9.2°

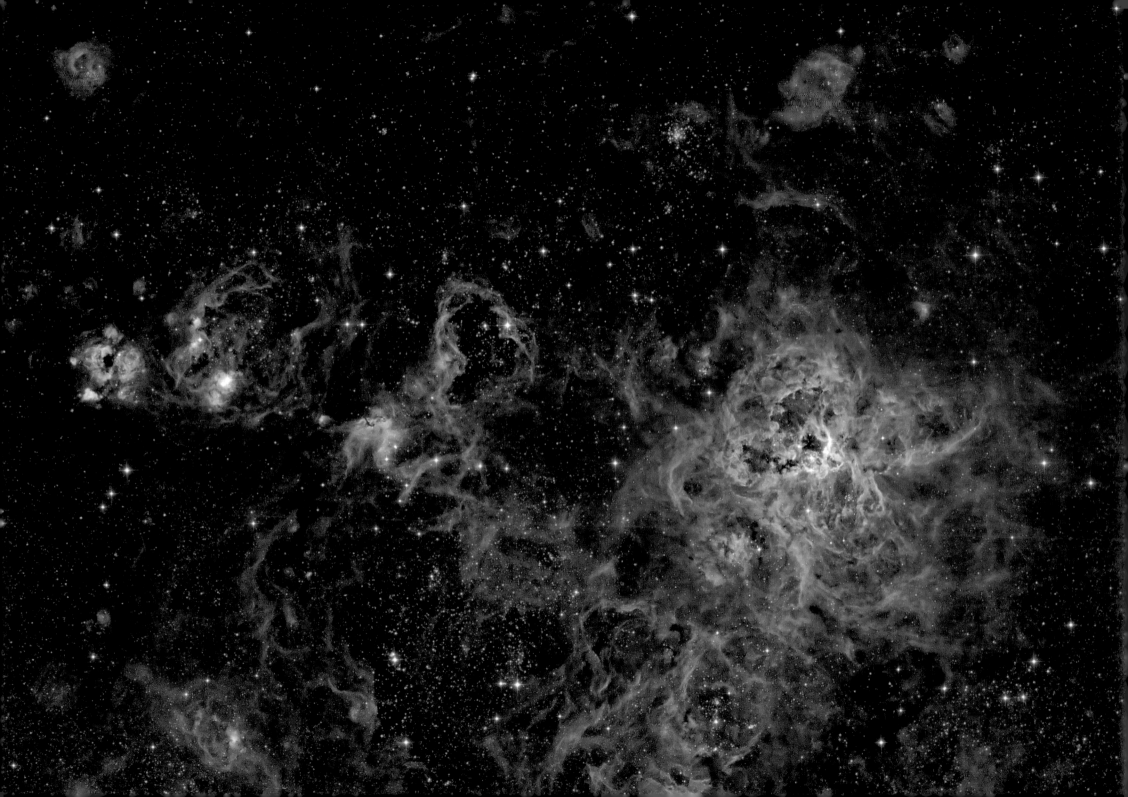

THE TARANTULA NEBULA

Through a telescope, the Tarantula Nebula is possibly the most splendid of all nebulae in the night sky, displaying convoluted, textured loops of nebulous light set against a star-rich background.

Visible to the naked eye in the eastern reaches of the Large Magellanic Cloud (LMC), this superlative object was first recorded by Lacaille. James Dunlop was the first to mention its irregular looped structures, which John Herschel naturally studied very closely during his southern survey.

Herschel's meticulous drawing of the nebula would later be used by other (over-enthusiastic) observers to prove that substantial changes had taken place within it. One such was C.E. Burton, an Irish amateur astronomer and telescope maker who was an assistant to the Earl of Rosse. In November 1874 he journeyed to the volcanic island of Rodrigues, northeast of Mauritius, to observe a transit of Venus. Making use of his southern vantage point, he drew a sketch of the Tarantula as seen through his 12-inch (30 cm) silver-on-glass reflector. When he later compared it against Herschel's sketch, he announced several changes in the nebula. Sadly, Burton died in 1882, just two days before he was about to embark on a second transit of Venus expedition at the young age of 35.

The Tarantula, some 158,000 light-years away, is the brightest emission nebula in the LMC, and it is indeed the most massive and largest-known star-forming region in the entire Local Group. The diameter of the nebula is over 900 light-years, and it contains a tremendous star cluster of some 2,400 massive, hot, young OB stars.

At the turbulent core of this cluster lies R 136, the densest concentration of very massive stars known. R 136 is the nearest super star cluster to Earth. Within its central eight light-years, 39 O3-type stars are crammed together, emitting 500 times more ionizing radiation than the Orion Nebula (Messier 42). Over a period of several million years, the most luminous hydrogen-burning stars have been forming within R 136.

The highly complex shape of the surrounding nebula is due in part to past supernova explosions that have created rapidly expanding—over 62 mi/s (100 km/s)—shells of ionized matter. The remnants of the dark molecular cloud out of which the stars have formed is spread out northeast to southwest behind them. The densest regions on the surface of this convoluted cloud glow brightly, forming an interwoven pattern of bright arcs that gave the Tarantula its characteristic looped form and name.

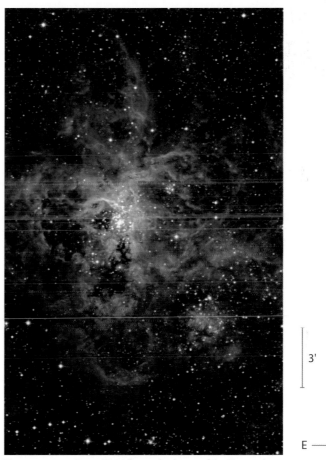

The super star cluster R136 lies at the heart of the Tarantula.

3'

N

E

E

N

3'

NGC 2070, Lacaille I.2, Dunlop 142, Bennett 35, Caldwell 103

Bright nebula in the Great Magellanic Cloud in Dorado, 5h 38.7min, −69° 6', Size 20' × 30'

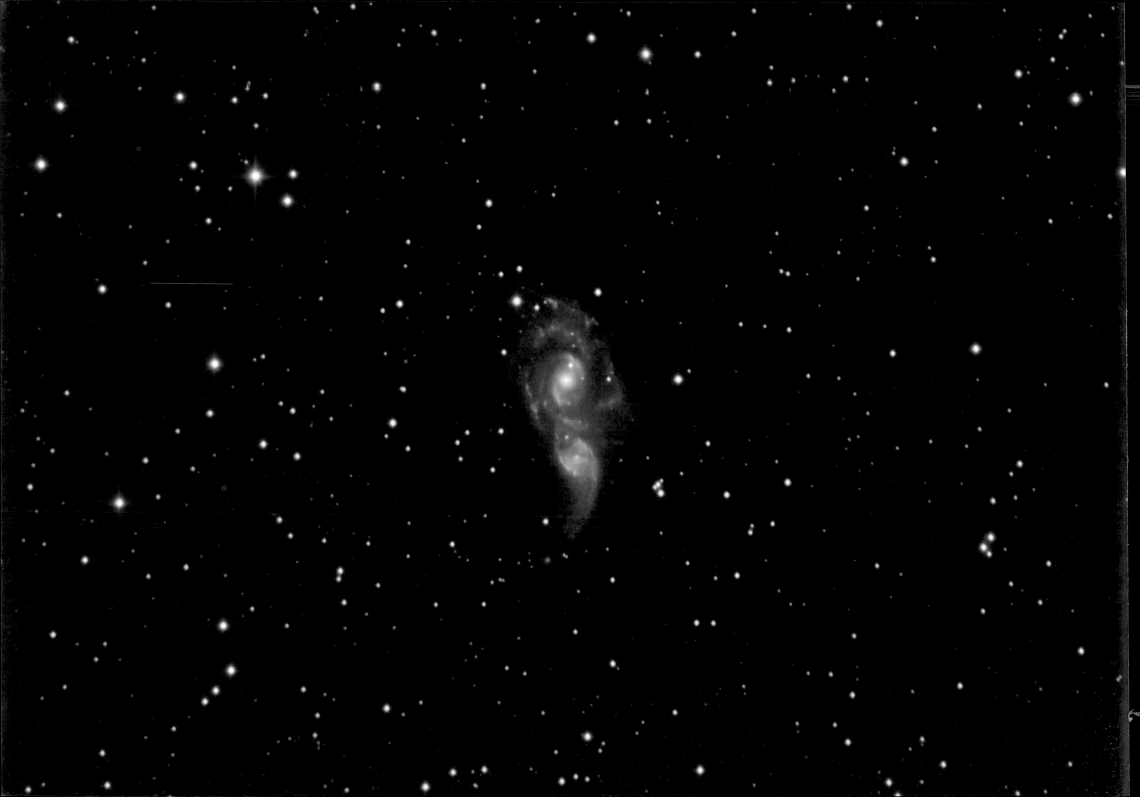

THE COSMIC OWL

Just off the main stream of the Milky Way, where it passes through Canis Major near the border with Lepus, lies an intriguing pair of galaxies.

NGC 2207, the westernmost component, was discovered in January 1835 by John Herschel at the Cape. In February 1898, it was observed by Herbert Howe, while he was using the 20-inch (50 cm) Clark refractor of the Chamberlin Observatory (University of Denver, Colorado, USA). Howe was engaged in a systematic review of southern nebulae, particularly those found by Lewis Swift, and in the process he discovered 60 of his own. Howe noted that NGC 2207 was bi-nuclear, with the easternmost nucleus being brighter. The fainter nucleus was catalogued as IC 2163.

The pair presents the observer with an interesting challenge. A small telescope will show them as a single hazy elliptical glow, with a brighter center, measuring $2' \times 1'$ oriented east-west. The challenge is to see them as two objects. Veteran observer Steve Coe reported seeing them well with his 13-inch (33 cm) Dobsonian but noted "the two galaxies were never seen as two distinct objects even at 220X." Armin Hermann used a 15-inch (38 cm) Obsession and noted that at lower magnifica-tions "the pair looks like one galaxy with a bright western part with a faint extension to the east." At higher power he was able to see the tidal arm of IC 2163 as a patchy feature east of the galaxy's center. At least one observer, Paul Alsing, has seen the pair clearly, noting broad and distinct spiral arms in NGC 2207, the distinct eye-shape of IC 2163, as well as its "showy tidal tail trailing outwards." No wonder—Alsing's remarkable observation was made with the 82-inch (208 cm) Otto Struve Telescope at McDonald Observatory (Texas, USA). The telescope was fitted with a 35-mm eyepiece delivering a 5' field of view and 812x magnification!

Detailed photographs of this pair reveal a beautiful duo of overlapping spiral galaxies. NGC 2207 is the larger one, displaying two long grand-design spiral arms with its north-northeastern side nearest to us. IC 2163 is oriented so that its north-northwestern side is closest to us, with its western arm hidden behind NGC 2207. Several hundred million years ago, IC 2163 moved from the near side of NGC 2207, passing within about 100,000 light-years of its center, to its far side.

Because of their close encounter, the disk of NGC 2207 has been strongly warped. IC 2163's disk was compressed and elongated, the large-scale gas-eous shocks creating a bright oval of star formation, visible in the accompanying photograph as "eyelids" around the central "eye" of IC 2163. The curving arc seen flowing eastward from IC 2163 is a tidal tail, the stretched-out remnants of several of its spiral arms.

Visible on the photograph a short distance northeast of the abrupt end of the tidal tail is a small round nebula. A team of astronomers led by Debra Elmegreen of Vassar College (Poughkeepsie, NY, USA) used the Hubble Space Telescope to identify it as a nucleated dwarf elliptical galaxy, with a V magnitude of 17.7. They also identified several regions of recent star formation in the galaxy pair. Two are located in the "eyelid" of IC 2163 and eight are in the northern spiral arm of NGC 2207. They conclude, however, that these clusters formed from local gravitational collapse, rather than resulting from cloud collisions, and that the interaction of the two galaxies has not led to unusual star formation.

Gravitationally locked in orbit, NGC 2207 and IC 2163 will continue to disrupt each other as their orbits inevitably converge, creating a single more massive galaxy several billion years from now.

The pair lie 114 million light-years away and are members of the NGC 2207 Cloud, which includes NGC 2217, NGC 2223, NGC 2280 and NGC 2139.

N
E 1'

NGC 2207 and IC 2163
Pair of galaxies in Canis Major, $6^h 16.4^{min}$, $-21° 22'$, Size 3.9' × 2.2'

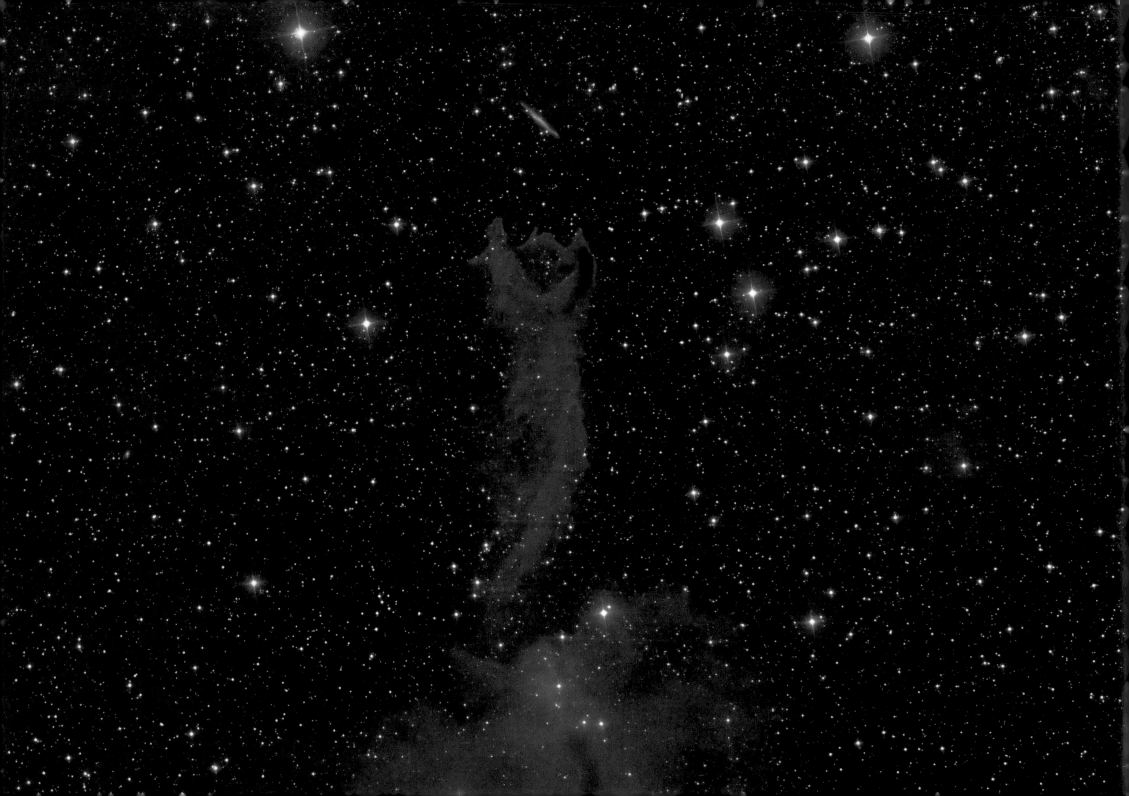

THE GALAXY CHASER

Within the extensive Gum Nebula (see p. 45) is a system of dark gas and dust clouds with bright rims and luminous tails that point away from the approximate center of the nebula. Because of their resemblance to comets, these clouds are known as cometary globules.

When such globules are blasted by ionizing radiation from a nearby source (usually an energetic O-type star) they fragment. The liberated material streams away to produce graceful tails, which can be up to 30 light-years in length.

In the case of the Gum Nebula, 36 cometary globules are known. They are arranged in a ring with a diameter of about 19°.

CG 4 is presented in the accompanying photograph, its gaping "mouth" lunging upward in pursuit of the barred spiral galaxy ESO 257–19, the streak-like nebulosity 6.5′ east.

CG 4 is one of the largest globules in the Gum Nebula. Its tail extends about 24′ westward, and the head, 8′ wide, points toward the peculiar star γ² Vel, 6° away. The ultraviolet radiation from this star is responsible for much of the shaping of this globule's impressive intricate structure.

The center of the head of CG 4 is almost completely eroded, leaving a hollow cavity with two "arms" surrounding it. This cavity, about 1.5 light-years across, contains diffused ionized gas, but no newly-formed star. The globule's total mass is in excess of 30 solar masses.

CG 6 lies to the northwest and is shown in the right-hand photograph above the brightest blue star. It is roughly 8′ long and 2′ wide at its broadest. Its "nose" also points toward γ² Vel, and its tail curves gently to the southwest. Its total mass is about 5.5 solar masses.

These globules are around one million years old, and formed from a common parent molecular cloud. Much of the nebulosity in the field between them is the remainder of this parent cloud. The darkest part of this cloud, west of CG 4 and south of CG 6, is the L-shaped Sandqvist 101 (DCld 259.2–13.2).

0.5°

E

N

The nebulous field surrounding CG 4 (top) and CG 6 (right of center).

E

N

3′

CG 4, Sandqvist 103, DCld 259.4-12.7

Cometary globule in Puppis, 7h 34.2min, −46° 54′, Size 24′ × 8′

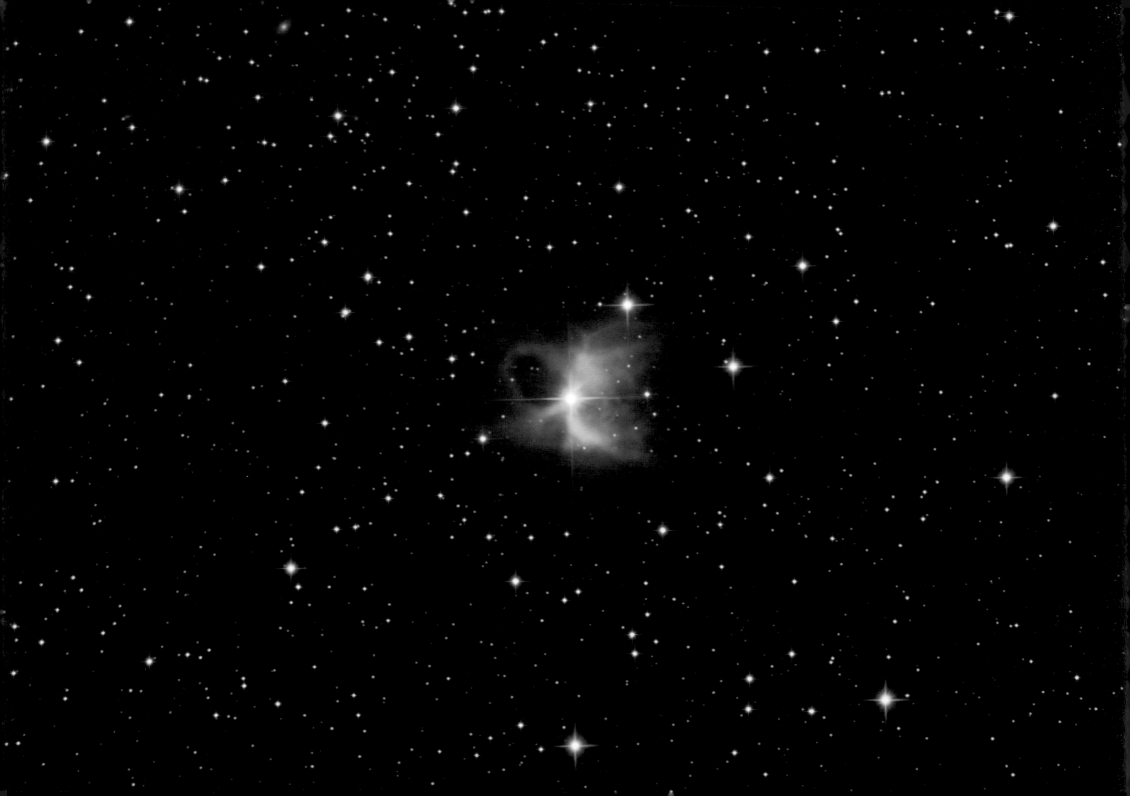

THE TOBY JUG NEBULA

Three degrees east of the foot of the False Cross, sharing the binocular field with the beautiful naked-eye open cluster NGC 2516, lies an ordinary-looking 7th-magnitude, yellow-orange star HD 65750.

Despite the thorough surveys of the southern skies by the early visual observers, the very curious nebula surrounding this star was only discovered in 1900 on a photograph taken by Harvard astronomer DesLisle Stewart. He described it as a very remarkable nebula, 2′ × 1′ in size, with two bright and two faint wisps in a spiral form.

Visually, IC 2220 is a challenge because of the glare of the bright star it surrounds. A telescope reveals it as a very faint haze with a brighter 1′ wisp pointing south-southwest and a shorter, fainter, streak pointing north-northwest. Two 10th-magnitude stars nearby add luster to the view.

HD 65750 is a cool, red giant that is undergoing substantial mass loss, generating a circumstellar envelope of interstellar dust (with a mass only one-hundredth that of the sun) that extends for half a light-year around the star, reflecting its light. This very rare example of an evolved star with its self-generated reflection nebula is a true southern

gem. An imaginary observer standing on the edge of the nebula would see the central star shining brilliantly at magnitude −10.9.

Since the nebula reflects the central star's light it has a similar color, in this case a pale orange-yellow. Measurements show that the color index for IC 2220 is B − V = +1.8.

Careful comparison of images taken four years apart reveal changes in the shape of the nebula: the northwestern wisp pointing away from the star, changed PA from 330° to 320°. It remains unclear if this change is caused by movement of the nebula, by changing illumination conditions or by a combination of both factors.

HD 65750 and its nebula are only 36 light-years away from the center of NGC 2516, and there is evidence that suggests it is a distant member of the cluster.

The curious nickname "Toby Jug Nebula" was coined by astrophotographer David Malin and his colleagues Paul Murdin and David Allen in their 1978 book *Catalogue of the Universe*. A Toby Jug is a traditional English pottery beer mug, with a large handle, in the form of a seated man or the head of a recognizable person such as an English king.

The Butterfly Nebula, another popular nickname for IC 2220, has an older pedigree. In 1973, the nebula was photographed by German astronomers Joachim Dachs and Jörg Isserstedt with the 24-inch (60 cm)/36-inch (91 cm) Curtis Schmidt telescope at Cerro Tololo (Chile). They wrote: "The main structural element of the nebula is a bright broad arc extending toward the northwest and the southwest from the central star. The brightest knot of nebulosity is located about 55″ south of the illuminating star.... Another extremely interesting feature of the dipole nebula is the bubble-like filament at the northeastern side of the central star... The nebula resembles a butterfly."

N
E ⌐
1′

IC 2220, ESO 124–3
Bright nebula in Carina, 7^h 56.9min, −59° 8′, Size 5′

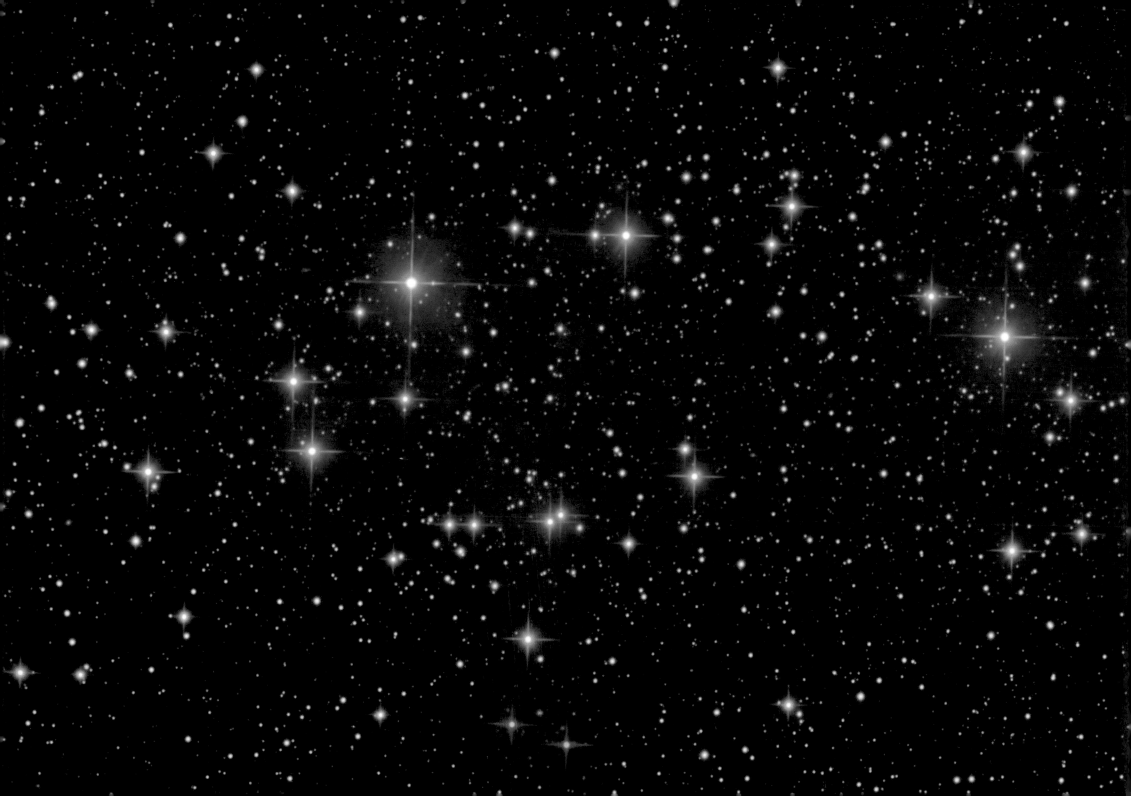

THE HEART CLUSTER

The Southern Right Angle is a large right-angled triangle of stars made up of γ Vel, λ Vel and ζ Pup (see the Milky Way panorama on page 11). Two degrees due south of γ Vel lies NGC 2547, a striking naked-eye open cluster that is a sparkling delight in even the smallest binoculars.

The brighter stars give it an overall triangular shape (about 17′ across), with one blue-white star (HD 68478, 6.5-mag.) outshining its companions.

Striking loops of star chains make this an exceptional stellar gathering. Lacaille saw it as "five faint stars, like the letter T, in nebulosity." James Dunlop said it was "a curiously arranged group" of stars, and in his sketch represented it as an inverted question mark.

The most obvious stellar chain curves north-south along the eastern border of the cluster, and includes the brilliant HD 68478. A second shorter east-west line of stars occupies the western portion of the cluster. Together, they suggest the shape of the Greek tau.

In *Touring the Universe Through Binoculars*, deep-sky observer Phil Harrington notes that "over 80 stars belong to this dazzling starry array, with more than a dozen shining brighter than 9th magnitude. This group always reminds me of a curved cross lying on its side."

These star chains enclose essentially starless sky when viewed under less-than-ideal conditions. According to South African observer Magda Streicher, the more obvious dark patches, rimmed by the stars, form a graceful cartoon heart shape, with the tip pointing to the north.

As is often the case with large open clusters, estimates of its visual extent vary widely. Dunlop reported a diameter of 12′, and early measures on photographic plates record values around 20′. A diameter of half a degree is not unreasonable, within which a modest-sized telescope will reveal about a hundred stars in addition to the dozen or so bright members.

John Herschel saw "a very large, loose, brilliant cluster of very scattered stars," estimating that between 100 and 150 stars could be seen.

Lacaille's original classification of NGC 2547 included it in the category of objects consisting of stars involved with nebulosity. Dunlop looked specifically for the nebulosity and failed to find any. While it is certain that the limited light-grasping power of Lacaille's small refractor (½-inch aperture) caused him to see the fainter stars as a nebulous haze, there is indeed a nebula associated with this cluster.

In 1985, three astronomers, Jan Brand, Leo Blitz and Jan Wouterloot, searched the ESO/SRC and Palomar Observatory Sky Survey prints for H II regions and reflection nebulae in order to study the structure and rotation of our Milky Way. They compiled a catalogue of 400 objects, the majority of which were new discoveries. One of these, Bran 115 (sometimes written BBWo 115), is an "extended red emission around [the] cluster [NGC 2547]." It has since been taken up in the catalogue of reflection nebulae published in 2003 by the Armenian astronomer Tigran Magakian.

NGC 2547 is a young grouping, more or less 30 million years old, that lies 1,400 light-years "down" our Local Arm of the Milky Way.

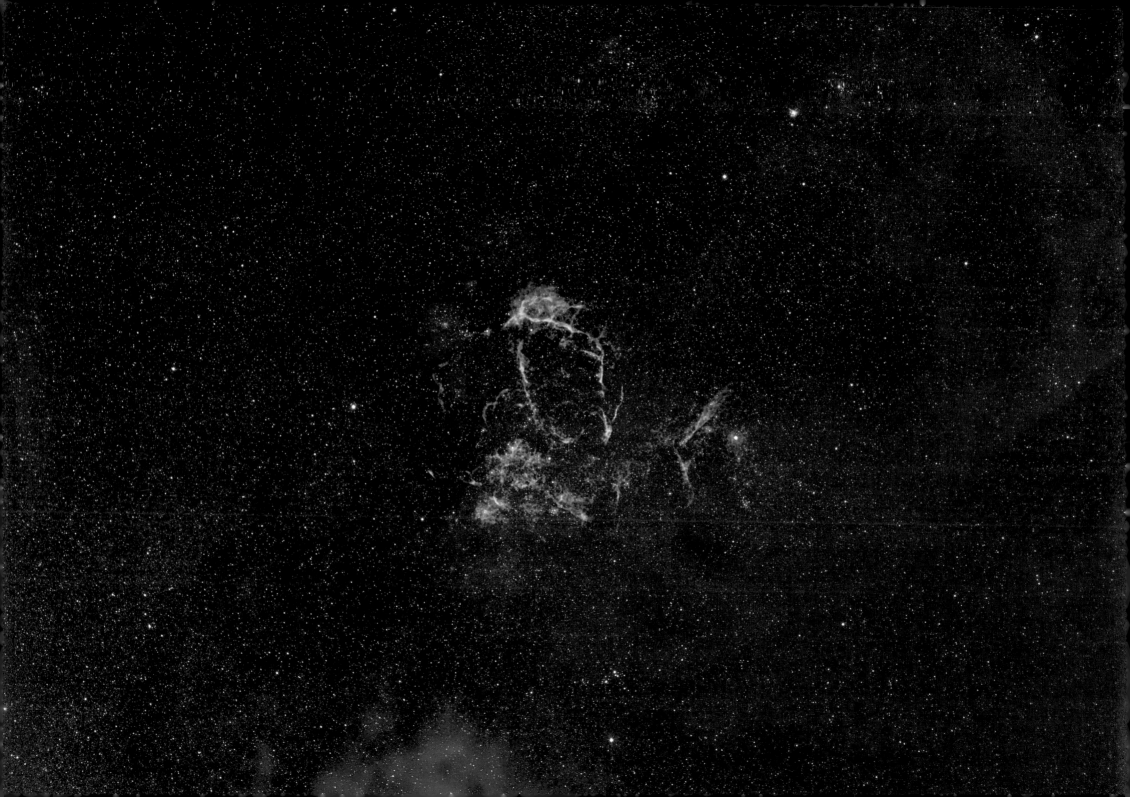

THE GUM NEBULA

For two centuries after Lacaille's constellation reform, a secret lay hidden amongst the stars of ancient Argo. Unseen by pioneering observers like James Dunlop, John Herschel and William Lassell, and undetected by early astrophotographic surveys of the southern skies, a huge nebula lay along the Milky Way, engulfing the Southern Right Angle.

About 1.5 million years ago, a massive star in our galaxy went supernova, enriching the interstellar medium with the nuclear products of its destruction. Today, its 800 light-year-diameter distorted bubble of starstuff is spread out over 36° of sky, and it can be seen in the accompanying photograph as the extensive red nebula in the center and to the right of the image (Gum 12a) with an isolated filament at extreme left (Gum 12b, in Antlia).

At the time of its destruction, this star had a companion that was sufficiently far away to not be destroyed by the powerful explosion. It was flung out into space, and today we see it as the 6th-magnitude runaway star ζ Pup; the brightest known O-type star, marking the northwestern corner of the Southern Right Angle. ζ Pup is the primary source of UV photons that ionizes the Gum Nebula and gives it its characteristic red glow.

As the Gum supernova remnant (SNR) expanded, it created a cavity, within which another star ended its life in a supernova explosion a few thousand years ago and 940 light-years away. This explosion created the Vela SNR, visible in the center of the image as a blue-green filamentary loop.

Another curious star in this region is γ² Vel, marking the southernmost corner of the Southern Right Angle. It lies about 1,000 light-years away from Earth and is the brightest Wolf-Rayet star in the sky. Flowing from it is a powerful stellar wind that is blowing a huge expanding bubble into the rich surrounding interstellar medium. The stellar wind bubble is 320 light-years in diameter (7.6° on the sky).

The Vela SNR and γ² Vel are just 140 light-years apart, so the expanding SNR has physically intersected the bubble blown off the Wolf-Rayet star, distorting its shape.

The Gum Nebula was discovered by Clabon Allen (famous as the editor of *Allen's Astrophysical Quantities*) in 1951 while examining spectra of stars in the region, which suggested the presence of a large nebulosity in the sky.

Its existence was confirmed the following year by Allen's student, Colin S. Gum, who found a 20° diameter crescent nebulosity containing γ² Vel and ζ Pup. Gum was conducting a survey of southern H II regions as part of his Ph.D. work, using a 4-inch (10 cm) f/1 Schmidt film camera, loaded with 22-mm disks punched from 35-mm film. The photographs, exposed for 20 to 60 minutes, each covered an 11° field of view. Analysis of these slivers of film led to a list of 85 nebulae, which he numbered "Stromlo 1" and so forth. In addition, Gum also noted the proximity of bright O- and B-type stars that could potentially be the source of nebular ionization.

In the case of what we now call the Gum Nebula, there were outlying fragments that were clearly ionized but had no suitable exciting stars nearby. This led Gum to conclude that these fragments formed part of a single, large, H II region. He wrote: "[T]here seems to be little doubt that all the nebulous fragments in this area are outlying parts of the large nebula in Vela and Puppis. When the isolated fragment (Stromlo 12b) is included, it appears that the fragments of the Vela-Puppis nebulosity are scattered over an area of sky covering roughly 40° by 30°!"

Gum died in 1960 following a skiing accident in Switzerland at the young age of 36.

N
E
2°

Gum 12
Bright nebula in Vela, Puppis, and Antlia, 7h 58min, −43°, Size 36°

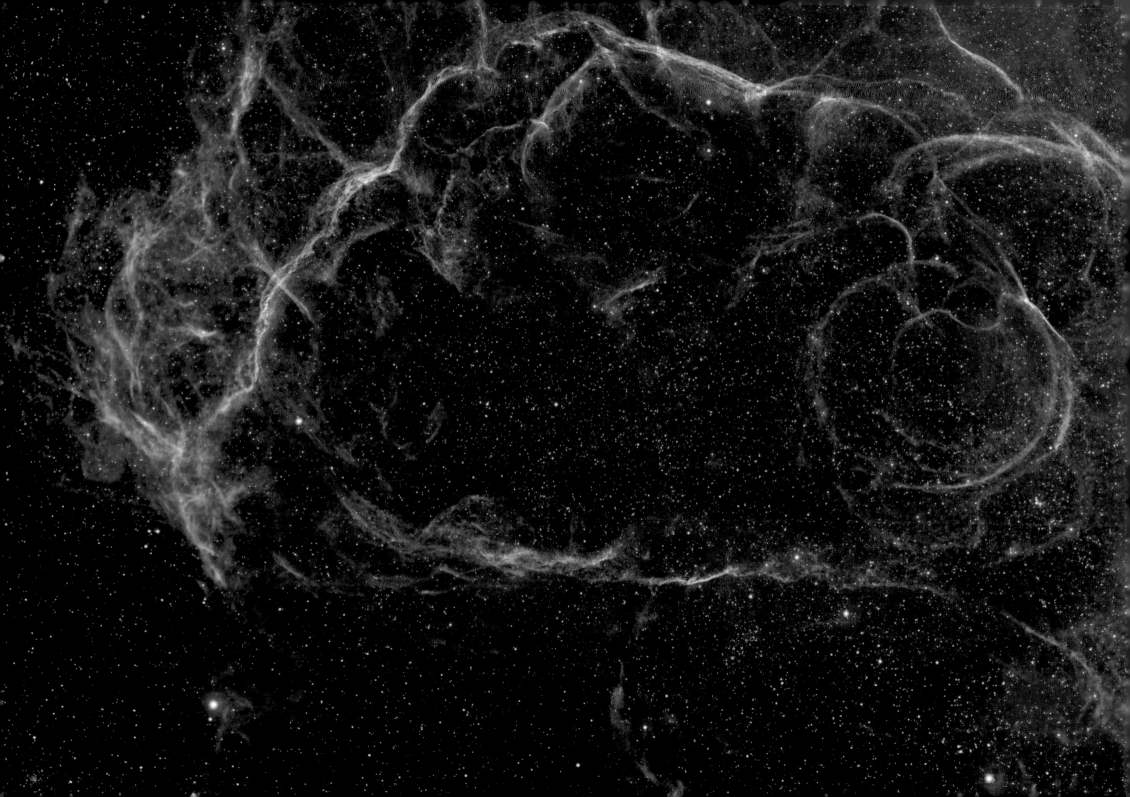

THE VELA SUPERNOVA REMNANT

The Vela Supernova Remnant (Vela SNR) lies within the massive Gum Nebula (see p. 45) and is one of the closest SNRs to Earth, located about 1,600 light-years away. The cataclysmic event that created this delicate filamentary object occurred approximately 11,000 years ago.

The nebulosity was first noticed in 1926, by the English astronomer Philibert Melotte while examining photographs made with the 10-inch (25 cm) Franklin-Adams Star Camera as part of a program of compiling a list of star clusters. On one plate he found a large extended nebula in Vela, consisting of "a number of bright nebulous streaks, some of the brightest of which outline an area, seven square degrees in extent, roughly oval in form." He did not, of course, realize what an exceptional object he had found.

Several years later, the region was photographed at Harvard's Boyden Observatory in Bloemfontein, South Africa. The astronomer in charge, John Paraskevopoulos used the 10-inch (25 cm) Metcalf triplet (a wide-field photographic telescope) to survey the southern skies. This telescope was designed and built by the Rev. Joel Metcalf, who ground the lenses as a pastime, mainly during summer holidays in Vermont, USA.

On a photograph examined in 1940, Paraskevopoulos found a "bright string nebula in Vela." Harlow Shapley, then Director of Harvard College Observatory, remarked on its extreme length and narrowness, writing that it was visible as an irregular wavy arc 4.5° long and about 2' wide. It became known as "Shapley's String Nebula" (or the "Bright String Nebula"), and it is the brightest western portion of the Vela SNR.

The connection between Melotte's nebula and the String Nebula was made in 1954 by Walter Baade and Rudolph Minkowski when they associated a recently discovered radio source with "a new type of galactic emission nebulosity... a loose mass of filaments which greatly resemble the filaments of the Cassiopeia source."

The Vela SNR can be seen in even small instruments, provided an O III filter is used. Veteran observer Sue French, using a 4-inch refractor, calls it "an astounding complex of nebulosity [that] is a good target even for a small, wide-field scope."

The brightest portion, as the accompanying images show, is to the north, where the 4.1-mag. star e Velorum (HD 73634, left of center in the image opposite) acts as a useful visual anchor.

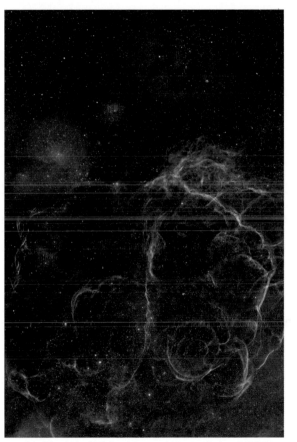

North of the Vela SNR lie three emission nebulae: RCW 33 (left edge, above center), RCW 27 (top-right) and RCW 22 (in between).

Vela SNR, Vela (XYZ), G263.9-03.3
Supernova remnant in Vela, 8h 34.0min, −45° 50', Size 4.3°

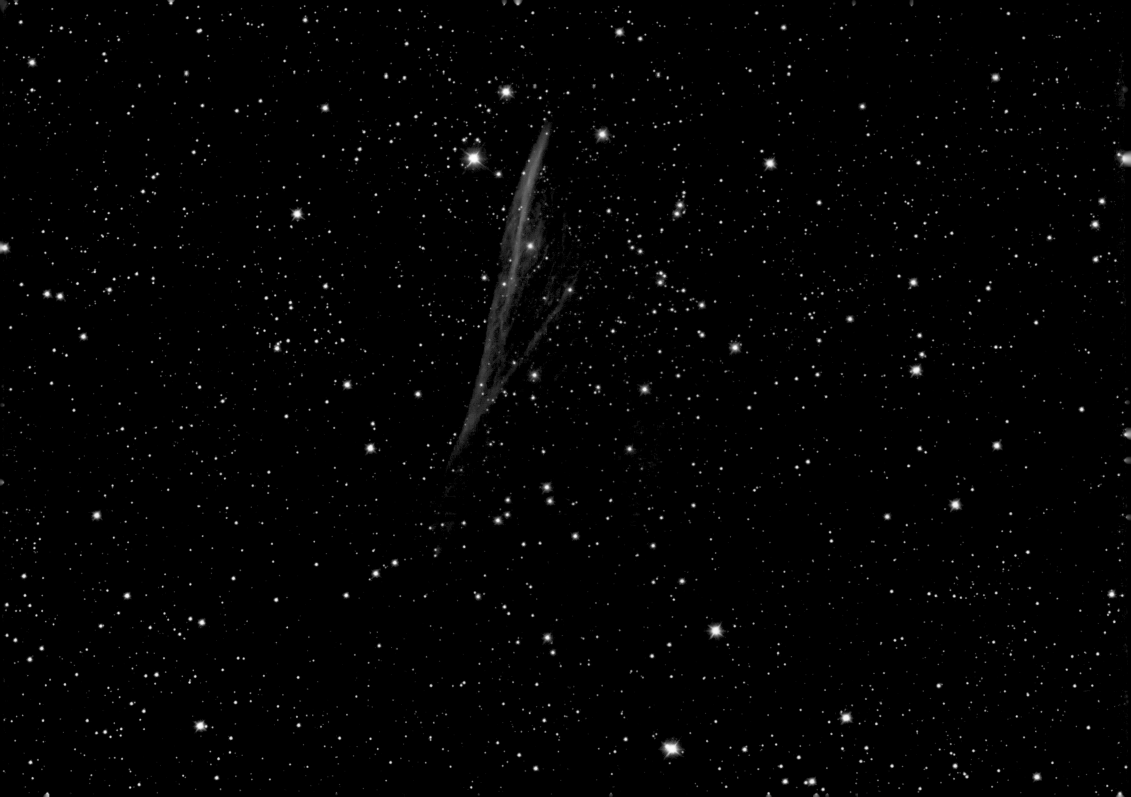

HERSCHEL'S RAY

Located just 3° south-southwest of the bright-orange star λ Vel, the easternmost star of the Southern Right Angle, is an outlying filament of the Vela Supernova Remnant (p. 47). It is shown in the photograph of the Gum Nebula (p. 45) to the bottom-right of λ Vel, which is left of the center of that image.

NGC 2736 is plainly visible using a modern 12-inch (30 cm) telescope, while even a 4-inch (10 cm), equipped with an O III or UHC filter, will show its slender form, running north-northeast to south-southwest for over 20′. Two stars (8.3 and 9.7 magnitude) at its northeastern edge helps secure its position, while two 8.6-mag. stars 6.5′ apart to the southwest help define its full extent.

Veteran observer Brian Skiff, using a 6-inch (15 cm) refractor, described it as a "remarkable, extremely long, extremely thin" nebula, 25′ long and 1.5′ wide, having a relatively sharply defined eastern border and a smoother fading western edge.

John Herschel discovered NGC 2736 in March 1835, from "Feldhausen," his temporary home in Cape Town, South Africa. His 18-inch (46 cm) f/13 speculum mirror telescope showed him an "extraordinarily long narrow ray of excessively feeble light… at least 20′ long." He noted that the northeastern end was brighter and narrower than the southwestern end.

Herschel's Ray was one of the objects studied some 40 years later by observers with the Great Melbourne Telescope (GMT) in Australia. In 1876, GMT observer Joseph Turner wrote: "I feel certain that Herschel could not have seen this object had it been as faint when he observed it as it is at present. Indeed, with regard to a great number of nebulae, the conviction seems forced upon one that they are gradually becoming fainter than formerly."

Several years later, GMT observer Pietro Baracchi saw it as "extremely faint, a long streak across the field, straight, very narrow, with a peculiar group of stars [to the northeast]… Streak spreads out at its [southwestern] end, and becomes a large irregular-shaped whitishness, without distinct contour." He added: "This object has been searched for in vain several times."

In 1940, Harvard astronomers Harlow Shapley and John Paraskevopoulos published a series of photographs made with the 60-inch (152 cm) reflector at Boyden, South Africa. They included NGC 2736 (which they nicknamed the Streak Nebula) noting its peculiar appearance as a 20′ long wedge, 3′ wide at the base.

Probably the most remarkable fact about this nebula (also called the Pencil Nebula or Herschel's Pencil) is that evidence suggests it is a part of the inner edge of the Vela SNR, heated by a blast wave from a more recent supernova, Vela Junior.

When Vela Jr exploded inside the Vela SNR, the latter was already many thousands of years old, and had swept up the interstellar medium into a cold, dense, shell at its boundary. A blast of hot gas vented from Vela Jr impacted the old wall, creating a curved sheet of emission tracing the inside edge of the Vela SNR shell.

Astronomy historian and deep-sky expert Wolfgang Steinicke notes in his authoritative *Observing and Cataloguing Nebulae and Star Clusters* that there are only two galactic supernova remnants listed in the New general Catalogue: Messier 1 (in Taurus) and the Veil Nebula (in Cygnus). Herschel's Ray can perhaps be counted as a third (although partial) member of this exclusive club.

E N 3'

NGC 2736, RCW 37
Bright nebula in Vela, 9h 0.2min, −45° 57′, Size 20′ × 2′

THE GLOWING BUTTERFLY

In the shadow of the False Cross lies the curious planetary nebula NGC 2899. It is positioned midway between the brilliant-white kappa Velorum (the easternmost star of the False Cross) and the attractive orange N Velorum.

The intricate details revealed in the photograph opposite are all but invisible in most telescopes. John Herschel's discovery observation, recorded on February 27, 1835, gives no hint of the nebula's exceptional form. In a finder the planetary appears stellar and care is needed to pinpoint it – the surrounding 1° field holds 80 stars brighter than 11th magnitude. In a 6-inch (15 cm) telescope, it is readily visible as a dim, subtly elliptical glow, 1.5′ across, that is ever-so-slightly brighter in the middle. It is noticeably bounded by four faint stars, one at each compass point, that seem to pin it down like a specimen in an entomologist's collection. Through 16-inch (40 cm)and larger telescopes the nebula's complex structure, such as the scalloped edges and narrow waist, can begin to be appreciated.

The identity of the central star, which energizes the nebula, is a puzzle. Two stars (magnitude 15.3 and 15.7), just resolved in the photograph, lie near the center and either could be taken for the central star. However, their spectra reveal them to be F-type stars, which rules them out since such stars are not hot enough to excite the nebulosity. Closer examination of the spectrum of the easternmost (brighter) star shows that it is most likely a binary, consisting of a cooler F-type star (dominating the optical spectrum) and a hotter UV-bright white dwarf. This makes NGC 2899 a rare example of a planetary nebula with a binary central star.

The reddish color of NGC 2899 is also remarkable. Planetary nebulae tend to be greenish because of the presence of ionized oxygen (O III). Spectral studies of NGC 2899 confirm the abundant presence of nitrogen in the nebula, and when nitrogen is ionized (N II) it glows red.

NGC 2899 is located in the galactic thin disk, some 3,900 light-years away, floating in space between the Orion Spur and Carina-Sagittarius Arm of our galaxy. On the accompanying photograph, the nebula extends for 2.2′ on its longest axis; deeper images trace it out to 2.6′, making its true diameter about 3 light-years.

Infrared studies of NGC 2899 have revealed some of the impact the formation of the nebula has had on its environment. Far beyond its visible extent lies a massive bubble, some 40 light-years across (½ in angular size). This bubble took around a million years to form and contains most of the mass originally lost from the highly-evolved central star as powerful stellar winds, with speeds up to 43,000 mph (70,000 km/h), swept its outer material away into space.

As if NGC 2899 is not already curious enough, there is some evidence to suggest it belongs to a very exclusive club indeed. One degree south of NGC 2899 lies the beautiful open cluster IC 2488, a large puff of soft light guarded by nearby N Velorum. Discovered by Lacaille, it was missed by John Herschel and was included in the Index Catalogue by Solon I. Bailey. Recent findings show that NGC 2899 may be a member of this open cluster. Available data place the objects at similar distances, but good radial velocity measurements would be needed to settle the matter. Interestingly, the faint planetary nebula VBRC 2 (PNG 277.7–03.5), also about a degree from IC 2488, has similar distance estimates that place it near the open cluster, too.

As a further aside, two well-known examples of suggested cluster/nebula pairings, NGC 2818 & NGC 2818A in Pyxis, and NGC 2437 (Messier 46) & NGC 2438 in Puppis, have recently been shown to be chance alignments with no real physical connection.

E

N 1′

NGC 2899, Gum 27, PN G277.1-03.8, RCW 43
Planetary nebula in Vela, 9ʰ 27.0ᵐⁱⁿ, −56° 6′, Size 1′ × 2′

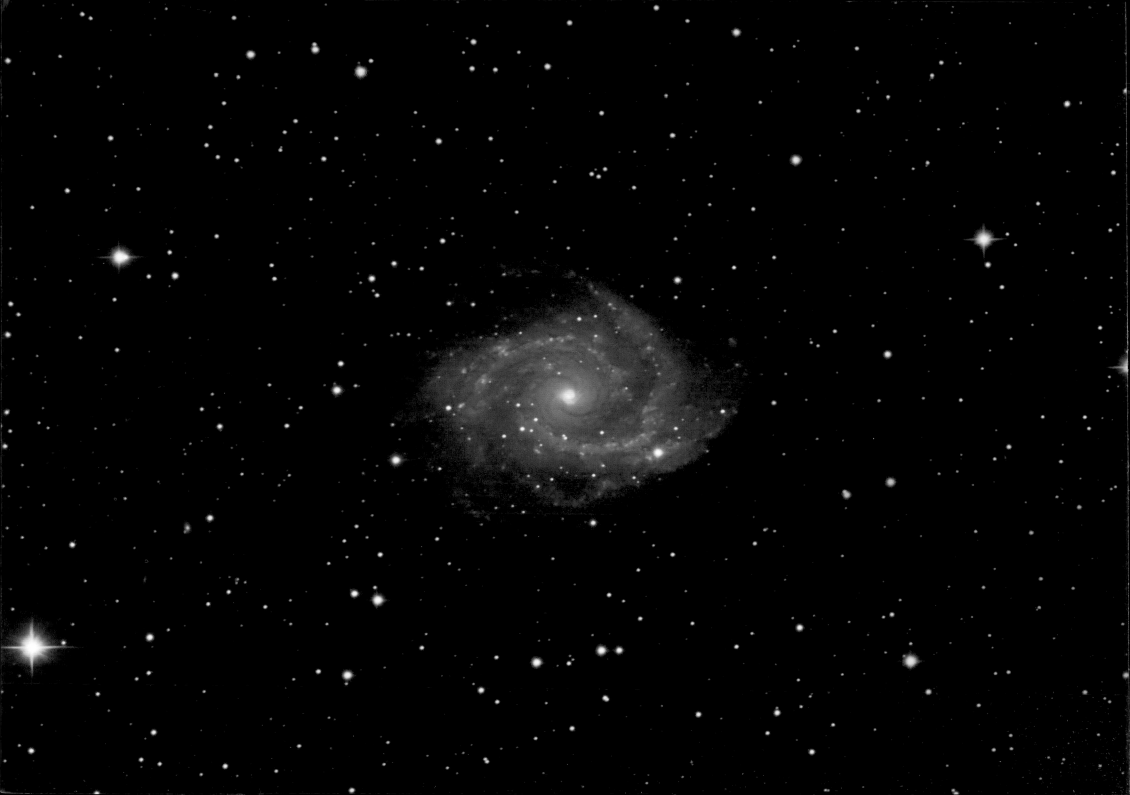

THE ANTLIA SPIRAL

Antlia is a dim patch of sky north of the False Cross, midway between Corvus and Canis Major. Its brightest star is only of magnitude 4.3, so we will have to take Lacaille's word for it that it represents *la Machine Pneumatique*, a state-of-the-art air pump used by experimental physicists of his day. Nine degrees due west of α Ant, at the foot of the air pump, lies the charming spiral galaxy NGC 2997.

It was discovered in March 1793 by William Herschel, three days before his son John's first birthday. As a man of 44 years of age, John Herschel observed it from Cape Town and noted it was a very remarkable object; stating it was faint, very large, with a much brighter center forming a distinct round nucleus and looking "exactly like Halley's comet as now (February 16, 1836) seen in the equatorial [5-inch (13 cm) f/17 refractor]."

Large binoculars under good skies may just show a glimpse of NGC 2997, which can be found by sweeping 3° east-northeast from the 6th magnitude pair ζ¹ Ant and ζ² Ant. The magnitude 7.0 star HD 84824, which lies 18′ east-southeast helps secure its position.

Through a telescope the galaxy appears as a large soft glow, gently illuminating an area of 5′ × 3′. A much brighter sharp nucleus pinpoints the center of the galaxy, and a 12th-magnitude star lies at its southwestern edge.

The galaxy's gentle glow is nicely described by John Herschel as "an extremely dilute atmosphere," and by Brian Skiff as a "large diaphanous object."

Not all observers agree on the prominence of the galaxy's nucleus, however. Neither William Herschel nor James Dunlop commented on an outstanding central region, while John Herschel was clearly impressed. Contemporary observers express opinions ranging from "a centreless soft glow" (Tom Lorenzin) to "very vaguely quite a large nucleus is discernable" (Victor van Wulfen) to "very suddenly brighter in the middle to an almost stellar nucleus" (Steve Coe).

American astronomer and deep-sky guru Brian Skiff has reported seeing some structure in NGC 2997 using a 6-inch (15 cm) refractor, notably the inter-arm gap visible in the accompanying photograph west of the nucleus. Veteran observer Steve Gottlieb reports observing detail in the inner arm to the north of the galaxy's nucleus with a 24-inch (60 cm) reflector. He noted it was "sharply concentrated with a very bright 40″ core. The spiral structure is unusual with a very long, relatively thick arm that curves from west to east on the north side of the core. This arm then bends south on the west side and contains a very faint 20″ H II knot."

NGC 2997 is a grand-design spiral galaxy with a well-defined symmetrical two-armed pattern. It is inclined about 40° toward us, with the southern part of the galaxy closer to us. Photometric analysis shows the presence of a normal (i.e. non-active) nucleus surrounded by several H II regions known as hotspots.

A recent infrared study identified a series of knots along the southern arm, each about 150 light-years across, strung out along a 13,000 light-year span. These knots, totally embedded in dust lanes and therefore not visible in the optical, are very young stellar clusters, with ages ranging from seven to ten million years, and with masses up to 50,000 solar masses. The youngest knot probably contains about 200 hot O-type stars.

The Antlia Spiral lies some 45 million light-years away and is relatively isolated, with no known companions within 360,000 light-years. It is the largest spiral galaxy in the loose galaxy group LGG 180, also known as the NGC 2997 Group. Other members include NGC 2784, NGC 2763, NGC 2835, and NGC 2848.

N

E

1′

NGC 2997, Bennett 41b

Galaxy in Antlia, 9ʰ 45.7ᵐⁱⁿ, −31° 11′, Size 8.9′ × 6.8′

THE EIGHT-BURST NEBULA

Near the border between Vela and Antlia, on the northward outskirts of the Milky Way, lies NGC 3132, "a very extraordinary object" in John Herschel's words. This planetary nebula is bright enough to be seen in binoculars, which shows it as a star, about 9th magnitude, positioned at the northern tip of a prominent ½° W-shaped asterism. With modest-sized telescopes the clearly elongated disk is apparent; as is the unusually prominent (10.0-mag.) central star, which is offset slightly eastward from the center. With care, the oblong disc is seen to be annular and irregularly bright, with the northwestern portion the least distinct. Its complex structure, apparent on photographs, is tantalizingly revealed in the largest instruments. The pair of 11th-magnitude stars about 2′ southeast is useful as an aid to judging its angular size. Visual estimates of the nebula's color vary substantially. Most observers comment on the lack of color, while others report a light-green or pale-blue tint.

John Herschel discovered it on March 2, 1835, and showed it to Thomas Maclear, Astronomer Royal at the Cape. Because of its brightness, the nebula was included in the *Cape Catalogue of Stars* that Maclear was preparing.

The first observer to compare NGC 3132 to the Ring Nebula in Lyra was William Lassell, observing with his 48-inch (122 cm) reflector from Tigné Point, Valleta, on the Mediterranean island of Malta in 1862. He sketched NGC 3132 and noted: "I think the nebula in Lyra if removed very much further off would present a similar aspect." The good quality of his drawings are remarked on in a 1912 Helwan Observatory Bulletin, which compared the sketches to newly-acquired photographs.

Lassell, who constructed the first large equatorially mounted reflectors, ushered in the modern era of large telescopes erected in remote locations that have good seeing conditions. Like the Herschels he used speculum mirrors, a convention that ended with the introduction of silvered glass primary mirrors by Foucault and others.

In the late 1930s, Harlow Shapley and John Paraskevopoulos photographed NGC 3132 at Boyden Observatory (South Africa) noting: "it could well be named the '8-burst' planetary from the number of distinct arcs on the boundary of the main disc or shell."

The bright star at the approximate center of NGC 3132 is HD 87892. Of spectral type A3, it is not energetic enough to illuminate the nebula. A visual companion was discovered in February 1977 by Lubos Kohoutek and Svend Laustsen using the ESO 3.6 m Telescope at La Silla. The discovery was made soon after the telescope's "first light" (November 7, 1976) and at the time only short exposures could be made. It may well be that this was the first discovery to be made with this instrument. The companion (15.8-mag., separation 1.71″ in PA 47°) was soon identified as a hot white dwarf star with sufficient UV radiation to light up the shell of material ejected from the parent star. The two stars are about one light-week apart.

In the accompanying photograph, pink regions are mainly glowing nitrogen (N II) and blue regions are dominated by glowing oxygen (O III). A thin pink stripe can be seen to the bottom-right of the central star, bisecting the nebula. This bar is the remnant of a ring that formed close to the progenitor star during the early development of the nebula. Its structure is maintained by the magnetic field, and is roughly 240 AU (3.6×10^{10} km / 2.24×6.21^9) thick and one-fifth of a light-year long.

NGC 3132 lies on the outskirts of the Local Arm, some 2,500 light-years away. It is about half a light-year across and is expanding at 21 mi/s (21 km/s), suggesting an age of about 4,000 years.

E
└ N ├───┤ 1′

NGC 3132, PN G272.1+12.3, Bennett 43, Caldwell 74
Planetary nebula in Vela, $10^h 7.0^{min}$, −40° 26′, Size 1.5′

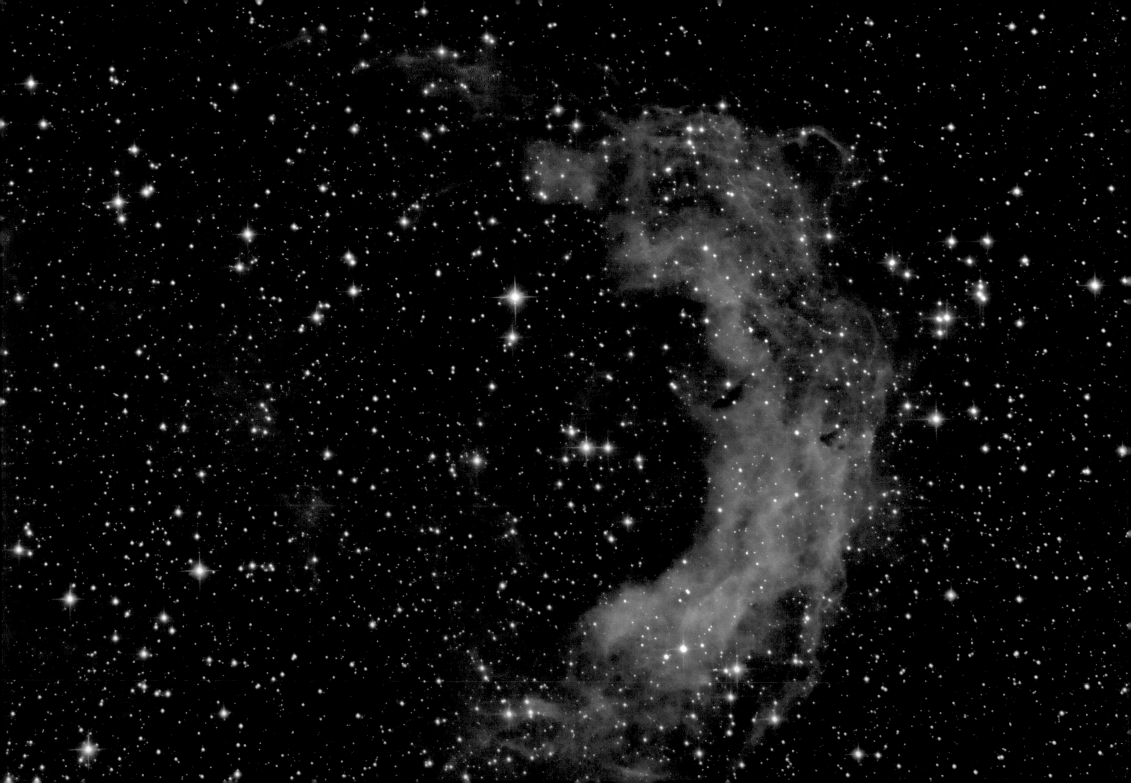

THE CARINA SMILE

Draw a line from ε Car to ι Car (the two southernmost stars of the False Cross) and extend it into the Milky Way for about 8°. You'll arrive at a spot northwest of the stunning Eta Carinae Nebula, where you'll find a delicate crescent of nebulosity.

NGC 3199 lies in a rich star field and can be seen in a small telescope as a sliver of light oriented north-south, with the southern part being brighter. A larger instrument shows it as a relatively bright, incomplete ring of nebulosity about 2.5' thick, tracing out an arc 15' long. It is fittingly described in volume 3 of the *Night Sky Observer's Guide* as being shaped like a smile.

Australian astronomer Glen Cozens has pointed out that credit for the discovery of NGC 3199 goes to James Dunlop, who made a 1° declination error in his catalogue entry for No. 332. John Herschel would later describe it as "semi-lunar" in shape with a forked tail.

NGC 3199 is classified as a Wolf-Rayet ring nebula, a glowing shell of dust and gas surrounding an energetic star. In the accompanying image, the brightest star immediately below the center of the photograph is 10.6-mag. HD 89358. Its spectrum was noted as having peculiar features as far back as 1893, when it was remarked upon by Harvard's Williamina Fleming (whose job title at one stage was "lady computer"). It has since been classified as a Wolf-Rayet (WR) star, the last phase in the evolution of a massive star before it goes supernova.

Any star that is more massive than 25 solar masses goes through this phase, suffering extreme mass loss as a powerful stellar wind up to 1243 mi/s (2,000 km/s), rips material away from it and creates a spherical shell (a WR bubble) around the star, that accumulates over successive ejection episodes. It is estimated that some 25 solar masses of material makes up NGC 3199.

The brighter arc of nebulosity in the northwest of NGC 3199 has been interpreted as a bow shock, formed as the wind from HD 89358 plows into the local interstellar medium. Recent spectroscopic investigations have found a slowly expanding shell around the star—at about 2 mi/s (4 km/s)—while faster moving material is found in the northwestern arc. This faster component is thought to be caused by the fast WR wind punching through a previously formed ejecta shell, thus creating the observed brighter arc.

NGC 3199 lies some 7,000 light-years away toward the Sagittarius arm of the Milky Way.

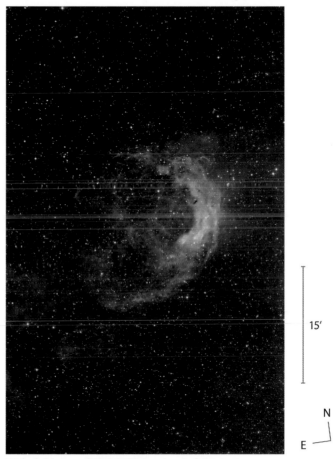

15'

N
E

Wide-field view of NGC 3199 showing its full extent.

THE VELA GLOBULAR

High up in the sails of the ancient Argo Navis, outside of the main stream of the Milky Way, lies the splendid globular cluster NGC 3201. Its general location is easily found by extending the long arm of the False Cross (which measures 9.2°) northwards about one-and-a-half times that distance.

The cluster, lying on a rich background of Milky Way stars, is easy to see with the slightest optical aid. Binoculars show a large but diffuse round glow, about 6′ across, which grows only slightly brighter toward the center, looking rather like a fuzzy coin.

A telescope reveals stars sprinkled across the entire disk, the most obvious of which are the cluster's red giant stars that have magnitudes from 12.0 to about 14.

A small telescope will reveal another interesting feature: unlike many globular clusters, NGC 3201 is not symmetrically round. In May 1826, its discoverer, James Dunlop, wrote: "the figure is rather irregular, and the stars are considerably scattered on the south [western] side," John Herschel would later call it "irregularly round." The eyepiece view gives the impression that the stars are denser and brighter on the eastern side. The southwestern portion of the cluster appears tattered, as if a mist of faint stars has been delicately sprayed out from its center. In contrast, the stars are more clumped together in the northeastern part of the cluster. It is as if someone picked up the central region and deposited it ever-so-slightly eastward. This effect, while obvious at the eyepiece, is not as prominent on photographs; although a thoughtful study of the image opposite may well reveal this offset-nucleus effect.

Larger apertures reveal fainter stars and emphasize how well-resolved NGC 3201 is, offering an almost bewildering array of dark patches and stellar chains.

NGC 3201 is one of the nearest globular clusters to the sun, located about 17,000 light-years away. It lies very close to the galactic plane, so its light is dimmed by interstellar matter. Studies have shown that the effect of this reddening is not constant: different parts of the cluster are relatively more or less obscured. Specifically, the eastern and southeastern parts of the cluster have the greatest extinction of starlight.

The cluster is known for its peculiar kinematic properties. Its radial velocity is some 304 mi/s (490 km/s) headed toward us, the highest of all known globular clusters. Furthermore, its orbit around the Milky Way is retrograde, i.e. opposite to galactic rotation, suggesting that some event in its history modified its motion. It may, for example, have originally belonged to a satellite galaxy that subsequently merged with our Milky Way.

As NGC 3201 (and other globular clusters) move along their orbits, they pass through the disk of the galaxy, the flattened region that is home to the graceful spiral arms. On average, once in a million years a globular cluster will cross the galactic disk. When this happens, the cluster's gravitational influence attracts stars, gas and dust, potentially leading to a local increase in density sufficient to trigger star formation. NGC 3201 appears to have crossed the galactic disk about 5.4 million years ago, at a point some 8,000 light-years from the sun. Investigations have shown that, near this point in galactic space, lie five open clusters (including VDBH 19 and VDBH 20 = Ruprecht 54). It is possible that the formation of one or more of these clusters were triggered by the passage of NGC 3201. Until the ages of these clusters are determined, it is impossible to say for certain if they had a globular cluster as a parent.

E

N 1′

NGC 3201, Dunlop 445, Bennett 44, Caldwell 79
Globular cluster in Vela, $10^h 17.6^{min}$, −46° 25′, Size 20′

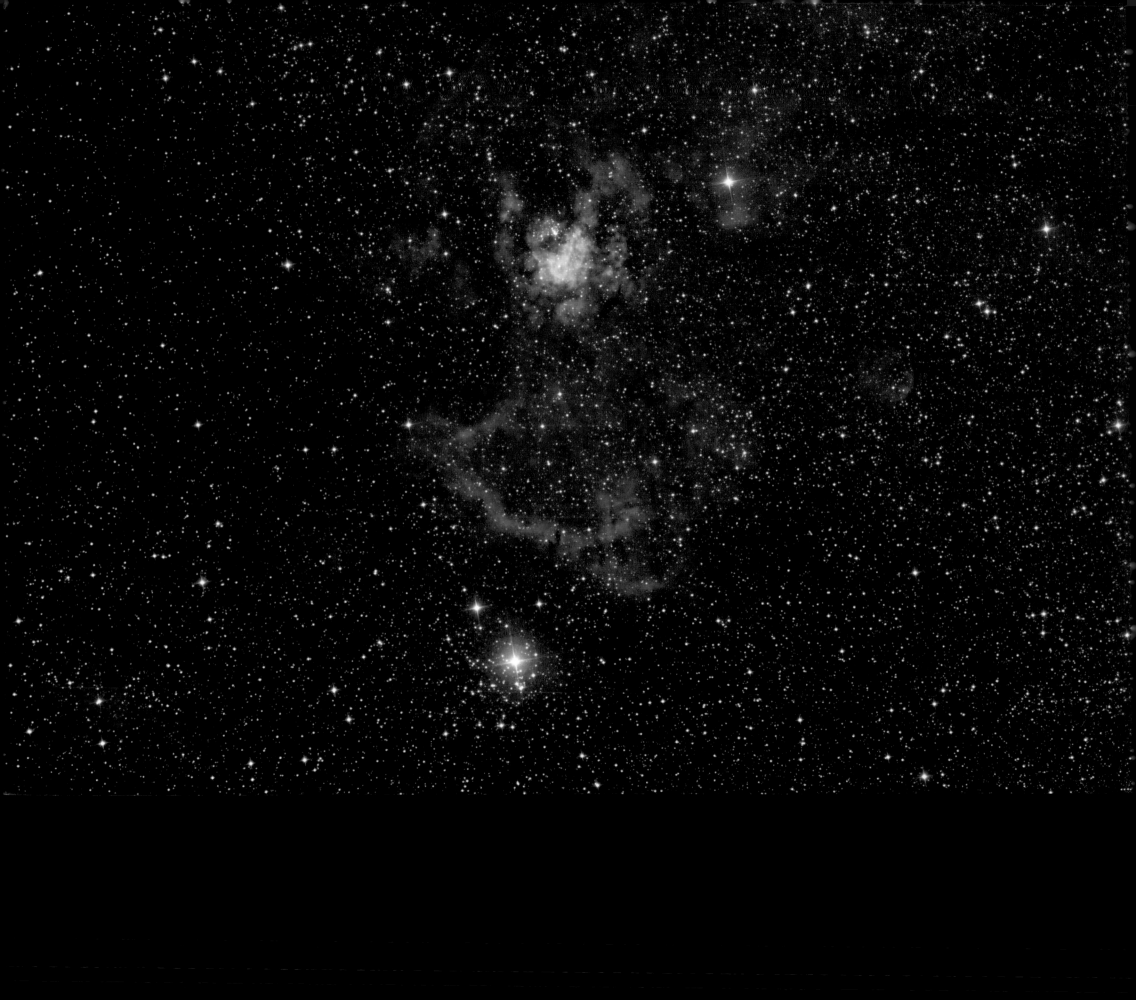

THE WESTERLUND NEBULA

hree degrees northwest of Eta Carinae along the Milky Way lies RCW 49, a large (90′ × 35′) emission nebula discovered during a hydrogen-alpha survey of the southern Milky Way from Mount Stromlo Observatory (Australia). Earlier, a smaller, brighter portion had been noticed by Colin S. Gum, who catalogued it as Gum 29. Gum commented that NGC 3247 may be a part of Gum 29.

NGC 3247 was recorded by John Herschel, who thought it was a curious object, consisting of several stars involved in some sort of nebulosity. Even though he observed it on three occasions, his reported positions were estimates, and his descriptions were rather poor. Consequently there has been some confusion about this object's identity.

In 1959, astronomers studying the Carina region in radio wavelengths found two strong sources, one of which was identified with the Eta Carinae Nebula (NGC 3372). Swedish astronomer Bengt Westerlund showed that the second source coincided with Gum 29. The region of strongest radio emission was photographed with the 74-inch (188 cm) telescope at Mount Stromlo and seen to consist of a compact group of stars, which became known as Westerlund 2. Subsequent in-vestigations have shown that a dozen or more hot massive stars make up the grouping, and it is believed to be the ionizing cluster for the surrounding RCW 49 star formation region.

Brent Archinal and Steven J. Hynes point out in their authoritative *Star Clusters* compendium that the nebulous cluster Westerlund 2 is the same as Herschel's NGC 3247.

In the accompanying image, the brightest part, measuring about 6′ across, is Gum 29. Within it lies the small star cluster Westerlund 2. Together, they make up NGC 3247. The much larger surrounding nebulous region is RCW 49. The elongated nebulous patch in the bottom-left corner is RCW 50. The brightest star in the frame (near the bottom-center) is HD 90772 (4.7-mag.), which marks the position of IC 2581. This sparse cluster was discovered on photographs taken with the 8-inch (20 cm) Draper telescope at Harvard's southern station at Arequipa, Peru. Binoculars show IC 2581 is dominated by orange-hued HD 90772, with a handful of faint stars nearby to the east. A telescope will reveal a 5′ wide grouping of faint stars scattered north and east of the colorful primary.

The wide-field view on the right hints at the complex nature of this Milky Way region.

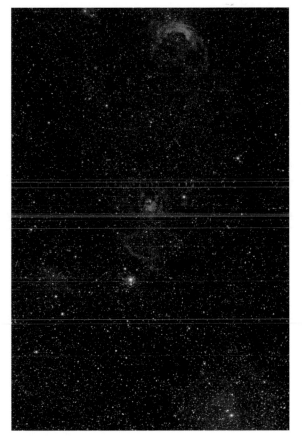

The nebulous field around the Westerlund Nebula (center) showing the Carina Smile (NGC 3199) at the top and part of Gum 30 at bottom-right.

0.5°

NGC 3247, RCW 49, Gum 29, Westerlund 2

Bright nebula in Carina, 10ʰ 24.0ᵐⁱⁿ, −57° 45′, Size 90′ × 35′

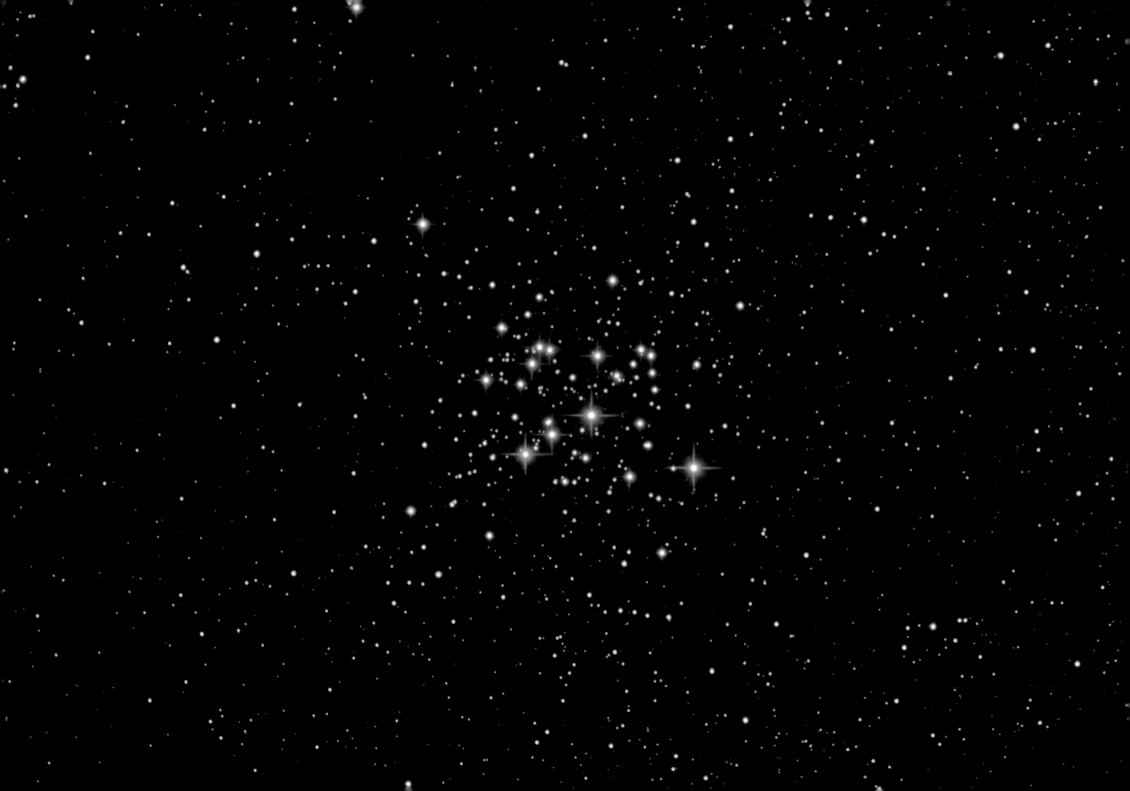

THE GEM CLUSTER

A stone's throw northwest of the fantastic Eta Carinae Nebula lies the brilliant Gem Cluster, NGC 3293. Discovered in 1751 by Lacaille while at the Cape, this beautiful compact cluster lies in the eastern portion of the bright nebula Gum 30.

Binoculars show a rectangular grouping of stars 4′ across, with three prominent stars in a row—of which the southwestern member is a deep orange color. In smaller binoculars or a low-power finder it resembles a globular cluster.

A telescope shows a very compact (5′ diameter) and star-rich grouping of bright blue-white stars, with the outstanding orange-red star (SAO 238228, color index B–V = +2.1) in the southwest. As is the case with the Jewel Box, observers may see different colors in the stars of this cluster.

The surrounding field of view is nebulous, most prominently so to the north of the cluster. Perhaps inspired by this misty background, South African observer Carol Botha traces the outline of a hubbly-bubbly pipe amongst the stars of the cluster.

NGC 3293 was christened the "Gem" by Australian astronomer Henry Chamberlain Russell, who noted in 1879 that "the beauty and symmetry of form in which the brightest stars are arranged—a double curve fairly representing the letter M, with a miniature Southern Cross in the center, and a bright red star at the foot—combine to make this a little 'Gem.'"

Interestingly, NGC 3293 was not thoroughly observed by John Herschel during his stay at the Cape. He only viewed it with his 5-inch (13 cm) refractor, calling it "a fine, bright, rich, not very large, cluster." Russell speculated that Herschel was preoccupied with the nearby Eta Carinae Nebula, and the goes on to say "we have in this cluster a most brilliant object standing as one of the outliers of the richest portion of the heavens; a portion where coloured stars, double stars, clusters, nebulae, and star dust, have been strewn with no sparing hand, a perfect mine of wonders either for the star-gazer or the astronomer."

NGC 3293 lies in the Sagittarius arm of our galaxy, some 9,600 light-years away. It is a young cluster, some 10 million years old, that ionizes the H II region Gum 30. It can be seen in the image to the right. Also visible in the right-hand image is the narrow dark nebula DCld 286.2+00.4 below NGC 3293, and the intricate Gabriela Mistral Nebula (NGC 3324) at bottom-left. Outlying regions of the Eta Carinae Nebula flow in from the right edge.

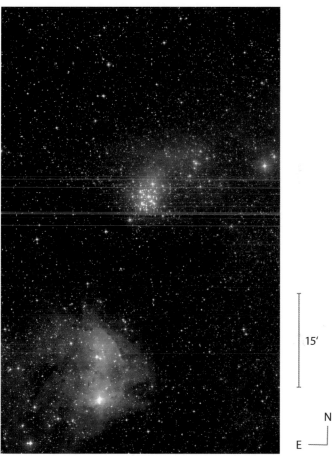

15′

N

E

The magnificent surroundings of NGC 3293, showing Gum 30, NGC 3324 and part of the Eta Carinae Nebula.

E

N

1′

NGC 3293, Lacaille II.8, Mel 100, Cr 224, vdBH 98
Open cluster in Carina, 10h 35.8min, 58° 13′, Size 5′

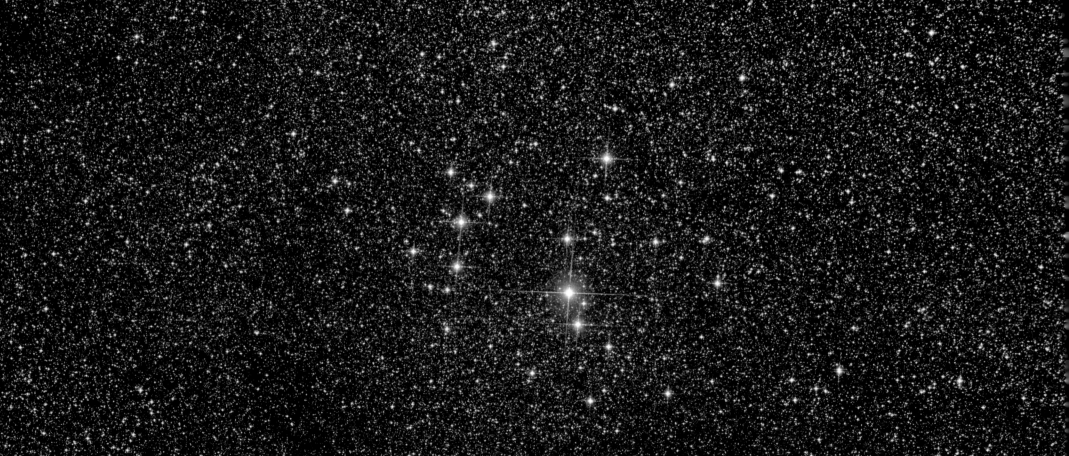

THE SOUTHERN PLEIADES

Two famous crosses pin down the most splendid region of the southern Milky Way: Crux (the Southern Cross) and the False Cross (ε Car, ι Car, δ Vel and κ Vel). Between the two and just outside the main stream of the Milky Way lies a large (10°) obvious stellar parallelogram called the Diamond Cross. Its northernmost star is θ Car (2.8-mag.), the luminary of the beautiful cluster IC 2602.

The cluster is readily visible with the naked eye alone, its brightest stars covering about ½° of sky. θ Car is by far the most prominent member, being almost seven times brighter than the next brightest star, which is 4.8-mag. As such, IC 2602 is an excellent naked-eye demonstration of averted vision. When looking directly at the cluster, most people only see θ Car itself, but when they are shown how to use averted vision, the cluster of fainter stars suddenly (and delightfully) pops into view.

IC 2602 is a delight in binoculars, with a dozen or so scattered bright stars set against a rich background. Besides the dazzling θ Car, the most striking feature of the cluster is the distinctive bowtie or W-shaped grouping of bright white suns on the eastern edge of the cluster. The de-

lightful moniker "Five of Diamonds" describes this little gathering well.

A good visual twin for IC 2602, at least in binoculars, is Messier 7 in Scorpius, rather than the Pleiades. The Pleiades is richer in naked-eye stars than IC 2602, allowing veteran observer Brian Skiff to rightfully gloat: "The North wins for once!"

In a small telescope, IC 2602 appears to consist of two distinct parts—the Five of Diamonds in the east and θ Car with a few companions in the west, separated by a 15' almost-starless space. In a 1° field of view there are about 60 stars brighter than 11th magnitude.

The first Western astronomer to document the Theta Carinae cluster was Lacaille, during his stay in Cape Town. His comment "like the Pleiades," is the origin of its popular name, the "Southern Pleiades."

Presumably because of IC 2602's large angular size, John Herschel did not catalogue this grouping. Since it is an obvious naked-eye object it is ironic that it was taken up in the Index Catalogue only after being "discovered" photographically. The credit goes to Harvard astronomer Solon I. Bailey, who created the first all-sky catalogue of deep-sky objects based on the examination of

photographs, taken with a 1-inch (3 cm) (f/13) Cooke lens. IC 2602 is the brightest object in the Index Catalogue.

It is a young cluster, only about 40 million years old; and at a distance of around 500 light-years, it is also one of the nearest open clusters.

IC 2602 shares another connection with the Pleiades other than its nickname: both are members of the Local Association, also called the Pleiades moving group. It has been suggested that the Pleiades, IC 2602, NGC 2516, Messier 34, the δ Lyrae cluster (Stephenson 1) and the α Persei group (Melotte 20) make up a reasonably coherent kinematic stream of young stars that could share a common origin.

Less than a degree due south of θ Car lies the gentle open cluster Melotte 101, visible at the bottom of the accompanying photograph. Binoculars show its ghostly presence as a delicate 15' glow, standing in stark contrast to IC 2602 and, calling to mind a comparison to Messier 46 and Messier 47. Melotte 101 consists mainly of 11th-magnitude and fainter stars. Curiously, John Herschel never recorded this cluster, even though it had been observed (and thus discovered) by James Dunlop.

IC 2602, Lacaille II.9, Caldwell 102

Open cluster in Carina, $10^h 43.2^{min}$, $-64° 24'$, Size 100'

E N 10'

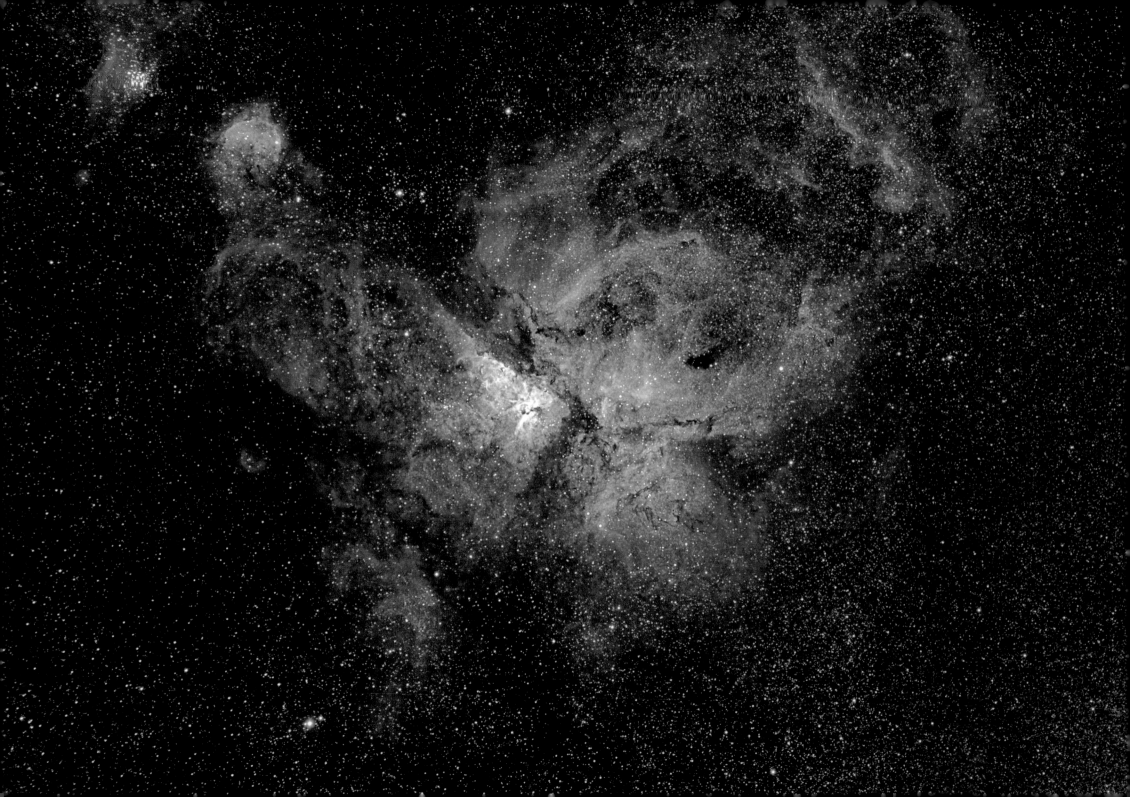

THE ETA CARINAE NEBULA

The brightest patch along the southern Milky Way, more or less midway between the Southern Cross and the False Cross, is the stunning Eta Carinae Nebula, a splendid region of both recent star formation and imminent stellar death.

The wide-field view on the facing page, spanning 4° × 2.8°, beautifully captures the most prominent visual impression: that of two large fans of nebulosity separated by a dark rift. Messier 42 fits comfortably within the southernmost fan.

The nebula contains more than 60 O stars, three Wolf-Rayet stars and several supergiants, giving us a snapshot of the formation of an OB association.

Within the nebulous folds of the northern fan lies the most luminous, and one of the most massive stars, in our galaxy: the mysterious η Car. This unstable star, on the brink of death, is thought to be a binary system composed of a luminous blue variable and a Wolf-Rayet star.

It is currently about 5th magnitude; when Lacaille observed and catalogued it in 1752, it was magnitude 2.3. The star underwent an eruption in 1837 that lasted for more than 20 years, and was briefly the second brightest star in the night sky, brightening to magnitude –1.

In the aftermath a beautiful bipolar nebula had formed around the star. Named the Homunculus by Enrique Gaviola, fifth director of the Cordoba Observatory in Argentina, it is the brightest visual nebula with a distinct color in the sky. Careful study of the expansion of the Homunculus has provided an accurate distance of 7,500 light-years.

The image to the right shows Eta Carinae, the bright orange-colored star, with the intricately shaped Keyhole Nebula (or the "Lemniscate," to use John Herschel's term) to its west. The scattering of fainter stars to the southeast is Trumpler 16. The Keyhole is the shredded remnants of the giant molecular cloud out of which Trumpler 16 was born some 3 million years ago.

Near the top-right of the image lies Trumpler 14, a slightly younger cluster that is radiating the dark molecular cloud in the lower part of the image. This relatively pristine cloud is not yet an active star-forming region, but it is only a matter of time before the ultraviolet radiation and stellar winds from the nearby massive stars trigger the process of star birth within it.

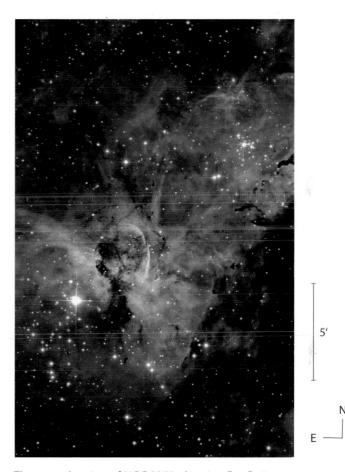

5'

N

E

The central region of NGC 3372, showing Eta Carinae (bright-orange star) with the Keyhole Nebula to its immediate right.

N

E

10'

NGC 3372, Lacaille III.5 & 6, Dunlop 309, Caldwell 92

Bright nebula in Carina, 10h 44.3min, –59° 53', Size 120'

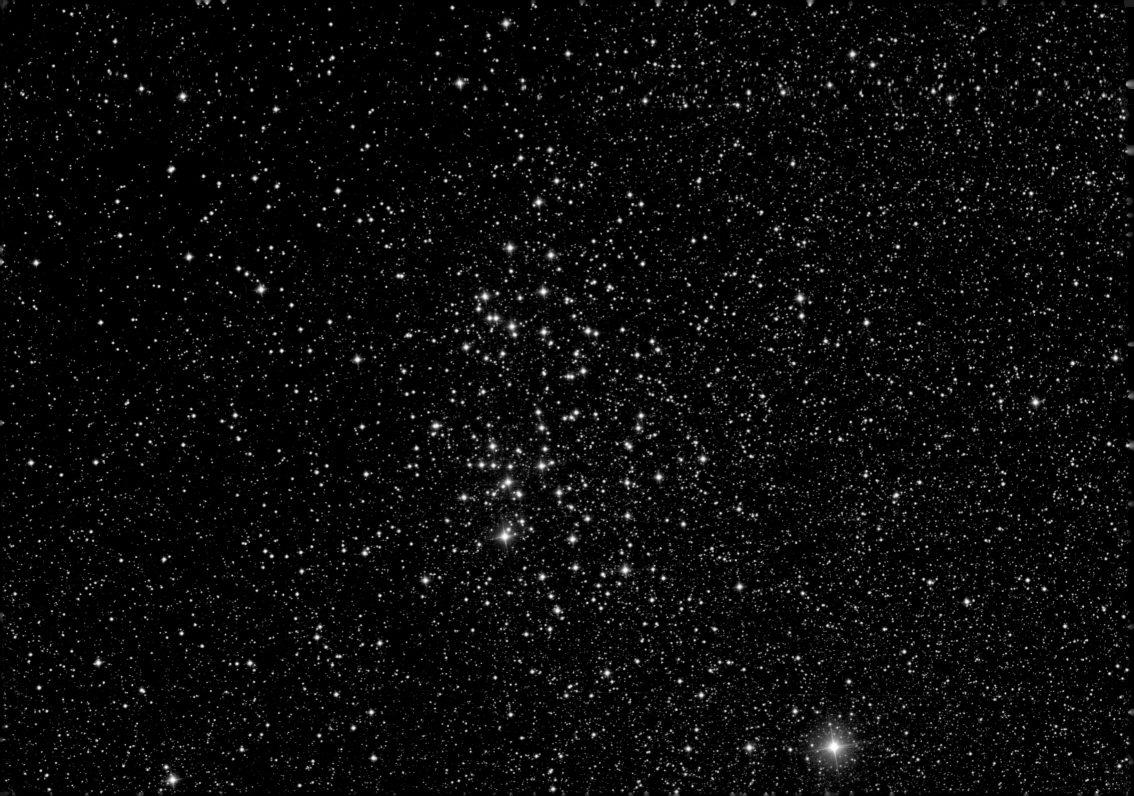

THE PINCUSHION CLUSTER

If the Milky Way's narrow glowing band that circles around our night sky is likened to a crown, then the crown jewels will be found in the short span from the Southern Cross to the False Cross. There the naked eye alone reveals prime examples of a bright nebula, a dark nebula, and several open clusters.

NGC 3532 is a stunning specimen of the latter. Looking westward from Crux, a bright knot in the Milky Way is seen. As a guide, the easternmost stars of the Diamond Cross, ω Car and θ Car, point toward it. Careful attention shows the knot to be a bright star with an elongated patch close by.

Even the slightest optical aid reveals the elongated patch as a brilliant star cluster bursting with starry gems and accompanied by the bright (3.9-mag.) yellow X Carinae. Overall, the cluster is diamond shaped, measuring 30' × 20' (oriented east-west), with its brightest stars of 8th magnitude. In binoculars the stars all appear white except for a 6th-magnitude yellow luminary on the northeastern edge of the grouping. Binoculars also reveal a striking black lane, running east-west, cutting through the center of the cluster. The surrounding star field is a visual feast, laced with streamers of dark nebulosity.

Through a telescope, the cluster appears almost three times larger as fainter stars are brought into view. It spans some 60' × 30', with many short star chains and pairings of stars scattered about. The dark lane through the center is lined with stars and takes on the appearance of a black arrow pointing eastward. A telescope also intensifies the star colors, adding a dozen or so pale-yellow or orange stars to this charming collection.

Lacaille was the first person to observe NGC 3532 with a telescope, his ½ inch (1 cm) aperture instrument showing it as about 25' in diameter. John Herschel's larger telescope presented an impressive view: "A glorious cluster of immense magnitude... the most brilliant object of the kind I have ever seen."

NGC 3532 has understandably garnered a host of nicknames. Ian Cooper of New Zealand refers to it as "The Pincushion," Paulo Oshikawa of Brazil calls it the "Firefly Party Cluster," while Alan Dyer notes that "Football Cluster" is widely used in Australia.

NGC 3532 is a comparatively rich cluster that contains a dozen red giant stars brighter than 8th magnitude. It lies some 1,600 light-years from Earth and is approximately 300 million years old.

1°

N

E

NGC 3532 set against a rich Milky Way star field laced with bright and dark nebulosity. The nebulous area at the bottom is part of the RCW 57 complex.

N

E

4'

NGC 3532, Lacaille II.10, Dunlop 323, Caldwell 91

Open cluster in Carina, 11h 5.5min, −58° 44', Size 50'

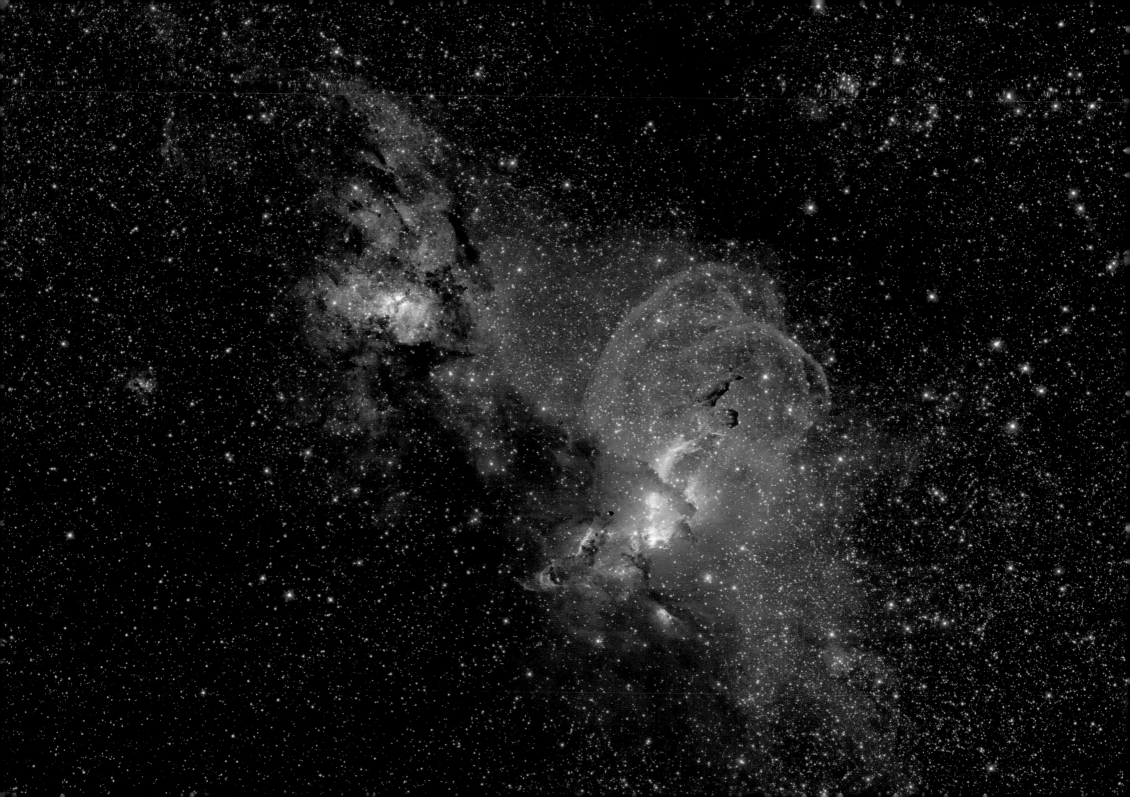

THE LITTLE TARANTULA NEBULA

Roughly midway between Alpha Crucis, the beautiful triple star at the foot of the Southern Cross, and the bright extended patch that is the Eta Carinae Nebula (NGC 3372), lies the prominent blue-white star λ Cen. And roughly midway between λ Cen and η Car lies the soft orange z Car, more prominent than its 4.6-magnitude suggests as the star field immediately around it is sparse. Through binoculars, the star's color is even more apparent. Half a degree north-northeast lies HD 96919 (5.1-mag.). These two stars point the way to RCW 57, two distinct regions of star formation.

The general area was first explored by John Herschel, who noted NGC 3603 (the more obscured area of bright and dark nebulosity to the top-left of the center of the accompanying image) and the brighter, complex, area bottom-right of center, a nebulous field consisting of NGC 3576, NGC 3579, NGC 3581, NGC 3582, NGC 3584, and NGC 3586.

Herschel noted that NGC 3603 was a very remarkable object, containing a bright red star at the center of a highly condensed nebulous cluster—a globular cluster with an intense nucleus. Herschel, as well as several observers with the Great Melbourne Telescope, sketched the complex nebulous field to the west, showing NGC 3576 and NGC 3586 as streaks of nebulosity, NGC 3584 as an elongated teardrop, NGC 3579 as a diffuse object, and NGC 3582 and NGC 3581 joined but with a narrow waist.

Colin S. Gum, in his 1955 survey of H II regions, assigned No. 38 to this area, which he described as two objects, each of complex structure, linked together with nebulosity, spanning 45' × 15'. Gum 38a is Herschel's nebulous field, and Gum 38b is NGC 3603. The later H II survey by Rodgers, Campbell and Whiteoak listed the area as RCW 57, noting it contained a bright crescent-shaped region 50' × 20'.

Both Gum objects have since been shown to be giant star-forming regions. Gum 38b is about 23,000 light-years away, while Gum 38a is three times closer, at about 7,800 light-years.

Gum 38b contains a young, bright and compact stellar cluster (seen as the 10.0-mag. double star HD 97950) at its core. Its massive stars together are 100 times more luminous than the Orion Nebula's cluster and one-tenth as energetic as the Tarantula Nebula region (NGC 2070). It is classified as a super star cluster, similar to those found in starburst regions of young galaxies.

The complex region Gum 38a consists of a giant H II region embedded in the center of an extended molecular cloud, most noticeable where it appears to separate NGC 3584 from NGC 3581-2. As the ionized gas of the H II region expanded, it swept up clumps of gas-forming dense cores, all along the length of the dark cloud. The cores are active star-birth sites, where very young, massive, protostellar objects are forming. Powerful stellar winds from the energetic young stars in the cluster at the center of the H II region have sculpted the surrounding molecular gas and diffuse interstellar medium into loops of glowing gas, extending to the north and beautifully shown on the photograph. These windswept glowing arcs were the inspiration for this star-forming region's nickname—the Little Tarantula.

Visible at the top-right in the image is a winding dark nebula, Sandqvist 127. To its right lies the open cluster NGC 3590. The curious small red S-shaped nebula far-left of the center in the image is known as Bran 351, catalogued in the 1980s by Jan Brand, Leo Blitz and Jan Wouterloot as part of their survey of southern H II regions and reflection nebulae.

E N 3'

NGC 3576–9 and NGC 3581-2/4/6, Gum 38a, RCW 57a

Bright nebulae in Carina, 11h 11.8min, −61° 19', Size 3' × 3' (NGC 3576)

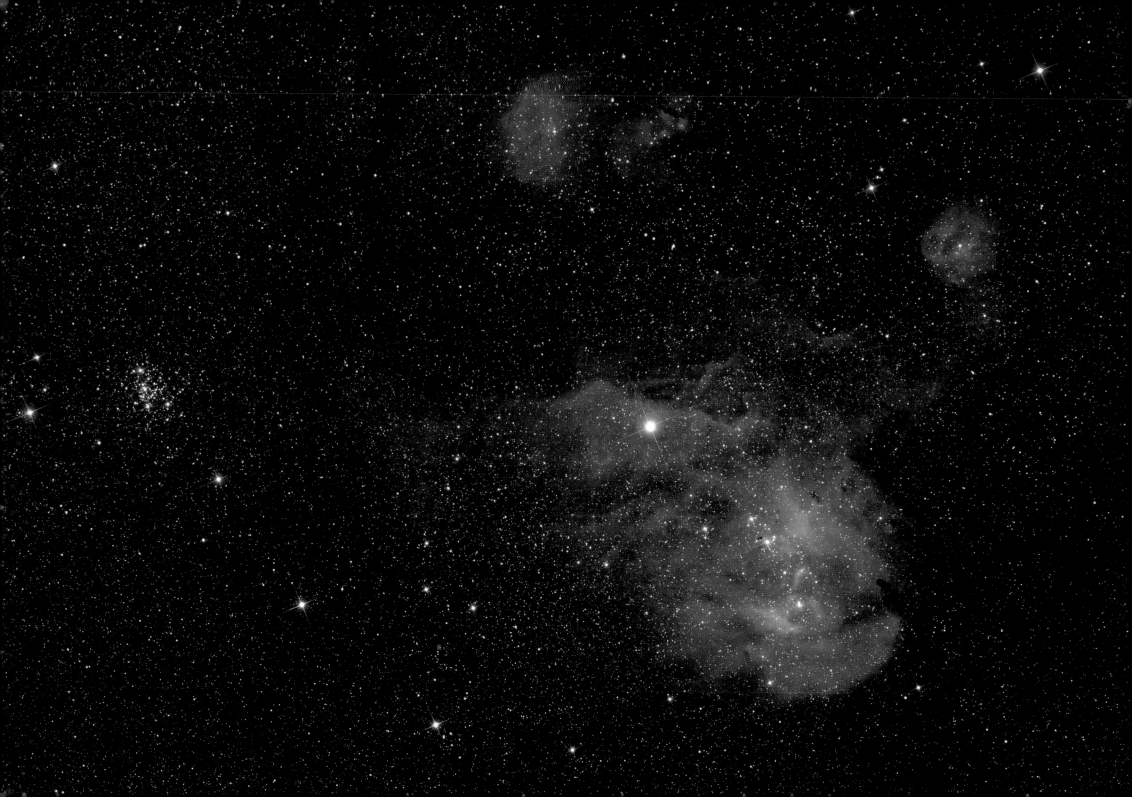

THE RUNNING CHICKEN NEBULA

Along the Milky Way, roughly between the tip of the Southern Cross and the incredible Eta Carinae Nebula, lies the prominent 3rd-magnitude star λ Cen. More or less centered on this blue-white beacon is the Lambda Centauri Nebula.

A modest-sized telescope with a wide field of view shows an elongated scattered stellar grouping about ½° to the southeast of λ Cen. The cluster was catalogued as Collinder 249, and its brightest member is HD 101205 (6.5-mag.). The surrounding nebulous field is extensive and is most obvious toward the southeast of the cluster.

IC 2944 is the northwest-oriented bright rim immediately west of λ Cen. IC 2948 is the bright region to the southeast, in the center of which lies Cr 249. The bright crescent section in the south has a noticeable "elephant trunk" dark cloud on its rim. IC 2944 and IC 2948 together are catalogued as RCW 62. The bright round cloud at top-center in the accompanying photograph is IC 2872 (Gum 39) and the fragment closeby to the south is Gum 40. The round cloud at top-right is RCW 61 (Gum 41).

Taken together, this nebulous complex is popularly known as the Running Chicken. It is a bright and extensive H II region, some 6,500 light-years away, that is energized in part by the blue giant star HD 101205, the brightest and most massive star in the region. The Running Chicken and its cluster of young OB stars is also known as the Centaurus OB2 association.

Within the Running Chicken, about ½° southeast of λ Cen, is a collection of stillborn stars, the Thackeray Globules (see overleaf).

The IC objects in this region were first noted by Royal Harwood Frost on photographs taken with the 24-inch (60 cm) Bruce refractor at Arequipa, Peru. He was an astronomical assistant at Harvard College Observatory and worked in Peru from 1902 to 1905.

The surroundings of the Running Chicken contain some truly delightful objects. The Rich Man's Jewel Box (NGC 3766) is the bright cluster to the left (north) of the Running Chicken in the photograph opposite. The wide-field view to the right shows the proximity of the Running Chicken to NGC 3603 and the Little Tarantula Nebula (Gum 38a).

Lambda Centauri, which lies about 420 light-years away, is in a chance alignment with the Running Chicken as seen from our vantage point.

1°

N

E

The Running Chicken (below), the Rich Man's Jewel Box to its upper-left, and the Little Tarantula with NGC 3603 at top-right.

N

E

10'

IC 2944, IC 2948, Ced 118, Caldwell 100
Bright nebula in Centaurus, 11h 35.8min, −63° 1', Size 40' × 20'

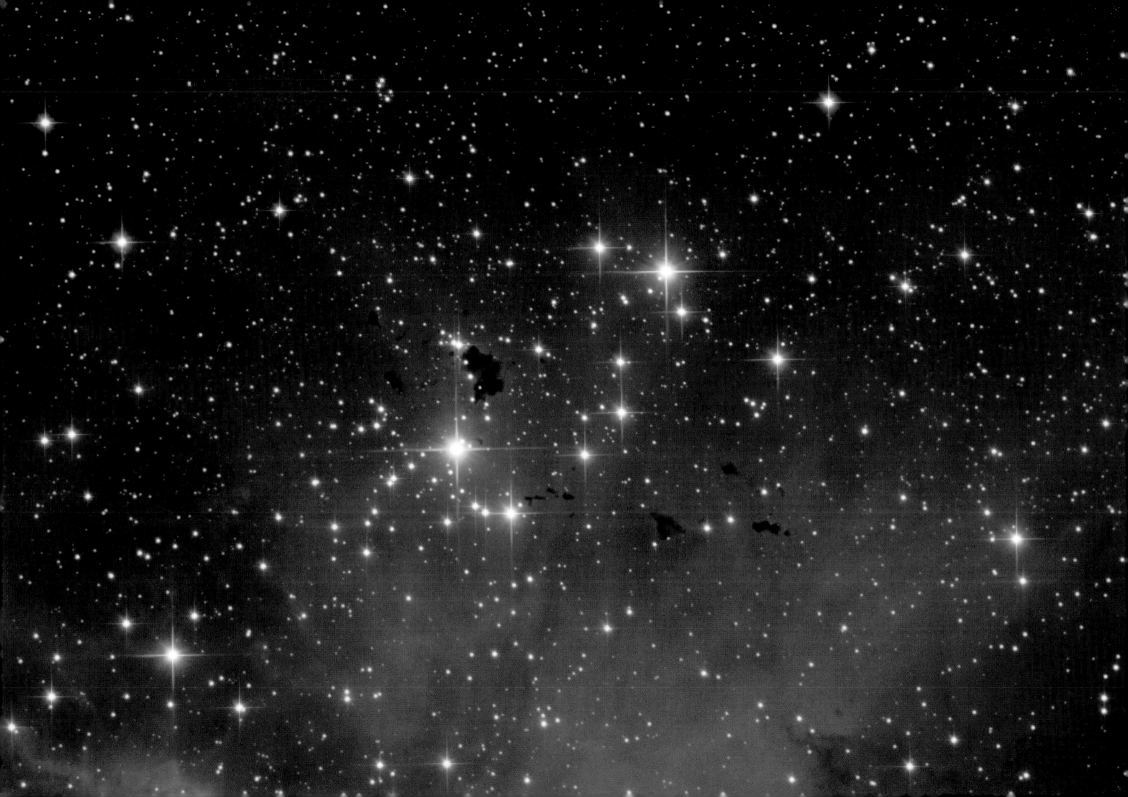

THACKERAY'S GLOBULES

Hanging like droplets of oil in a starry sky, Thackeray's Globules are a beautiful collection of stillborn stars in the Running Chicken Nebula (see previous chapter). This complex of dark globules, starkly revealed upon a bright H II background, was discovered in 1950 by British-South African stellar astronomer Andrew David Thackeray with the 74-inch (188 cm) Radcliffe telescope in Pretoria. Thackeray described them as "highly irregular dark nebulae sharply silhouetted against the general background of nebulosity."

The largest globule, Thackeray 1, lies 26′ southeast of λ Cen. It has an angular size of 30″ × 60″ and can be seen in the photograph opposite, 1.3′ north-northeast of 6.5-mag. HD 101205—the brightest star in the image.

Thackeray noted that Thackeray 1 had a bright lane crossing the dark area, concluding correctly that the globule was enmeshed in the H II region, rather than merely being projected in front of it.

Observations four decades later showed that Thackeray 1 consists of two separate globules that are superposed, with a combined mass of 15 solar masses, measuring 1 × 1.5 light-years across.

More recently, a large complex of globule fragments have been discovered surrounding Thackeray 1. These tiny globules must have a very short lifetime and are probably continuously formed and destroyed.

Thackeray's Globules are located physically within the Running Chicken nebula, but they are far from the intense radiation that ionizes the nebula and that could destroy them rapidly. Once a globule has been exposed from a previously existing molecular cloud by the strong UV radiation, it is shaped by violent and highly dynamic processes that are as yet not understood.

Globules that do lie near the energetic edge of an H II region are generally comet-shaped with a tail streaming away from the ionizing source.

Over 50 globules have been discovered in the vicinity, distributed within a 13 light-year-wide volume of space. They are short-lived phenomena, thought to be the remnants of a disintegrated "elephant trunk" cloud similar to the famous "Pillars of Creation" in the Eagle Nebula (see p. 139).

These ethereal globules are a fitting memorial to David Thackeray, who died in Sutherland (the remote observing site of the South African Astronomical Observatory) in 1978 in a freak road accident after an observing run on the 74-inch (188 cm) telescope.

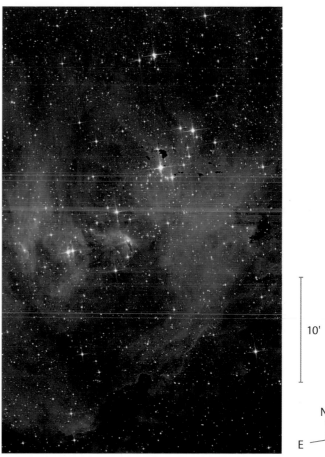

10′

N

E

An "elephant trunk" on the southeastern edge of the Running Chicken points the way to Thackeray's Globules.

N

E

1′

Thackeray 1
Dark nebula in Centaurus, 11ʰ 38ᵐⁱⁿ 16.3ˢ, 63° 21′ 1″, Size 1′

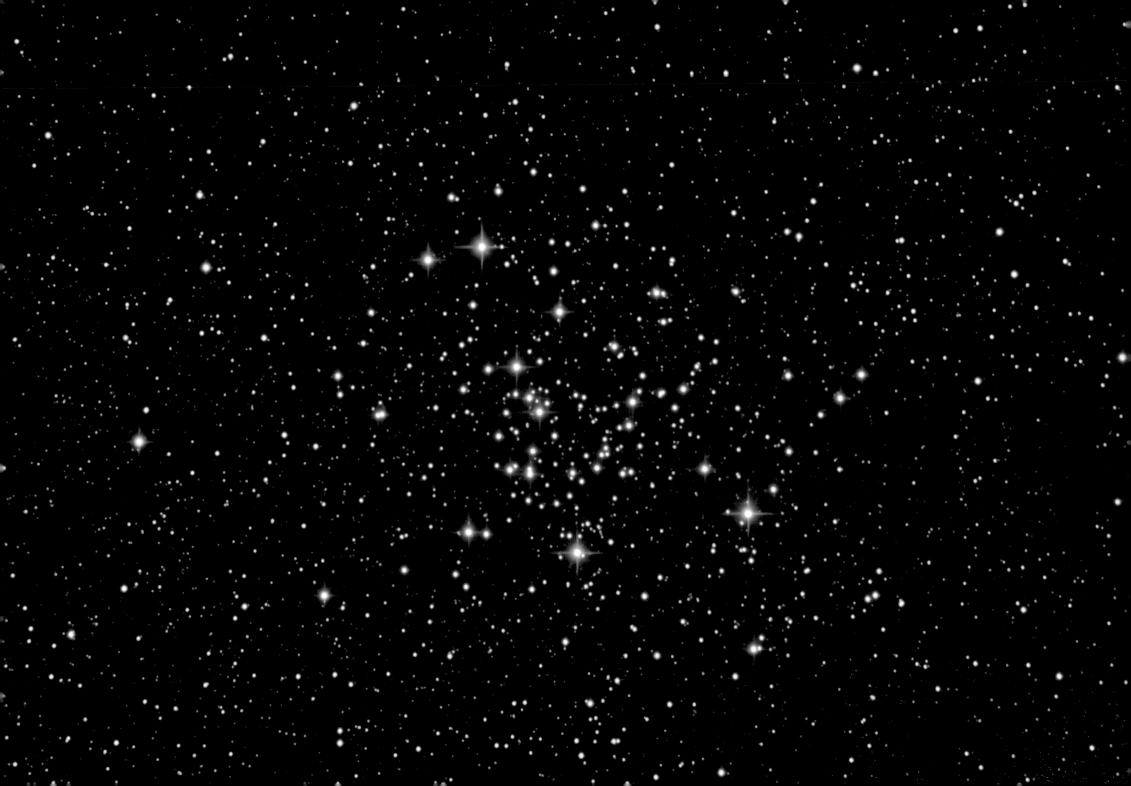

THE RICH MAN'S JEWEL BOX

A long the spine of the Milky Way, midway between the Southern Cross and the Diamond Cross, lies the gorgeous open cluster NGC 3766. Located on the back leg of the Centaur, a sharp-eyed and careful observer will be able to spot this cluster with the naked eye.

In binoculars this region explodes into a myriad bright stars, some arranged in graceful stellar chains. Nevertheless, NGC 3766 stands out distinctly against this rich background because of its bright, compact triangular shape, spanning some 10′ of sky. The three luminaries, which visually anchor the grouping, form a narrow triangle pointing northwest, and two of them shine as bright, orange-red beacons.

Through a telescope the cluster's triangular shape, colorful stars and richness invite a comparison to the more famous Jewel Box (NGC 4755). A modest-sized instrument shows some 30 brighter stars, with many fainter ones liberally sprinkled in between. The cluster stars (and those in the immediate vicinity) invite the eye to trace out stellar loops, creating fanciful shapes that are perhaps best appreciated with an eyepiece giving a ¼° field of view or so.

The cluster was discovered by Lacaille in the 1750s from Cape Town, South Africa, and in his ½-inch (1 cm) aperture telescope he saw it as "three faint stars in nebulosity." Lacaille was observing from a boarding house in Strand Street in what was then already the central business district of a growing Cape Town. Today, the ever-increasing light pollution would give a similar view in a larger instrument.

The Scottish astronomer James Dunlop, working from Paramatta, Australia, noted this cluster during his very first evening of observing on April 27, 1826. He remarked on its colorful nature, seeing red stars near the western and eastern sides, a fainter red star near the center, and a yellow star near the southeastern border.

Australian observer E. J. Hartung noted "a pattern of star loops giving a lobed appearance and containing orange, yellow, white and bluish stars."

The two prominent orange-red stars at opposite ends of the cluster are both red supergiants. The westernmost one is an irregular pulsating variable star known as V910 Cen. The Algol-type variable BF Cen is also a member of NGC 3766.

The charming double star B 798 (magnitudes 9.1 and 9.4, separation 4.9″) lies north of the cluster's center. It was first measured by the Dutch astronomer Willem van den Bos in 1925, using the 26.5-inch (67 cm) refractor at the Union Observatory in Johannesburg, South Africa. The same telescope was used by R. T. A. Innes in 1910 to discover I 887 (components both 9.1-mag., separation 0.6″), a close double in the heart of this stellar family.

For a brief time, NGC 3766 was referred to as the "Pearl Cluster" on the Internet. Thanks to detective work by Australian astronomy historian Andrew James, it is now known that the name was invented to promote the on-line sale of jewelry products!

NGC 3766 is located in the Carina arm of our galaxy and is a young cluster, having formed some 22 million years ago in a nebula now long-dispersed.

It contains a large proportion of so-called Be stars, which are rapidly rotating stars surrounded by flattened gas shells. The average equatorial velocity of these stars is 165 mi/s (265 km/s), which is about twice the rate of normal B-type stars. The circumstellar disks are formed by centrifugal ejection of matter. However, the behavior of these stars is still poorly understood, and they continue to stimulate research and debate, making NGC 3766 an excellent subject in which to study the formation mechanism of Be star disks.

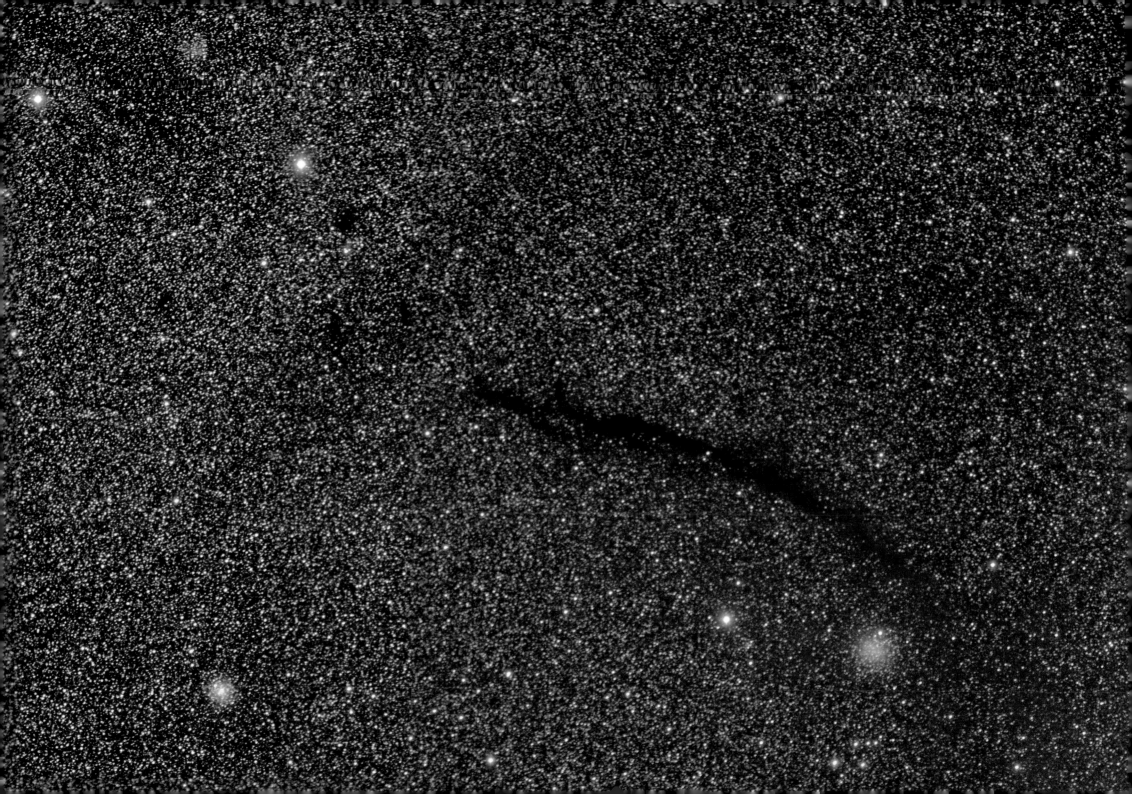

THE BLACK PYTHON

The striking little constellation of Musca the Fly, embedded in the Milky Way due south of Crux, is home to a delightful serpentine dark nebula that is a wonderful sight in binoculars. Unlike E. E. Barnard's curved "Snake Nebula" (see p. 119) in Ophiuchus—which is about 1° long—the Black Python is 2.5° in length and lies fully stretched out, as if sunbathing on the shores of the Milky Way.

The brightest stars of Musca form a squashed rectangle, with Alpha and Gamma Muscae making up the westernmost side. The Python bisects this side, perhaps biting off more than it can swallow!

Poor sky conditions that result in low-contrast views (such as during bright moonlight) hide the Python, but under good skies it is easily seen in binoculars. It varies in width from 1.5' to 4' and is more prominent in the northeast. Near the middle of the Python's body is a lone 9.4-mag. star. This portion of the Milky Way is rich in smaller dark regions, and an irregular less-distinct stream seems to connect the Python to the impressive Coal Sack some 7° to the north.

Through a large telescope the Python shows a hint of faint haze, but remains essentially starless; the 9.4-mag. star near the center acquires a companion to the east, two magnitudes fainter.

One of the earliest photographs clearly showing the Python was taken in 1909 by Harvard astronomer Solon I. Bailey. Bailey traveled to South Africa to search for a possible new site for Harvard's southern observatory, which was then in Arequipa, Peru. Near the village of Hanover, in the Great Karoo, Bailey set up a temporary observatory and carried out meteorological observations assisted by a local, Mr L. S. Shultz. In addition, Bailey used a ½-inch Cooke lens to produce nine wide-field (30° × 40°) images of the southern Milky Way. One of the images, centered on the Coal Sack, clearly shows the Black Python, although Bailey does not draw attention to it in the accompanying descriptive comments. Together with images taken at Mandeville in Jamaica, and Norwell, Massachusetts in the USA, this work constituted the first systematic photographic representation of the entire Milky Way.

The Swedish astronomer Aage Sandqvist catalogued the southeastern portions of the Python as Nos. 141, 143 and 145 in his 1977 survey of the ESO(B) Atlas.

Sharing the binocular field with the Black Python are two lovely, contrasting globular clusters, NGC 4833 and NGC 4372. NGC 4833 (at bottom left on the accompanying photograph) lies less than 1° north of δ Mus on the eastern side of Musca, while NGC 4372 flanks γ Mus on the western side. The pair present an interesting study in contrasts. While both globulars have a single bright star very near them, NGC 4833 is large and bright (it was discovered by Lacaille) and NGC 4372 is large and faint (James Dunlop was the first to record it). Both objects are included in the Bennett and Caldwell catalogues.

Also visible on the accompanying photograph, at top-left, is the open cluster Collinder 261, a beautiful rich grouping of faint stars that is often overlooked.

N

E

15'

Sandqvist 141/143/145, DCld 301.0-08.6
Dark nebula in Musca, 12h 27.5min, −71° 25', Size 150' × 12'

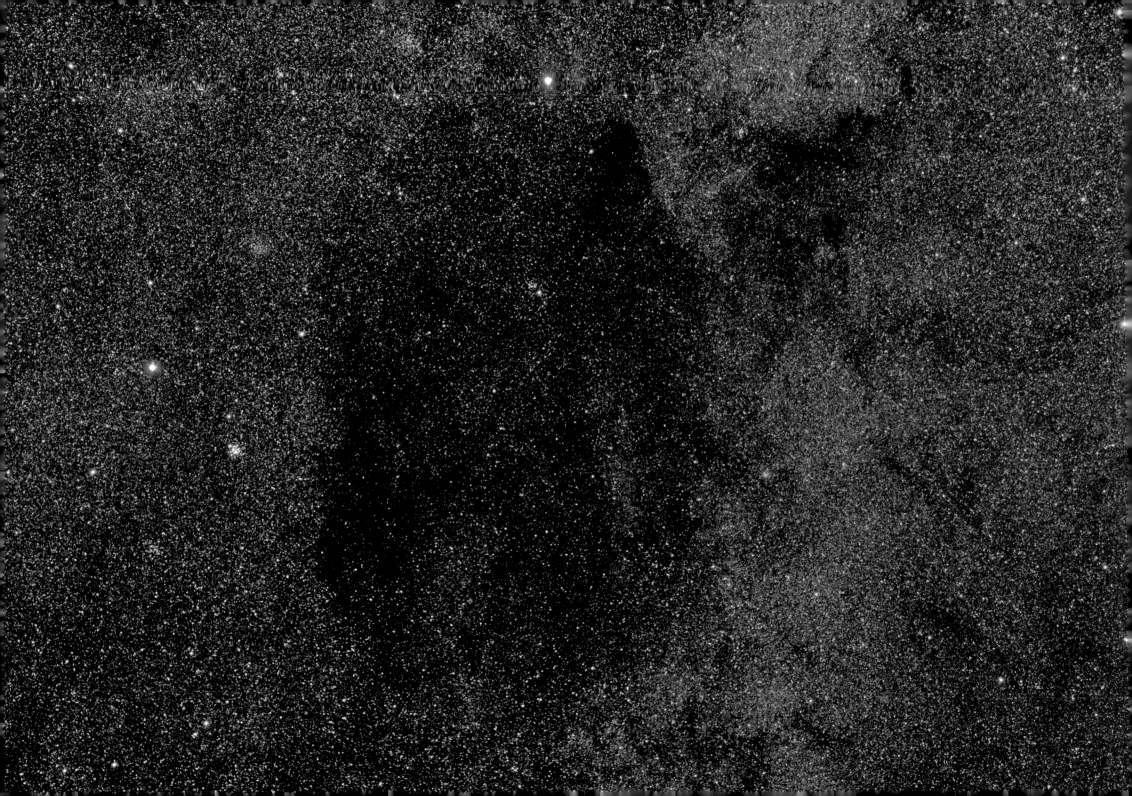

THE COAL SACK

Along the road of the Milky Way, like a dark puddle, lies the famous Coal Sack. Also known as Magellan's Spot and the Black Magellanic, the Coal Sack has a teardrop shape, spreading out over 7° × 5°. Tendrils of darkness extend away from its southern tip into the Milky Way. Under very good skies, the Coal Sack itself reveals filamentary structure, visible in large binoculars or a rich-field telescope.

As the accompanying photographs show, it is richly peppered with faint stars. Harvard astronomer Solon I. Bailey, commenting on one of the earliest images of the Coal Sack, noted that it only appeared dark because of the surrounding bright Milky Way.

To the Inca of South America, who had a unique and extensive system of "dark constellations" created from dark nebulae along the Milky Way, the Coal Sack was known as "Yutu," an indigenous Andean ground-dwelling bird of very ancient lineage. Amongst some Bushmen groups of southern Africa, the Coal Sack was known as the "Old Bag of the Night."

Between the tip of the Diamond Cross (marked by θ Car) and the Southern Cross lies another dark gap in the Milky Way. On a dark night, it appears as if the Large Magellanic Cloud has been torn out of this section of the Milky Way and cast aside, while the Small Magellanic Cloud could have occupied the vacancy that is the Coal Sack.

The eccentric Ukranian-born Harvard astronomer Sergei Gaposchkin created a detailed visual rendering of the Milky Way in 1957, referring to the larger gap as the "Coal Scuttle." Gaposchkin's creativity clearly also extended to his writing: his last published article was called "The 22d Most Remarkable Star RY Scuti." He also called RY Scuti the "most secret Super-Star." His article also referenced a Frank Sinatra song!

The two bright stars in the accompanying image are Acrux (α Cru) at the top, and Mimosa (β Cru) at the left. Several open clusters can also be found, including the Jewel Box (to the bottom-right of β Cru), NGC 4852 (below β Cru), Trumpler 20 (between α and β Cru), NGC 4349 (left of α Cru) and the Coal Sack Cluster, NGC 4609 (below α Cru).

The wide-field view to the right shows the location of the Coal Sack at the "foot" of the Southern Cross. The panoramic view of the Milky Way on page 11 shows some of the dark tendrils oozing out of the Coal Sack in the direction of the Diamond Cross, passing between the Running Chicken and Musca.

2°

N

E

The Coal Sack, appearing like a shadow cast by the Southern Cross.

N

E

30'

Caldwell 99

Dark nebula in Crux, 12h 50min, −62° 30', Size 7° × 5°

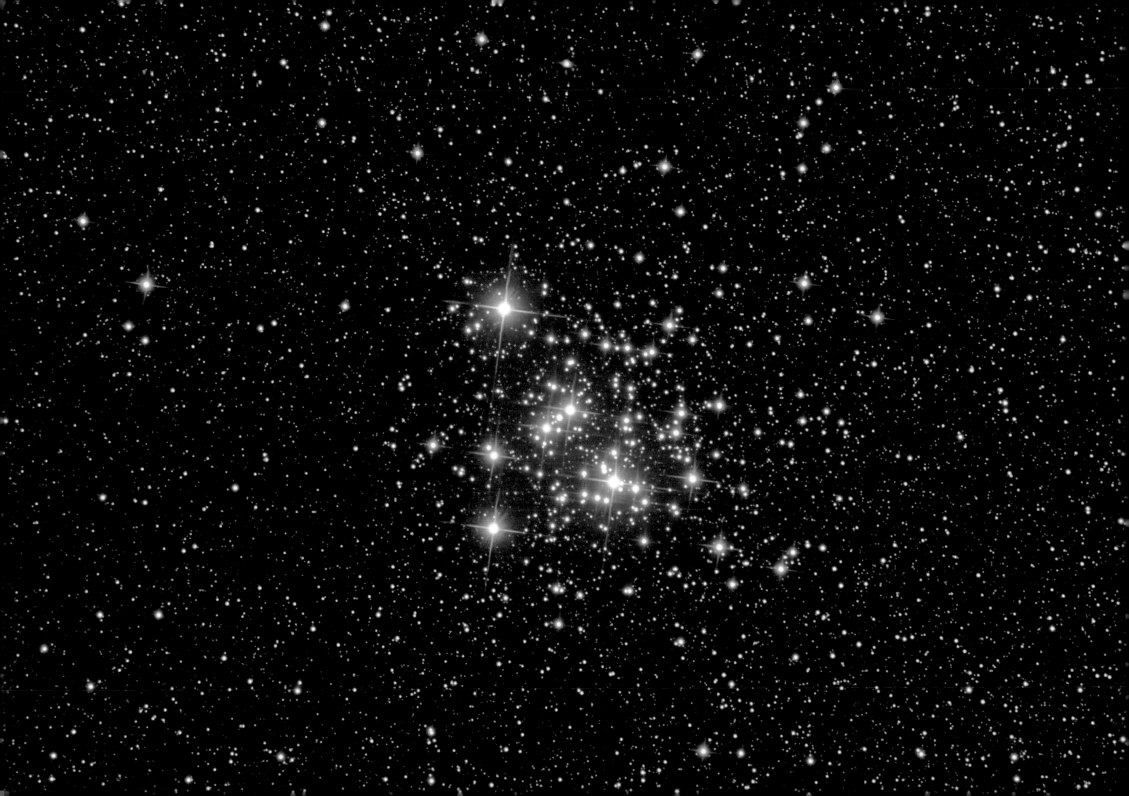

THE JEWEL BOX

anging like a sparkling Christmas decoration off the short arm of the Southern Cross (see the image on the previous page), the Jewel Box is one of the celebrities of the southern skies. This small, bright open cluster must be one of the most looked-at deep-sky objects at star parties and astronomy outreach events.

To the naked eye it appears as a bright spot of light more or less midway between β Cru and the Coal Sack. Binoculars show a triangle of bright stars (6th to 8th magnitude) with a bright knot (or a row of stars) in the center. The southernmost of these stars is a 6th magnitude blue-white luminous supergiant, and it is probably the most massive star in the cluster.

Through a small telescope the A-shape (pointing to the northwest), is immediately apparent. The central star of the "A" (SAO 252073) is a 7.5-mag, eye-catching, orange-red gem, a red supergiant star similar to Betelgeuse. It is sometimes called Kappa Crucis but this is incorrect as it is too faint to have received a Bayer designation. Indeed, as Stephen James O'Meara has argued, no single star can be identified as Kappa Crucis—rather, the entire cluster receives the Greek designation, as is the case with Omega Centauri.

John Herschel studied this cluster closely, noting that despite it being neither large nor rich, it is "an extremely brilliant and beautiful object when viewed through an instrument of sufficient aperture to show distinctly the very different colour of its constituent stars, which give it the effect of a superb piece of fancy jewellery." Herschel listed eight stars in which the "colour is conspicuous": three greenish-white stars; two green stars; and a blue-green, a ruddy-colored and a red star.

Some 40 years after Herschel's observation, the Australian astronomer Henry Chamberlain Russell, then director of Sydney Observatory, undertook a careful study of the Jewel Box and noted the following colors: yellow with tinge of green, red, blue, between blue and green, and green with a yellow tinge. In addition to being an energetic observer, Russell pioneered astrophotography in Australia. He was an "exceedingly blunt person," astronomer and historian Wayne Orchiston has written, who openly feuded with other prominent Australian astronomers, on one occasion received a parcel bomb, and was physically assaulted by an observatory worker!

Despite these authoritative reports of star colors, most are certainly a fiction of the observer's visual perception system, rather than an astrophysical reality. Nevertheless, they are real in a phenomenological sense—and beauty is indeed in the eye of the beholder. Australian observer and astronomy historian Andrew James speculates that if it were not for the reddish SAO 252073, "the Jewel Box would 'lose its lustre' and be considered like any other of the bright clusters."

Another intriguing feature of the Jewel Box is the impression of a "cluster within a cluster." In addition to the bright stars making up the "A," a swarm of 10th-magnitude and fainter stars surrounds the southern leg of the "A," spilling out southward. These stars form a roughly circular 8' diameter glow, over which the "A" is offset. The first observer to notice these fainter members was James Dunlop, who recorded "a multitude of very small stars on the south side."

The Jewel Box is a young star cluster, around 14 million years old. It lies in the Sagittarius arm of our galaxy some 6,400 light-years away.

N
E
1'

NGC 4755, Lacaille II.12, Dunlop 301, Caldwell 94
Open cluster in Crux, 12h 53.7min, −60° 22', Size 10'

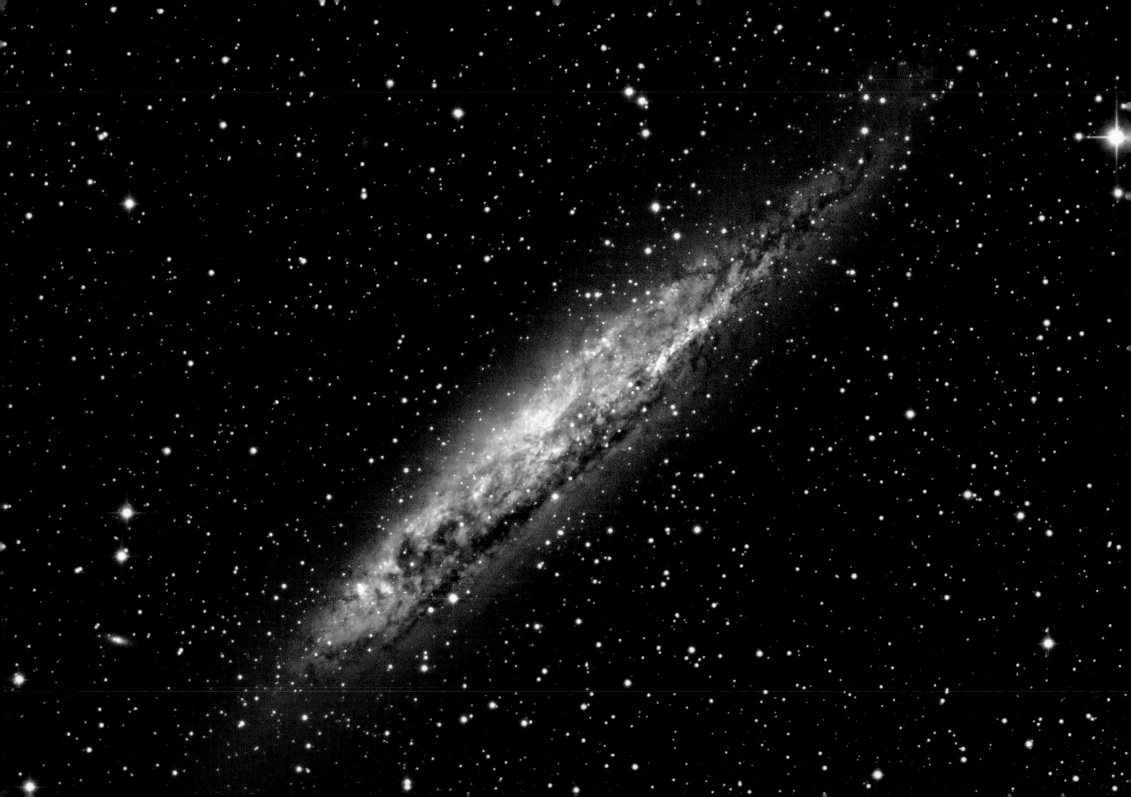

THE GOLDEN COIN GALAXY

Outside the main stream of the Milky Way, 8° due north of Crux, lies 2nd-magnitude γ Cen. Due east is the spectacular naked-eye globular cluster Omega Centauri. Halfway between these two is the wide 4th-magnitude stellar pair ξ¹ and ξ² Cen, and between these two stars lies the beautiful NGC 4945, a nearby almost edge-on spiral galaxy.

Under good skies, large binoculars show it easily as a fat elongated glow nestled within a triangle of naked-eye stars. With attention, its soft light can be traced out to 7.5' × 1.5'. Poor observing conditions, however, render it invisible in binoculars, making it a challenge to see under suburban skies.

Through a telescope NGC 4945 is an easy target, appearing as a ghostly slash hanging in black space between two 4.5-mag. stars. This makes it one of the easiest bright galaxies to find. Its spindle-shaped body stretches out beyond 15' in length, ending in faded extensions. The southwestern end is noticeably fainter, so that the brighter core appears offset to the northeast. At higher magnification, mottling is noticed along its length. The bright, central portion appears to bulge outward slightly to the northwest, an impression created by the dark dust lane skirting its southeastern side (as the photograph opposite clearly shows). A short chain of stars trails away from the galaxy's southwestern edge, and a 9th-magnitude yellow star lies to the south.

NGC 4945 was discovered by James Dunlop from Paramatta, Australia, in April 1826. Astronomy historian Glen Cozens notes that this was the first galaxy that Dunlop discovered, seen during the second evening of his ground-breaking project to catalogue southern nebulae and star clusters. Dunlop's 9-inch (23 cm) speculum mirror showed it as "a beautiful long nebula, about 10' long, and 2' broad… the brightest and broadest part is rather nearer the south preceding extremity than the centre, and it gradually diminishes in breadth and brightness toward the extremities, but the breadth is much better defined than the length."

The French doyen of galaxies, Gérard de Vaucouleurs, drew attention to NGC 4945 in his photographic survey of southern galaxies made with the 30-inch (76 cm) Reynolds reflector at Mount Stromlo Observatory, Australia. He noted it was "one of the largest late-type spirals at a very low latitude; little known." De Vaucouleurs added that an earlier reference to NGC 4945 was made by John Henry Reynolds. Reynolds, examining photographs of spiral nebulae, wrote that NGC 4945 was "of unusual type, complicated irregular ring, much inclined to line of sight with no nucleus, the southwestern half being very faint." Interestingly, the telescope that de Vaucouleurs had used for his survey was donated to the observatory (then known as the Australian Commonwealth Observatory) by Reynolds, in 1924. This was the second 30-inch (76 cm) telescope Reynolds had donated, the first being to the Helwan Observatory in Egypt, in 1905.

Located some 12 million light-years away in the nearby Centaurus A galaxy group, NGC 4945 is a barred spiral galaxy, inclined at 70°, spanning 57,000 light-years. The detection of X rays from a compact nuclear source confirmed the presence of a central black hole. Several lines of evidence point to the existence of rapidly rotating clouds of gas surrounding the nucleus. Recently, a fast-rotating nuclear ring of gas, with a diameter of about 1,000 light-years, has been detected .

Two faint galaxies are visible in the accompanying photograph. At the lower left edge, about 3' north of NGC 4945's northeastern tip, lies the 14th-magnitude spiral galaxy ESO 219–25. About 6' northwest of NGC 4945's center lies Cen 5, a faint dwarf galaxy discovered in 1997 to be a member of the Centaurus A galaxy group.

N
E
1'

NGC 4945, Dunlop 411, Bennett 57, Caldwell 83

Galaxy in Centaurus, 13ʰ 5.4ᵐⁱⁿ, −49° 28', Size 19.8' × 4.0'

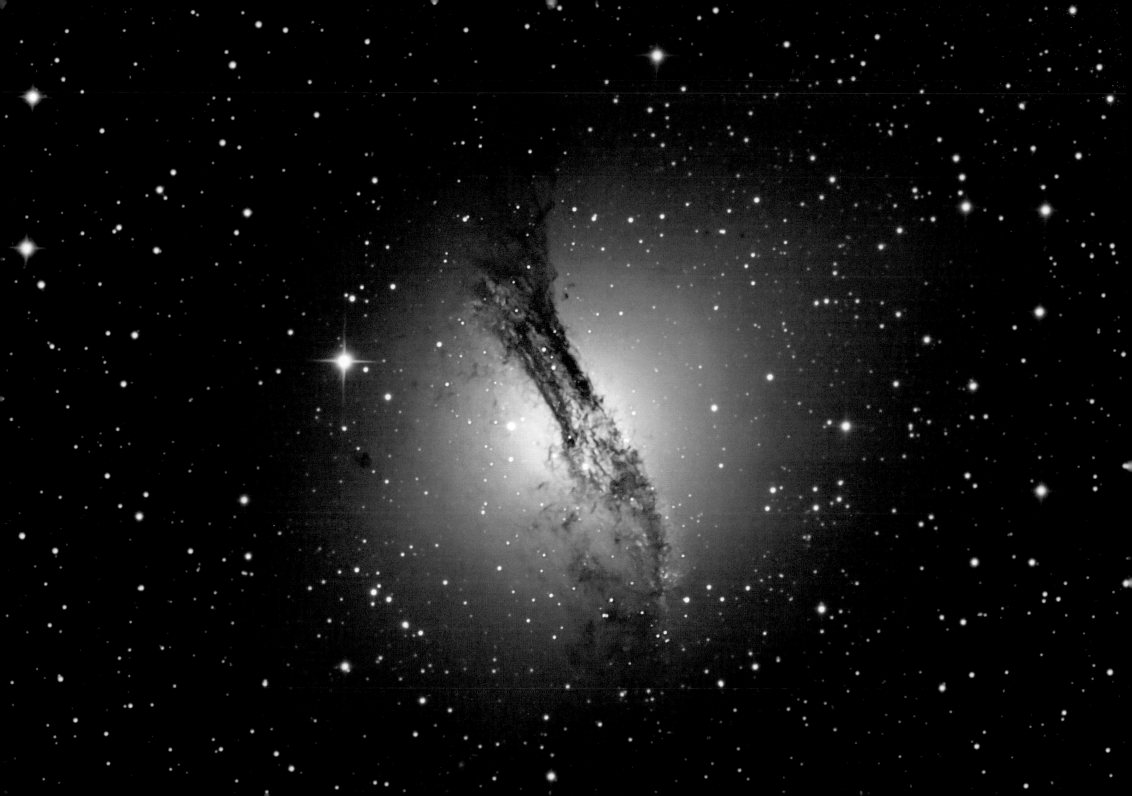

THE HAMBURGER GALAXY

Just 4.5° due north of the giant naked-eye globular cluster Omega Centauri lies the fascinating galaxy NGC 5128. Binoculars readily show it as a large almost-circular glow about 5′ across, flanked by two small stars, while high-powered binoculars show the famous dark lane.

In a small telescope, the dark lane is an obvious feature that divides the 7.5′ × 6′ nebula into two unequal lobes. The southernmost lobe is a thin bright band in comparison to the bulging northern one, creating the unmistakable impression of a celestial hamburger. Larger telescopes reveal a wealth of detail. The interior edges of the lobes are sharply terminated by the dark lane. A 12th-magnitude star is prominently located within the dark lane toward the northwest. A filament of dim light, broader in the northwest, runs from this star centrally down the dark lane for about 2′. The northern lobe, almost a complete hemisphere, has a stubby tapering tail in the northwest, shown in the photograph on the left and revealed as a region of star formation.

The Hamburger was discovered by James Dunlop in Paramatta (now a suburb of Sydney), Australia, in 1826. The associated radio source, Centaurus A, was also discovered from Sydney, some 120 years later.

John Herschel saw "an elliptic figure, cut away in the middle by a perfectly definite straight cut... The internal edges have a gleaming light like the moonlight touching the outline in a transparency." He called it "a very problematic object" and concluded it "must be regarded at present to form a genus apart."

The nature of NGC 5128 has been an enduring puzzle. Edwin Hubble (1922) classified it as nebulous. There is still disagreement about its classification, as either a peculiar spiral or a peculiar elliptical galaxy. Sidney van den Bergh stated in 2009 that NGC 5128 "does not find a natural home in the Hubble classification scheme." Gretchen Harris of the University of Waterloo (Canada) argues that it is an elliptical galaxy, based on the properties of its halo stars and its globular cluster population.

NGC 5128 spans some 94,000 light-years and contains a black hole with a mass of 50 million suns. Its prominent disk of gas and dust, several thousand light-years-wide, is thought to be the result of a merger, some 500 million years ago, between a small gas-rich galaxy and a giant elliptical galaxy. It is the closest active galaxy and lies at a distance of about 12 million light-years.

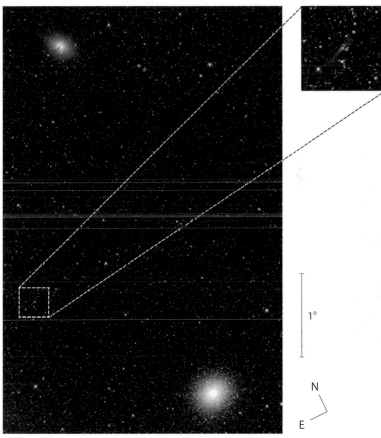

Wide-field view showing NGC 5128 (top) and Omega Centauri (bottom). The curious galaxy Fourcade-Figueroa (LEDA 47847) can be seen near the left edge, below center.

1°

N

E

E

N

1′

NGC 5128, Dunlop 482, Bennett 60, Caldwell 77, Centaurus A

Galaxy in Centaurus, 13h 25.5min, −43° 1′, Size 25.7′ × 20.0′

Omega Centauri

The most magnificent globular cluster visible from Earth rides on the back of the Centaur and appears to the naked eye as a bloated 4th-magnitude star.

Large binoculars show this cluster as an impressive oval moon-sized glow, with individual stars sprinkled over its surface. Less than 1° to the southwest lies 6th-magnitude HD 116197; from which two rows of stars diverge toward the cluster, creating the lovely impression of an ice-cream cone topped with a million stars.

A telescope shows a host of faint stellar points scattered upon a glowing bed of unresolved stars. Rows, loops and clumps of stars abound. Entirely unlike the spectacular 47 Tuc, which has a small bright nucleus, Omega Centauri displays a broad (10′) compact center. Another striking visual feature is the pair of dark patches immediately east of the nucleus, joined by a prominent short row of 12th-magnitude stars running east-west. The northern patch is the easiest to see.

The first person to see it through a telescope was the youthful Edmond Halley, who in 1677 visited the island of St. Helena, the most southerly land under British control. In Cape Town (then a Dutch colony) in the 1750s, Lacaille saw it as resembling "a big diffuse comet." The first to recognize its stellar nature was James Dunlop, observing from Australia. Dunlop saw it as a "beautiful globe of stars... the largest bright nebula in the southern hemisphere."

The 19th-century American observer Lewis Swift, at Lowe Observatory in the San Gabriel Mountains just north of Pasadena, California, called the famous Messier 13 in Hercules "a tame affair" when compared with Omega Centauri, noting that many thousands of faint stars made up the cluster. Swift would have been astounded to learn that in 2009 astronomers compiled a catalogue of almost one million stars belonging to ω Cen.

It is our galaxy's most luminous and most massive globular cluster, located in the galactic halo some 16,000 light-years away. Its orbit about the galaxy is highly eccentric and is also retrograde—clues suggesting that ω Cen is the remnant nucleus of a dwarf galaxy that merged with our Milky Way in the distant past.

Its total population is estimated at 10 million stars, and in the central region the stellar density is about 13 times higher than in our solar neighborhood. There is some evidence for an intermediate-mass black hole (13,000 – 50,000 solar masses) in the heart of this gigantic stellar system.

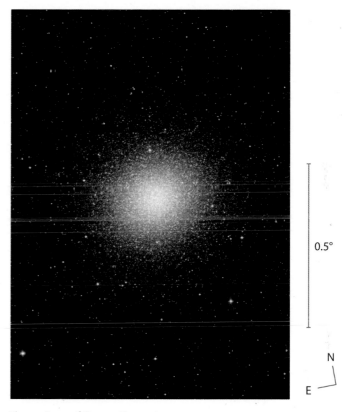

0.5°

N

E

The environs of Omega Centauri.

E

N

1′

NGC 5139, Lacaille I.5, Dunlop 440, Bennett 61, Caldwell 80

Globular cluster in Centaurus, 13h 26.8min, −47° 29′, Size 55′

THE SPIRAL PLANETARY

Tucked into the northeastern corner of Musca is one of the most intriguing southern deep-sky objects. Midway between the Pointers and the angular shape of the Fly lies NGC 5189, which John Herschel rightly called "a very strange object." This odd planetary nebula lies some 7′ north of HD 117694 (7.2 mag.), the bright blue-white star in the accompanying photograph.

NGC 5189 is one of the brightest southern planetaries. Large binoculars hint at its presence, and a small telescope plainly shows its irregular nebulous form, somewhat like a rectangle.

In a moderate-sized telescope the nebula is nestled within a perfect diamond of 11.5-mag. stars that measures 3.8′ × 1.8′; the two easternmost stars are orange. Overall it appears as a narrow elongated haze that is oriented northeast-southwest, with the northern edge more sharply defined. The ends of the central bar blossom out into small lobes; the southwestern lobe is brighter, whereas the northeastern one is smaller and less distinct. The whole figure is about 1.3′ from tip to tip.

In smaller telescopes there is a single 11.9-mag. star involved, near the western tip. A larger instrument shows this star as one of a trapezoid of 12th–to 13th-magnitude stars, oriented east-west, with the nebulosity arranged inside it; almost as if its brightest portions are avoiding touching its neighboring stars. Larger telescopes, or with the use of an O III filter, shows the nebulous bar as the highlight of an east-west extended oval of faint light. The famous spiral shape, distinctly shown on the photograph, can be a challenge for modest-sized telescopes.

James Dunlop was the first to see the nebula, noting only that it was small and very faint. Herschel described it as a "nebula of oval figure, but having a central and brighter axis somewhat curved, and terminating in two masses brighter than the rest." Using the short-lived Great Melbourne Telescope, Albert le Sueur called it "a small but beautiful spiral [with] two brighter knots".

A clerical error around the turn of the 20th century led to NGC 5189 being recorded as a new find, IC 4274. Williamina Fleming, Harvard's first famous woman astronomer and discoverer of the Horse Head Nebula, examined photographic plates and catalogued "Fleming 93" based on its spectral signature. She recorded the declination correctly (–65°), which corresponds to a North Polar Distance (NPD) of 115°. Somehow, when the entry was processed for possible inclusion in the Second Index Catalogue, the NPD was transcribed as 155°, resulting in a spurious new object. This error was later carried over into the NGC 2000.0.

In 1940 Harvard astronomers Harlow Shapley and John Paraskevopoulos presented the American National Academy of Sciences with a series of photographs of "instructive curiosities and abnormal forms" made with the 60-inch (152 cm) Rockefeller reflector at Boyden Observatory (South Africa). One of the objects they showcased was NGC 5189, which had such a "remarkable knotted structure" that they felt it best to reproduce a drawing rather than the original two-hour exposure.

In the 1970s, astronomers from the Royal Observatory of Belgium in Uccle were searching for H α objects in the southern Milky Way, and recorded NGC 5189 on their survey photographs, noting that "filaments in the form of a butterfly are clearly visible."

A recent study of its filamentary and knotty structure suggests that it has experienced at least two mass outflows generating two bipolar structures, and that its "chaotic" appearance is the consequence of the encounter between the two sets of bipolar outflows.

E
N
1′

NGC 5189, Dunlop 252, IC 4274, Ced 123, Gum 47, Bennett 62
Planetary nebula in Musca, 13h 33.5min, –65° 58′, Size 2.3′ × 2.3′

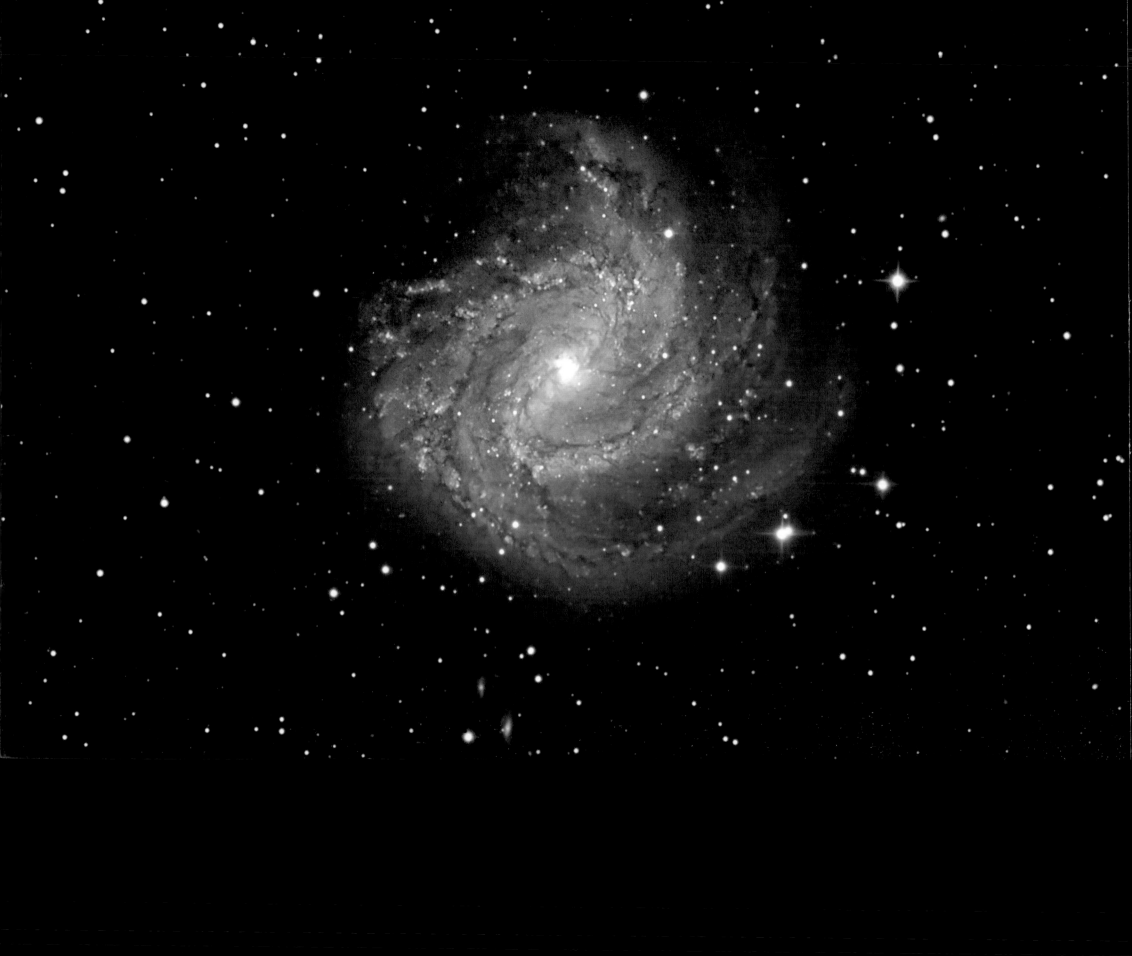

THE SOUTHERN PINWHEEL

The Southern Pinwheel is a bright galaxy on the border between Hydra and Centaurus, midway between (and slightly east of) Spica and Omega Centauri (NGC 5139). It lies about 8° south-southeast of 3.0-mag. γ Hya, and some claim to have seen it with the naked eye alone. In his authoritative *Atlas of the Messier Objects* German observer and author Ronald Stoyan points out that it is one of the most challenging Messier objects to observe from northern latitudes.

It was discovered in the 1750s by Lacaille, the only galaxy in his brief list of southern splendors. Messier added it to his list in February 1781. John Herschel noted it was "a perfect analogy" to NGC 4258 (Messier 106) in Canes Venatici.

The South African comet hunter Jack Bennett included it in his catalogue of southern comet-like deep-sky objects, compiled in the mid-1960s. Bennett noted that the bright nucleus of the galaxy could be mistaken for a comet when seen in adverse conditions. Four years after starting his compilation, while comet-hunting from his backyard in Pretoria, Bennett discovered a supernova in Messier 83. With this discovery he became the first person to visually discover a supernova since the invention of the telescope (prior discoveries either pre-dated the telescopic era, or were made photographically). Bennett had less success with local government, though. In the 1960s, new roads were being laid out near Radcliffe Observatory (Pretoria) and were given star names. Bennett was horrified to see a road sign indicating CANOPSUS street. When he contacted the local municipality to have the error corrected he was informed by an official that unfortunately the street name had already been assigned and that he should have the name of the star changed instead.

From southern skies, this almost face-on galaxy is easy to see in even small binoculars as a large, faint, circular glow surrounding a much brighter spot, sharing the field with an attractive miniature "corona australis" of stars (6.8 to 8.6-mag.) 2.5° to the south.

Through a modest-sized telescope the subtle beauty and detail of its two elegant spiral arms is alluring. An 8-inch (20 cm) telescope begins to reveal the tantalizing details. Veteran observer Steve Gottlieb (California, USA) reported observing it with a 24-inch (60 cm) reflector, noting that at 200× magnification it had "a photographic appearance," with a third less well-defined outer arm.

The Southern Pinwheel is a grand-design spiral galaxy, 56,000 light-years across and inclined 24° toward us. Despite careful searches, it shows no signs of a nuclear black hole. Around the nucleus is a sizeable star-formation region, about 650 light-years long and 100 light-years thick. Thirteen star clusters have been detected in this region, with masses ranging from tens of thousands to over a million solar masses (some stars are more massive than 30 suns). The clusters are between three and 20 million years old, and it is speculated that their formation was triggered following a close encounter with the companion galaxy NGC 5253, a dwarf irregular, about a billion years ago. The closest large galaxy to the Southern Pinwheel is NGC 5264, 260,000 light-years distant.

The Southern Pinwheel lies some 14.7 million light-years from our galaxy. It is the dominant galaxy of the M83 galaxy group, which in turn may form a subgroup of the Centaurus A/M83 group.

At least three smaller galaxies are visible in the accompanying photograph: ESO 444–85 (bottom edge of the image), LEDA 724525 (above it) and LEDA 722819 (toward the top-right).

N
E
1'

Messier 83, NGC 5236, Lacaille I.6, Dunlop 628, Bennett 63
Galaxy in Hydra, 13h 37.0min, −29° 52', Size 12.2' × 13.1'

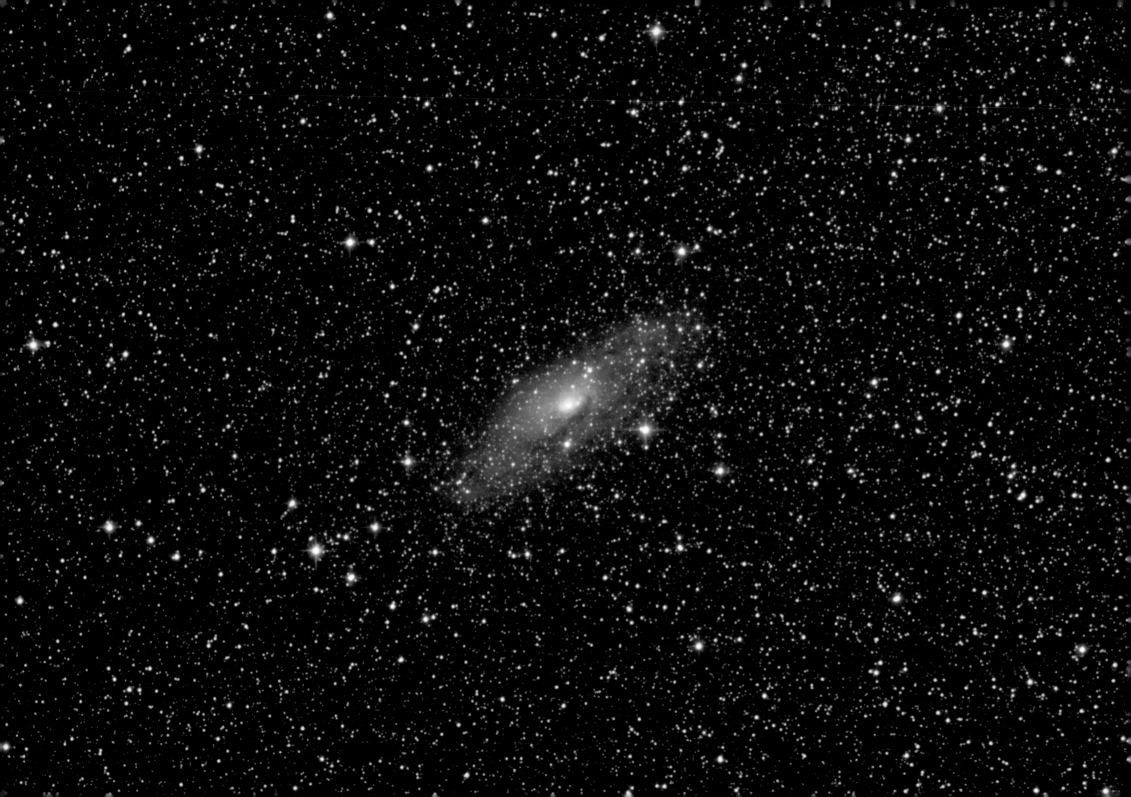

THE CIRCINUS GALAXY

With the Pointers (see p. 97) as starting point, draw an isosceles triangle to the south, with sides 5.5° long. This brings you to a point 3° west of α Cir, where the delicate and unexpected Circinus Galaxy lies.

A small telescope shows it as an extremely faint, small fuzz, north-northwest of a 10th-magnitude star. Modest-sized instruments do not reveal much more: only the core is seen, a small round evenly-illuminated glow that is reasonably faint but still obvious as a non-stellar object. In larger telescopes the elongated form of the central region is suggested, with mere hints of an outlying glow. The accompanying photograph reveals its much larger extent.

Curiously, the great visual observers of the pre-photographic era failed to discover it. One of the great observers was, of course, John Herschel, and in a letter to him, dated April 15, 1834, Thomas Maclear, then Her Majesty's Astronomer at the Cape of Good Hope, wrote: "As Nelson swept the seas you sweep the skies, leaving little for those who may come after you." Despite this great praise, Herschel never "made landfall" on this "island universe."

This hidden galaxy was finally revealed. in 1977, when it was noticed by Gosta Lynga (famous for his authoritative compilation of open cluster data) on a photograph he had taken with the Uppsala Schmidt telescope at Mount Stromlo Observatory (Australia) as part of a southern Milky Way survey. Being more interested in stellar astronomy than extragalactic work, Lynga informed his colleague Kenneth Freeman (an astronomer at Mount Stromlo) of the discovery. Freeman quickly acquired optical spectra using the 74-inch (188 cm) telescope and confirmed that it was a galaxy. "Soon afterwards," Freeman writes, "we mapped it in the 21-cm (8 in) line at Parkes: the H I profile again confirmed that it was a fairly massive galaxy with an unusually high H I content."

The new galaxy was described as having a non-stellar nucleus, 10″ across, within a bright nuclear region, about 50″ wide. The surrounding diffuse elongated disk had a major axis of about 5′. A prominent dust lane was noted, running from its origin south of the nucleus toward the northeast. These features are clearly visible in the accompanying photograph.

Freeman estimated its distance at over 10 million light-years and that therefore it was not a member of the Local Group of galaxies.

Modern studies show that it is a large, highly inclined (about 65°) spiral galaxy with an active galactic nucleus that is heavily obscured by dust lanes and surrounded by a star-forming ring. It has an extended stellar disk, and radio observations have revealed double radio lobes and an enormous neutral hydrogen envelope.

At a distance of about 13 million light-years, the Circinus Galaxy is amongst the nearest active galaxies to our Milky Way.

In the mid-1990s a supernova, catalogued as SN 1996cr, erupted in this galaxy. Astronomers have found similarities to the more famous SN 1987A in the Large Magellanic Cloud: both objects showed an unexpected increase in X-ray output over time. Multi-wavelength observations suggest that both stars experienced pre-explosion clear outs of their surroundings. In this scenario, a large cavity surrounding the progenitor star is cleared out, possibly via strong stellar winds. When the star explodes, the blast wave expands into this cavity until it encounters the denser swept-up material; the impact causing the system to glow brightly in X-ray and radio emission.

N · E · 1′

ESO 97-13, LEDA 50779

Galaxy in Circinus, $14^h 13.1^{min}$, −65° 20′, Size 6.7′ × 3.0′

THE POINTERS

The Southern Cross, icon of the southern heavens, has two brilliant stars pointing toward it. Lying to the east of Crux, at very similar declinations and 4.4° apart, are the Pointer Stars: α Centauri (−0.27 mag., third brightest star in the night sky) and β Centauri (+0.61 mag., 11th brightest).

The Pointers may be compared to Castor and Pollux in Gemini, a fainter pair but with similar angular separation and magnitude difference. More than a thousand years ago, the Pointers could be seen from Europe, accounting for their inclusion in the ancient Greek constellation Centaurus. Over the centuries, the slow effects of precession inexorably changed their position in the night sky, and modern star gazers have to venture to more southerly latitudes to enjoy this splendid pair.

Despite the almost total lack of stellar iconography in sub-Saharan African traditions, including modern-day depictions of stars on flags and coins, African peoples have a rich ethnoastronomy, and the stars of the Pointers and Crux feature prominently in their lore. In certain traditional Bantu cultures, such as the Sotho, Tswana and Venda, the Pointers are seen as two female giraffes, with the stars of Crux being male giraffes. To the |Xam Bushmen, the Pointers were two male lions who were once men, but were turned into stars by a magical girl. In a Southern African Khoikhoi legend that calls the Pointers are called *Mura*, meaning "the eyes," are a representation of the baleful glare of some great celestial beast.

α Cen, at bottom-left in the accompanying photograph, is a beautiful yellowish double star, seen in the telescope as magnitude −0.01 and +1.35 components separated by just over 5″. With an orbital period of 80 years it is possible to personally witness a complete revolution of these stars.

α Cen has the distinction of being the first star to have its distance measured. A long series of careful measurements were made by Thomas Henderson and his assistant William Meadows at the Royal Observatory in Cape Town, and the results were published in 1833. Furthermore, α Cen was also the nearest known star to the sun, a record that stood for 82 years. It took second place with the discovery, also from South Africa, of Proxima Centauri.

This dim companion to α Cen was discovered in 1915 by Robert Innes at the Union Observatory in Johannesburg, who then began a series of observations to determine its distance. Unknown to him, Joan Voûte at the Cape Royal Observatory had also been measuring this star's distance and suspected that it was closer than α Cen. Innes announced his discovery of the closest star in 1917, but it would only be in 1928 when convincing confirmatory measurements were published, by Harold Alden based on observations he made at the Yale Southern Station (Johannesburg, South Africa).

β Centauri at upper-right is a bright blue triple star, consisting of two giant stars in very close proximity (less than 5 Astronomical Units separate them when farthest apart) with a third star (3.9 mag.) about 1 arcsecond distant. The system lies over 300 light-years from Earth.

In the accompanying photograph, between the Pointers, nearest to α Cen, the open cluster NGC 5617 can be seen; a beautiful telescopic subject set in a stunning star field. Directly below NGC 5617 is the moderately faint cluster Trumpler 22.

A 5.2-mag. star, midway (and 40′ south) between the Pointers, lies on the northern edge of a small dark nebula, DCld 313.3–00.3, which is associated with RCW 85, a dim bright nebula.

N

E

15′

α Centauri (HD 128620), β Centauri (HD 122451)

Stars in Centaurus, 14h 39.7min, −60° 50′ (α), 14h 4.8min, −60° 22′ (β), Separation 4.4°

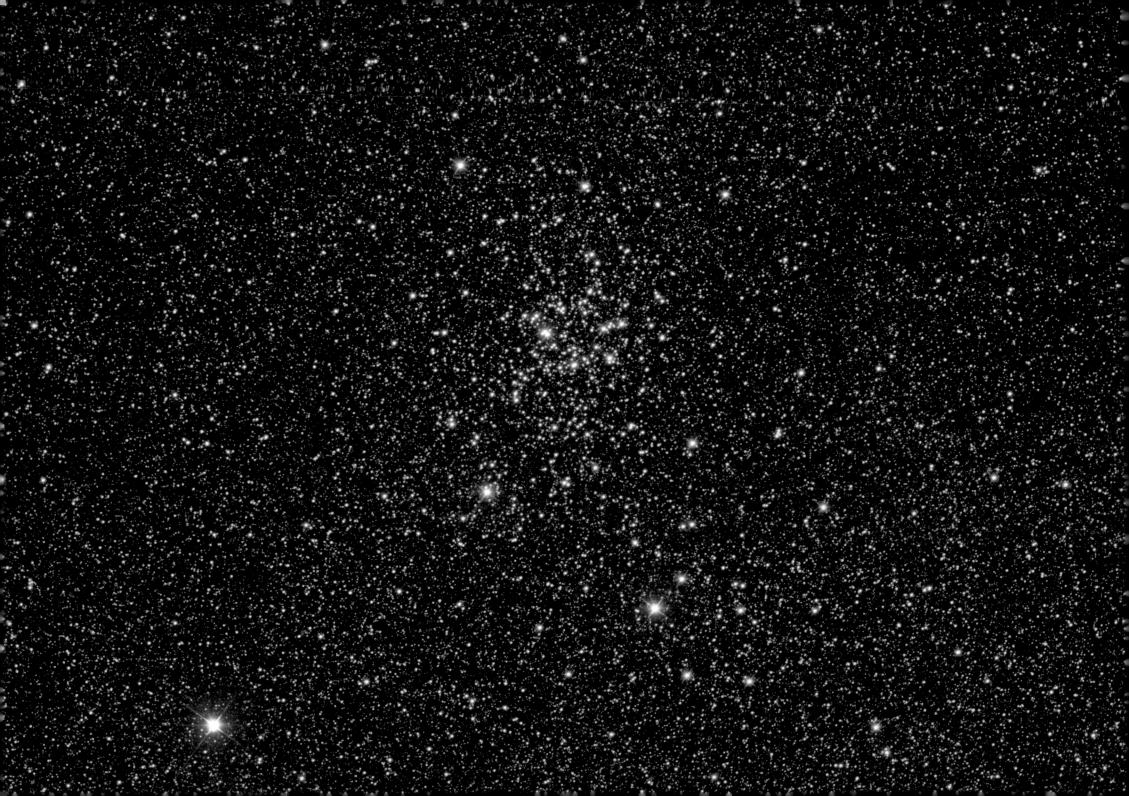

Norma's Jewel Box

Ara is a striking constellation, readily found between the tail of the Scorpion and the Southern Triangle. It consists of a narrow isosceles triangle, almost 4° long, flanked on each side by two stars. The resulting pattern makes a striking butterfly, skimming just above the Milky Way on some private eastward mission. The traditional Ara pattern, however, is that of an altar. Its wide base is on the east and the sacrificial surface is to the west. Some unspecified offering burns on the altar, creating a billowing cloud of smoke, which in the sky is clearly visible as a bright 4° patch along the Milky Way known as the Norma Star Cloud. Embedded in the southwest of Ara's smoke, visible to the naked eye as a bright spot, is the magnificent star cluster NGC 6067.

Binoculars give a grand view, showing the bright star cluster exhibited on an immensely rich Milky Way background, laced with hazy nebulosity of unresolved stars and winding patches of nearly starless sky. It is easy to mistake NGC 6067 for a globular cluster as you scan across it with binoculars.

A telescope reveals it as one of the heaven's best: hundreds of stars packed into a 15′ diameter cluster and gathered in the center to a denser knot. Just off-center from the hub lies an eye-catching 9th-magnitude double star, HJ 4835, much brighter than its fellow cluster members and with a reddish primary component. Widely scattered stars flesh out the cluster with an almost endless supply of chains and clumps, a playground for the imaginative mind.

James Dunlop was the first to examine NGC 6067 telescopically, although Lacaille no doubt would have seen it from Cape Town. John Herschel called it a "most superbly rich and large cluster, 20′ at least in diameter," noting HJ 4835, with a separation of 11″, near its center.

The British-South African astronomer Andrew David Thackeray, famous for showing in 1952 that the distance to the Small Magellanic Cloud was two times greater than had been assumed (and thus doubling the age of the Universe), studied NGC 6067 with the 74-inch (188 cm) Radcliffe telescope. He noted that the contrast in colors of the blue and red stars is easily seen through the telescope and that it "perhaps deserves the designation 'jewel-box' even more than κ Crucis which contains only one bright red star."

Thackeray also drew another interesting comparison, noting that NGC 6067 "looks as if it were the nucleus of the [Norma] Cloud in much the same way as Messier 11 looks as if it were the nucleus of the Scutum Cloud."

NGC 6067 is important for calibrating the cosmic distance scale since it hosts several Cepheid variables—stars that follow Leavitt's law, which describes the relation between period and luminosity (magnitude). One of these cluster variables is V340 Nor, which has a period of about 11 days. Interestingly, V340 Nor is the brighter, reddish, component of Herschel's double star HJ 4835.

Some 12′ southwest of the center of NGC 6067 lies the planetary nebula HeFa 1 (PNG 329.5–02.2), discovered in the early 1980s by astronaut astronomer Karl Henize and Capetonian colleague Tony Fairall. They noted it was a low surface brightness object with weak ring structure and a diameter of 22″. For some time it was suspected to be a member of NGC 6067, but recent measures of the nebula's radial velocity show it to be a background object.

NGC 6067 is a long-lived cluster with an age of about 100 million years, hosting at least 16 red giant stars. The cluster measures some 40 light-years across, and lies in the Sagittarius arm of our galaxy about 5,700 light-years away.

E / N

3′

NGC 6067, Dunlop 360
Open cluster in Norma, 16ʰ 13.2ᵐⁱⁿ, −54° 13′, Size 15′

The Eye of the Scorpion

Messier 4 is probably the easiest globular cluster to find as it lies just over 1° west of Antares. It was discovered in 1746 by the Swiss astronomer and theologian Jean-Philippe Loys de Chéseaux, who began observing at the age of 18. Messier added it to his catalogue in May 1764, noting Lacaille's earlier observation from Cape Town.

From a dark-sky site, Messier 4 can be glimpsed with the naked eye. Through binoculars, it appears as a large hazy disc with faded edges, and stands in beautiful contrast to the nearby brilliant and colorful Antares. With attention, a striking feature of Messier 4 can be seen in binoculars: a ridge of stars that runs through the center of the cluster. The earliest mention of this ridge was made by William Herschel, who observed it in 1783.

The cluster's brightest stars are 11th-magnitude, so partial resolution is possible with large binoculars, and is readily achieved with a small telescope. Modest-sized telescopes show Messier 4 as a very loose gathering of stars. The ridge of stars, 2′ long, cuts north-south through the cluster, offset slightly to the east of the center. The cluster's horizontal branch is at 13.5 magnitude, so it begins to fill in under good sky conditions or with a larger aperture. South African observer Carol Botha says that there is a sense of opulence and abundance, with the central region seemingly draped in strings of pearls.

Loops and clumps of stars are playfully scattered about within and around the cluster. Australian deep-sky master Ernst Hartung noted a concentric pattern in the stars, and veteran observer Steve Coe describes the chains as being arranged like the seats in an ancient Roman stadium.

Lacaille quite succinctly recorded it as looking like a "small comet nucleus," which is about all the detail he could hope for from his ½-inch aperture telescope. Messier's superior optics showed him "a cluster of very small stars."

William Herschel had a much grander view, recording "a rich cluster of considerably compressed small stars surrounded by many straggling ones. It contains a ridge of stars running through the middle from sp to nf. The ridge contains 8 or 10 pretty bright stars. All the stars are red."

Messier 4 is the closest globular to us, at 7,200 light-years. It orbits our galaxy every 116 million years in a very eccentric path, so that it spends most of its time in the outer parts of the galaxy. At perihelion it approaches to within 1,900 light-years of the center of our Milky Way. Together with the fact that it has a relatively small mass has led to the suggestion that it was a much larger system in the past (perhaps the nucleus of a dwarf galaxy) and that its frequent and close passages through the Milky Way has robbed it of stellar content.

Closer still to Antares in the night sky is the small globular cluster NGC 6144, just 40′ away. It can be seen in binoculars as a small round glow, and stands in stark contrast to its brilliant neighbor. In September 1887, William Finlay, First Assistant at the Royal Observatory in Cape Town, "discovered" an object, IC 4606, which is now believed to be a re-observation of NGC 6144.

Finlay's claim to fame is his discovery of the great September comet of 1882. His boss, David Gill, the Astronomer Royal at the Cape, was inspired to photograph the huge comet in a novel manner: he mounted a portrait camera on a telescope and took guided, wide-field images. The comet was beautifully rendered, but Gill instantly recognized the technique's true power: many stars were recorded on the plates. He realized that this method could be used to produce star charts, on which the stars could be measured for position and brightness. The rest, as they say, is history.

E
N 1′

Messier 4, NGC 6121, Lacaille I.9, Bennett 7
Globular cluster in Scorpius, 16h 23.6min, −26° 31′, Size 36′

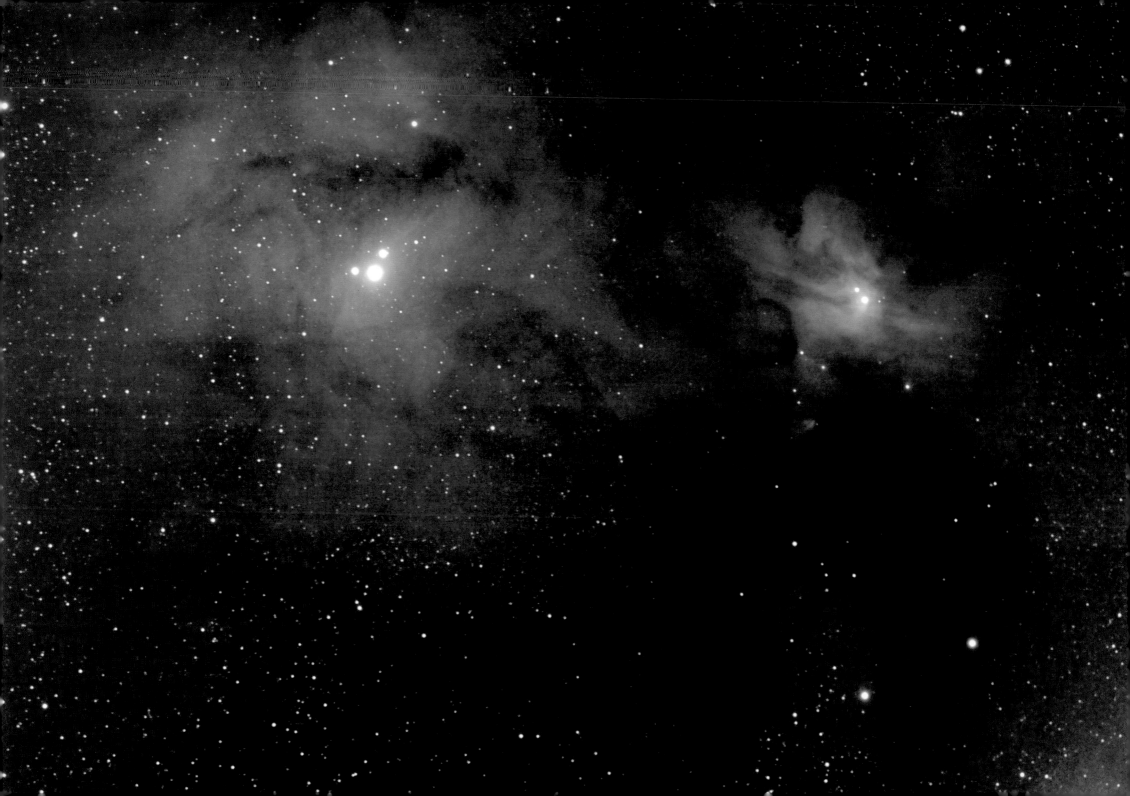

THE RHO OPHIUCHI REGION

The haunting beauty of the nebulous field around ρ Oph is elegantly shown in the accompanying image. American astrophotography pioneer E. E. Barnard said it was "the most puzzling region that I know of in the sky." He wrote: "The nebula itself is a beautiful object. With its outlying connections and the dark spot in which it is placed and the vacant lanes running to the east from it, it makes a picture almost unequalled in interest in the entire heavens."

The hot blue star ρ Oph is the brightest star in the accompanying image, near the upper left. The pair lie almost 400 light-years away, in a gas and dust-rich region of the Milky Way. Their light is reflected off these interstellar clouds creating the soft-blue glow seen extending for well over 1°.

The soft glow surrounding ρ Oph was first noticed by Barnard in the early 1880s with his 5-inch (13 cm) refractor. In 1895 he wrote: "For fully ten or twelve years I have known of a vast region of nebulosity in Scorpius near Antares. I tried a number of times to locate this nebulosity, but could never definitely settle its extent and exact position. I first knew of its presence in my early comet seeking, having come across it repeatedly in my sweeps. I have looked it up a number of times since being at the Lick Observatory [with the 6.5 in/15 cm and the 12 in/30 cm refractors], but the examination was always unsatisfactory."

Only when he photographed it (in March 1895, with the wide-field Willard portrait lens) was he finally able to begin to appreciate the wonderfully intricate bright and dark nebulous field. "The brighter and more complicated portions of the nebula center about ρ Ophiuchi... [t]he greatest mass or masses—for it is gathered in cloud-like forms—is around the three stars of ρ Ophiuchi.... [where] the nebulosity assumes a splendid ribbed appearance."

This bright nebula was subsequently taken up as IC 4604, while Barnard assigned No. 42 to the general area in his own catalogue: "though not wholly dark, it is partly so... the semi-vacant region in which this, the great nebula of Rho Ophiuchi, lies is about 3.5° in diameter."

In the accompanying photograph, the two stars to the far right of ρ Oph (1° south) lie within IC 4603. The brightest star is 7.9 mag HD 147889. Barnard said the surrounding nebulosity "takes the form of four bright and beautiful whorls which centre at this star."

The large dark nebula below IC 4603 is LDN 1688, which continues eastward to become Barnard 44. The more compact nebula to its lower left is LDN 1696, which extends northeast into the straggling Barnard 45. A wide-field view showing their glorious extent is presented on page 105.

Of B 44 and B 45, Barnard wrote: "The dark lanes... are remarkable, especially the very long ones whose sides are so sharply defined. The main lane begins roughly at the star 22 Scorpii... and runs eastward, extending brokenly nearly to the region of Theta Ophiuchi."

The Rho Ophiuchi cloud complex is one of the youngest (about a million years old) and closest (approximately 420 light-years) star-forming regions. The molecular clouds that make up this stellar nursery have a very filamentary structure, with lengths up to 80 light-years and widths as little as 6 light-years. More than 300 embryonic stars have been catalogued in the complex. LDN 1688 is the centrally condensed core of the region, where the visual extinction is upwards of 50 magnitudes, providing a very effective screen against background stars.

N
E
6'

IC 4604, Cederblad 131b, LBN 1111
Bright nebula in Ophiuchus, 16h 25.6min, −23,5°, Size 71'

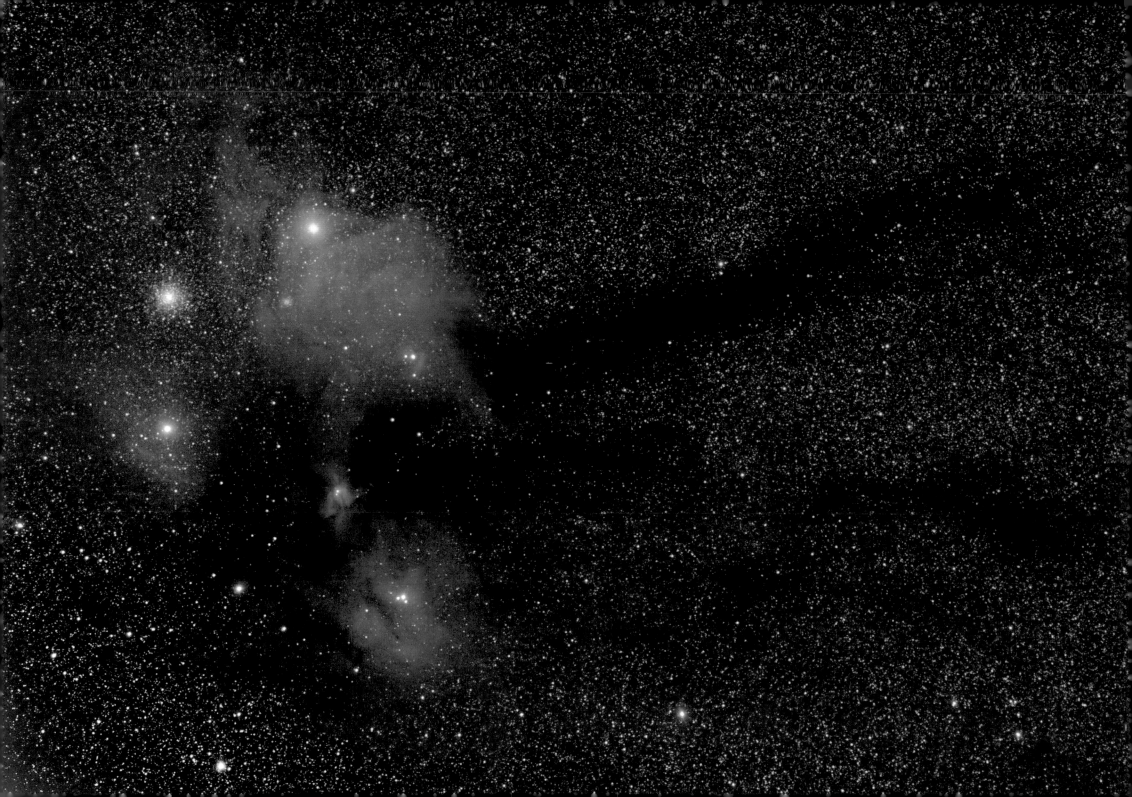

THE ANTARES NEBULA

Identification chart
p. 168

The region south and west of Antares contains a remarkable collection of bright and dark nebulae, beautifully illustrating the influence of different types of stars on interstellar clouds.

Antares, the heart of the Scorpion, can be found on the accompanying photograph toward the top-left, appearing as a pale-orange disk. To its bottom-left is the grand globular cluster Messier 4.

Antares is a cool red supergiant star, and its striking naked-eye color (color index B – V = +1.83) invites comparison to the Red Planet, Mars (it is suggested that *anti Ares* means "rival of Ares," i.e. "rival of Mars"). Situated in a region of the Galaxy rich with gas and dust, Antares is not energetic enough to ionize the surrounding clouds. Instead, it lights up its dusty environment, which then reflects its predominantly yellowish starlight and creates the subtle Antares Nebula (Cederblad 132). The Toby Jug Nebula, page 41, is another example of a yellow reflection nebula.

Over the lower-right portion of the Antares Nebula is a small blue nebula, IC 4605, around 22 Sco. This star is a B3-type main-sequence star, so it is just not quite energetic enough to ionize the surrounding clouds, resulting in a reflection nebula.

When E. E. Barnard imaged this region in 1905, he commented: "The star 22 Scorpii strikingly resembles a human eye, the lids being formed by two strips of nebulosity."

Below Antares in the lower part of the image is a large blue cloud, the magnificent Rho Ophiuchi Nebula. Light from this stellar system, more than 2,000 times brighter than the sun, penetrates the surrounding clouds and is scattered, creating another reflection nebula. See page 103 for a detailed view of this delightful region.

Near the left edge of the image, below Messier 4, lies σ Sco, a quadruple star system containing at least one blue giant, energetic enough to ionize the surrounding interstellar gas and make it glow with the characteristic pink-red hue of hydrogen, creating the nebula Cederblad 130. Barnard's description notes that σ Sco "is involved in a very dense mass which connects with the fainter part of the [Antares Nebula]. The condensation about this star is irregular, and extends mostly north and south."

To the right of the Antares Nebula, trailing off northward, is a prominent smoky molecular cloud, the dark nebula B 44, a "great vacant lane that runs east from the region of Rho Ophiuchi." Barnard wrote that "it is about 32′ wide and has its begin-

ning in a vacant area in which is the star 22 Scorpii." It is continuous for more than 6°, then gradually shatters into fragments and continues in broken spots as far east as θ Oph, a total length of over 10°.

A second extensive finger of dusty nebulosity, B 45, lies about 2° northward of B 44, near the right-hand edge of the photograph. Barnard described it as "rather definite, 2° long… This appears to be a real, dark object."

These two lanes can be seen to their full extent in the photograph on page 108. In discussing them, Barnard wrote: "These lanes and spots, though mostly devoid of all stars, are not truly vacant, for there is apparently some sort of obscuring material in them. This is especially marked in the large, elongated spot B 45… which is a fragment of another lane running east from Rho Ophiuchi."

Near the right-hand edge of the image, just below the main stream of B 44, is the small (13′) but distinct nebula B 238, oriented north-south, with an 8th-magnitude star immediately below its northern tip.

The small bright spot at the left lower edge and directly below σ Sco is the lovely globular cluster NGC 6093 (Messier 80, Bennett 73).

E
N
30'

Cederblad 132, vdB 107, LBN 1107
Bright nebula in Scorpius, 16^h 29^min, −26.4°, Size 100′ × 80′

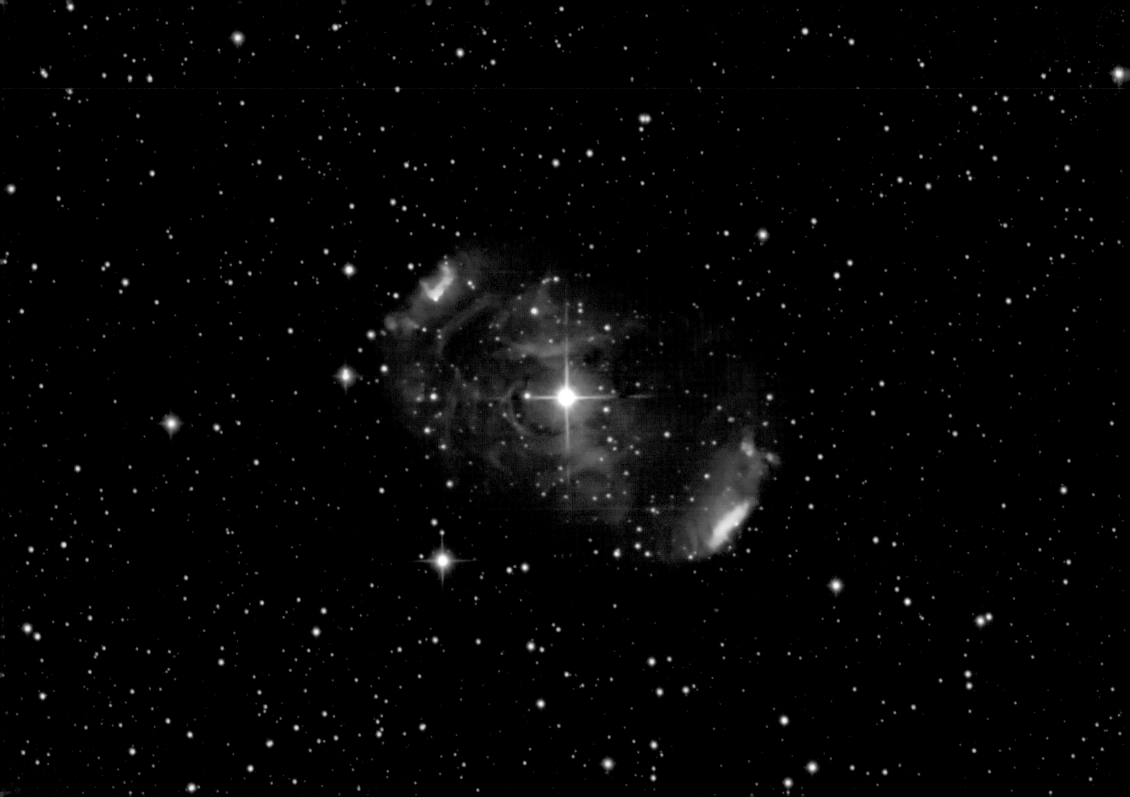

THE TIE FIGHTER NEBULA

The Milky Way between Scorpius and the Pointers (α and β Cen), glowing brightly with the combined light of distant suns, is remarkably poor in bright naked-eye stars. Most of this region of sky was assigned to Norma—the set square and ruler—by Lacaille, one of 14 constellations he created. Its brightest star is 4.0 mag. γ^2 Nor—like Puppis and Vela, Norma has no alpha and beta stars. Epsilon Normae (4.5 mag) lies 3° to the north-northeast, and a little over 1° east-southeast, near the border with Ara, lies 6.8-mag. HD 148937, an ordinary-looking blue-white star.

On July 1, 1834, John Herschel turned his telescope on the star and noted it was double, with a very faint companion (13.2 magnitude) due north (see accompanying photograph). He also recorded two nebulae near it. The brighter one (NGC 6165) he saw as a small elongated nebula east of the pair, while the western nebula (NGC 6164) was only "violently suspected." Almost a century later, R. T. A. Innes at the Union Observatory (Johannesburg, South Africa) noted another companion star, slightly brighter at 12.6 magnitude, three arcseconds due west.

A modest-sized telescope reveals the two nebulous components as short, faint, arcs flanking the bright central star to the northwest and southeast, creating the impression of a TIE fighter (of *Star Wars* fame) cruising through deep space. NGC 6165 is the brighter, southeastern component, as the accompanying photograph clearly shows. Careful study under good sky conditions will reveal dim nebulosity immediately around the central star, tenuously linking the lobes together in a Z-shape. A larger telescope may reveal the outlying bubble, which is brightest 9′ northeast of the central star.

The presence of the bright central star makes observing the nebulosity of this "southern gourmet object" a challenge, as Australian deep-sky observer Gerd Bahr-Vollrath notes: "Clean optics and an extremely transparent night were necessary to see anything at all."

NGC 6164–5 was provisionally catalogued as a planetary nebula by Karl Henize (in 1967) based on its morphology. He called it "an object of unusual interest... [t]he shape of the nebula is roughly that of a figure '8' with small knots in the nebulosity showing central symmetry."

Follow-up spectroscopic observations showed that the star exhibited marked signs of mass ejection, and that the radial velocities of the two nebulae suggested they had been symmetrically ejected from the star.

Modern spectroscopic studies of HD 148937 have revealed it to be a very rare specimen—a hot luminous O-type star with a mass about 40 times that of the sun, having a variable spectrum. Only four other stars of its type are known in our galaxy.

Some 3.5 million years old, HD 148937 has passed the half-way mark in its life span and is likely to self-destruct as a supernova. Several thousand years ago it underwent a giant eruption, ejecting the gas that created the bipolar lobes that Herschel recorded. A larger bubble, about 24′ across, surrounds this inner double-nebula and was first detected in 1960. This bubble is thought to have been formed during an earlier active phase of the star's life as its stellar wind carried gas away from the star.

Instead of being the dying breath of a dwarf star, NGC 6164–5 is an energetic young nebula surrounding a youthful massive star. It lies some 4,200 light-years away and spans about 4 light-years.

N
E
1′

NGC 6164, NGC 6165, Cederblad 135, Gum 52, RCW 107

Bright nebula in Norma, 16h 33.9min, −48° 7′, Size 6′ × 4′

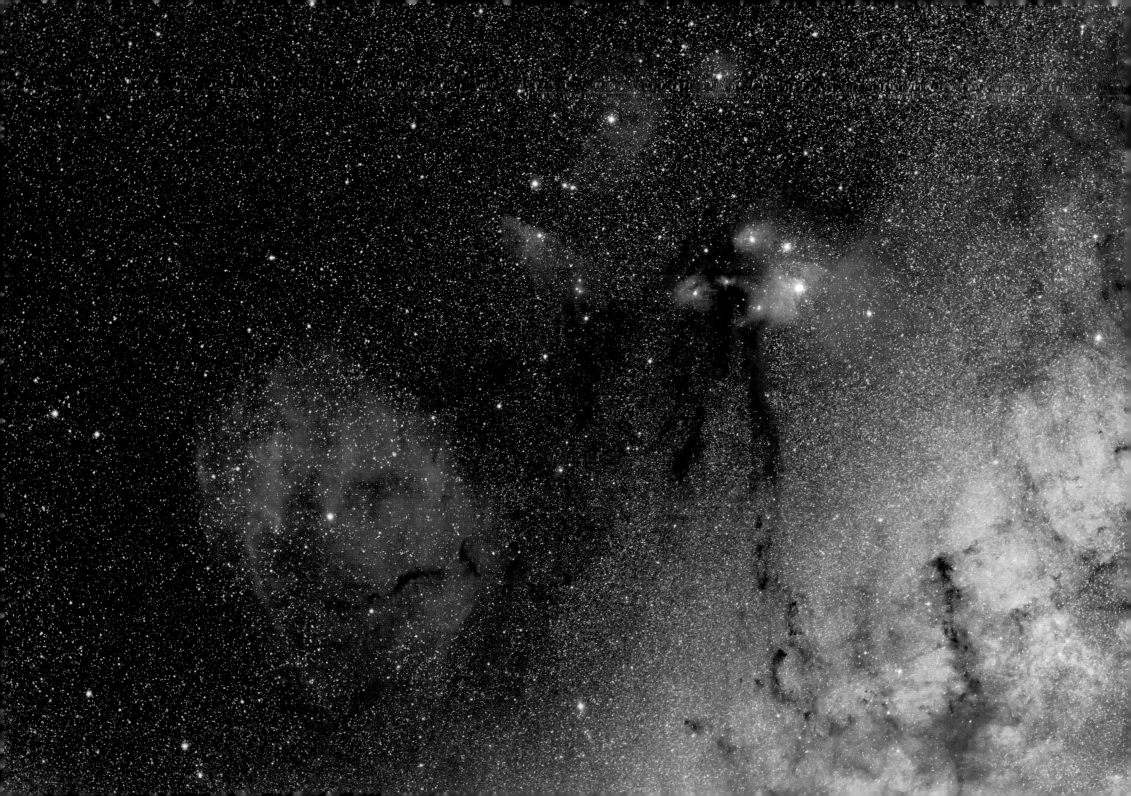

THE KOBOLD

Identification chart
p. 169

The sky between western Scorpius and the broad path of the Milky Way is a true spectacle, as the accompanying photograph shows. The 33° × 24° view is centered on the left foot of Ophiuchus the Snake Bearer.

At the top of the image, visible as a large red elongated nebula with a bright central star (δ Sco), is Cederblad 125e. To its upper right, surrounding π Sco, is the smaller Ced 125d. The blue wisp below and to the left of Ced 125e is IC 4592, the Blue Horse Head Nebula, with ν Sco as its eye. Farther to the right of IC 4592, and slightly down, is another blue cloud, IC 4604, the famous Rho Ophiuchi Nebula (see p. 103). The bright, red nebula to its upper-right is Ced 130 around σ Sco. Immediately to its right is a bright spot, the globular cluster Messier 4 (p. 101). Below and slightly to the right is Antares, α Sco, visible as a bright pale-yellow blob. The yellowish nebulosity around it and to the bottom-left is Ced 132, the Antares Nebula (p. 105). The large diffuse red nebula to the right, surrounding τ Sco, is RCW 129. Below the Rho Ophiuchi Nebula, extending downwards, are two long streams of dark nebulosity. The left, less distinct one, is Barnard 45, while the broader lane to the right is Barnard 44.

The bottom-left part of the image is dominated by a massive red nebula, more or less centered on ζ Oph, which marks the left knee of Flamsteed's Ophiuchus. Catalogued as LBN 24 and Sharpless 2–27, the nebula is more typically referred to as the Zeta Ophiuchi cloud.

Noting the prominent 3.5° dark nebula below ζ Oph, as well as two less distinct dark patches left and right of the star, prompted one of us [DW] to nickname it the "Kobold," as it bears a striking resemblance to the imaginary face of the seldom-seen monster of Germanic myth.

Zeta Ophiuchi is a blue-white main sequence star located some 360 light years from Earth. It had a violent past and is now in exile—it is an isolated runaway star ejected from its place of birth, the Scorpio-Centaurus OB association. Calculations suggest that it was once part of a binary star system, paired to a much more massive star that eventually went supernova. The tremendous explosion flung ζ Oph away into space, and it is still hurtling along at 95,000 km/h, headed approximately north-northeast on the sky, more or less away from Antares. The stellar wind from this rapidly moving star has interacted with the interstellar medium, creating a bow shock—Spitzer Space Telescope images have revealed the shock about 5′ (or half a light-year) ahead of it. On its incredible journey, ζ Oph has encountered a diffuse interstellar cloud, and its intense UV radiation is causing the cloud to glow. Instead of remaining invisible, the hidden Kobold is now revealed. It is the nearest example of an H II region around a runaway star.

The dark nebulae making up the Kobold's eyes and mouth are part of the Ophiuchus North cloud complex; a vast region of 23 known molecular gas clouds with a total mass of about 4,000 solar masses, illuminated by stars from the Sco-Cen OB association. The clouds are distributed between 260 and 550 light-years from the Earth. Within these clouds about a dozen dense cores have been identified, which are potential stellar birth sites due to their being young stellar objects (YSOs) about half a light-year across containing some 10 solar masses of matter.

The mouth and eyes of the Kobold are seen projected on the H II region, between us and ζ Oph. The mouth is a 560 solar mass cloud consisting of LDN 190, 191, 204, 234, 244, 255 and 260 (the latter containing a YSO). The left eye is the dark nebula Khavtassi 647. The right eye, weighing in at a few hundred solar masses, consists of LDN 145 and LDN 156.

N
E
2°

LBN 24, Sh 2-27
Bright nebula in Ophiuchus, 16h 36min, −12.7°, Size 11.9° × 8.6°

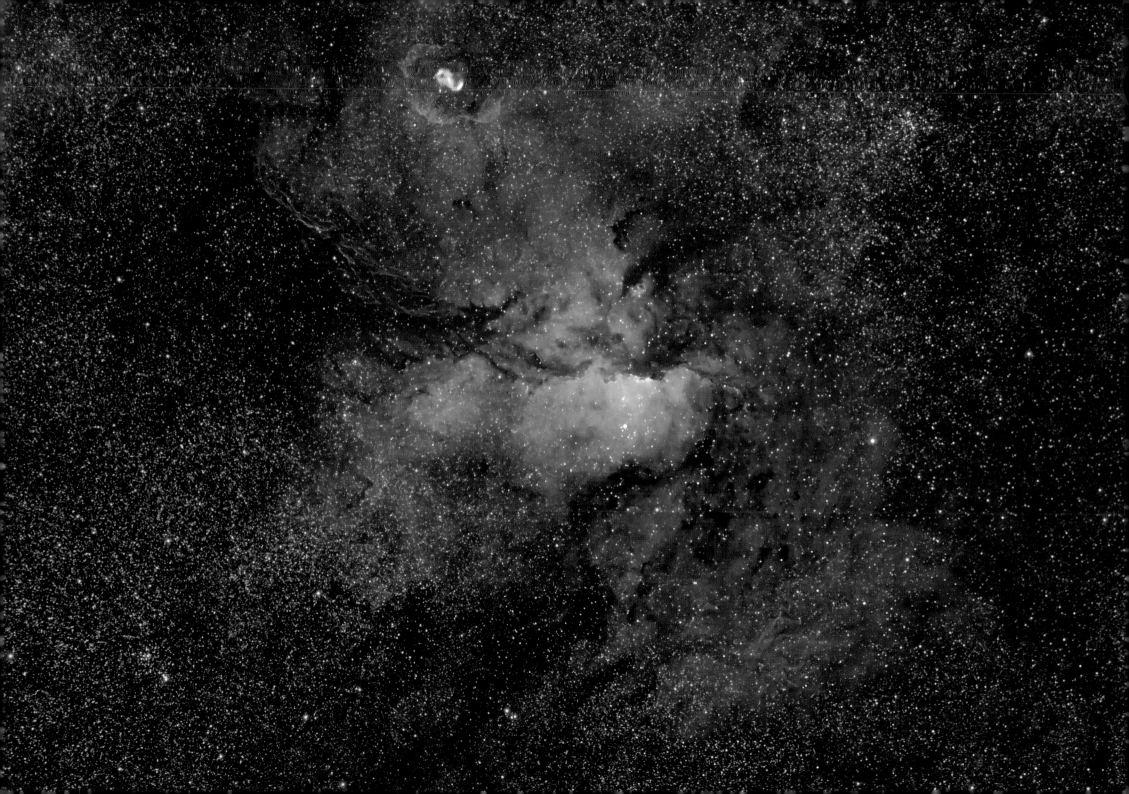

THE FIRE BIRD NEBULA

Not far from the TIE Fighter Nebula (NGC 6164/6165, visible at the top of the photograph opposite) within the star-rich stream of the Milky Way between Scorpius, Ara and Norma lies the glorious Fire Bird Nebula (NGC 6188, RCW 108) with its associated open cluster NGC 6193.

The bright star near the center of the photograph opposite is HD 150136 (5.7 mag.), which marks the location of NGC 6193—a rather unexciting open cluster that can, nevertheless, be seen with the naked eye as a bright spot along the Milky Way. It was discovered by James Dunlop who noted that "a very considerable branch or tail proceeds from the north side, which joins a very large cluster." This cluster is NGC 6200, visible at bottom-left in the photograph—did Dunlop perhaps see the nebulous arc pictured?

John Herschel at the Cape recorded NGC 6193 as a scattered cluster of about a dozen stars with stragglers, noting that "in its preceding part is a fine double star... and yet more preceding is a very large, faint nebula, in which the preceding part of the cluster is involved."

Nearby NGC 6200 was described by Herschel as "a great space full of milky way stars, so thickly sown as to merit being called a cluster."

This region of sky is richly detailed with faint glowing clouds and dark patches, testing the limits of the observer's skill and the observing conditions. Australian deep-sky guru E. J. Hartung, for example, mentions only that "there is some faint nebulosity involved."

The Fire Bird nickname, a creation by one of the authors [DW], is flying toward the right in the image opposite. HD 150136 is its rapidly beating heart, and its wings are raised, caught in mid-flap. The fainter fiery-red nebulosity near the bottom of the frame is the flames through which it is flying, and the dark nebulosity trailing off to the bottom left is the burnt-out charcoal remains of the fire.

NGC 6193 is a very young cluster (1–2 million years) that lies at the center of the Ara OB1a association. Other members include the intermediate-age (20–30 million years) cluster NGC 6167 (visible at top-right) and NGC 6204 (½° northeast of NGC 6200). Radiation from the hot stars within NGC 6193 is eroding the edge of a molecular cloud, causing it to glow, producing NGC 6188. It is probable that star formation within the molecular cloud has been triggered by this influx of radiation. The complex lies about 4,000 light-years away in the Sagittarius arm of the galaxy.

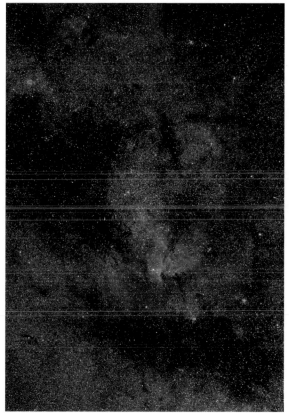

Wide-field view (centered on R.A. 16ʰ43.7ᵐⁱⁿ, Dec. -47° 20') showing southern Scorpius (below center), northern Ara (top), and eastern Norma (left).

NGC 6188, RCW 108
Bright nebula in Ara, 16ʰ 40.1ᵐⁱⁿ, −48° 40', Size 150' × 150'

THE FALSE COMET CLUSTER

One of the first constellations a novice southern sky observer learns, after Crux and Orion probably, is the recognizable Scorpion. A sharp bend in its gracefully curved outline, at ζ Sco, marks the position of the glorious cluster NGC 6231.

With the naked eye, NGC 6231 appears as a hazy patch just north of a triangle of stars. Binoculars show it as a conspicuous knot of bright white stars, some 10′ across, standing out clearly from the rich background field.

A telescope reveals eight or so brilliant stars arranged in a east-west grouping that measures 10′ × 5′. About double that number of fainter stars are scattered amongst these, with about 100 even fainter ones fleshing out the cluster. Strewn to the south and east is a large field of faint stars.

In his classic *Burnham's Celestial Handbook*, American astronomer Robert Burnham Jr calls it a "handful of glittering diamonds displayed on black velvet," and likens it to "a miniature edition of the Pleiades, with a central knot of 7 or 8 bright stars."

A mere ½° due south lies a triangle of prominent yellow-tinted stars made up of ζ 1 Sco, ζ 2 Sco, and HD 152293. This grouping, suggests American observer Tom Lorenzin, is the Baby Scorpion,

clinging to the back of its mother's tail.

This glorious naked-eye star cluster was known as far back as Ptolemaic times, although not noticed as nebulous. The first telescopic view of NGC 6231 was enjoyed by the 17th-century theologian and pioneer deep-sky observer Giovan Battista Hodierna, around the year 1646. Some 30 years later, a youthful Edmond Halley traveled to the island of Saint Helena (latitude 16° South) to compile a star catalogue, and in the course of his work noted its nebulous presence.

Lacaille's ½-inch (1 cm) telescope showed him a "close group of seven or eight close faint stars," while James Dunlop's substantially larger 9-inch (23 cm) telescope showed a cluster "considerably congregated to the center, about 10′ in diameter, with a large branch of very small stars extended on the north side."

John Herschel recorded it as a "fine, bright, large cluster, pretty rich," with a 10′ major axis.

Located some 6,000 light-years from Earth, NGC 6231 is one of the youngest open clusters in the galaxy. It is rich in massive young stars: its bright O-type stars formed less than four million years ago in a burst of star formation, which may have been triggered by the merging of low-mass

objects to create high-mass stars. It also contains a population of less massive stars some 10 million years old.

NGC 6231 is the "nuclear cluster" of the rich Scorpius OB 1 association, an extended system of massive young stars (O and early B-type stars), with associated ionized nebulosity (the Prawn Nebula and Gum 55; see overleaf).

It has garnered several nicknames, including the Northern Jewel Box, and the False Comet Cluster.

Michael E. Bakich, a senior editor for *Astronomy* magazine, has suggested that the "False Comet" moniker is to be attributed to John Herschel. Bakich notes that the triangle of ζ 1 Sco, ζ 2 Sco, and HD 152293, along with NGC 6231 and a spray of Milky Way stars extending some 1° north-northeast, together resemble (to the naked eye) a comet. He suggests that the "False" does not imply "fake," but rather the term was used by Herschel to commemorate his temporary home in Cape Town—which lies on the shores of False Bay. Furthermore, Bakich notes: "Indeed, we also now call the slightly larger region around the False Comet the Table of Scorpius for the same reason. Herschel's observatory looked out toward Table Mountain, above which the Scorpion often perched."

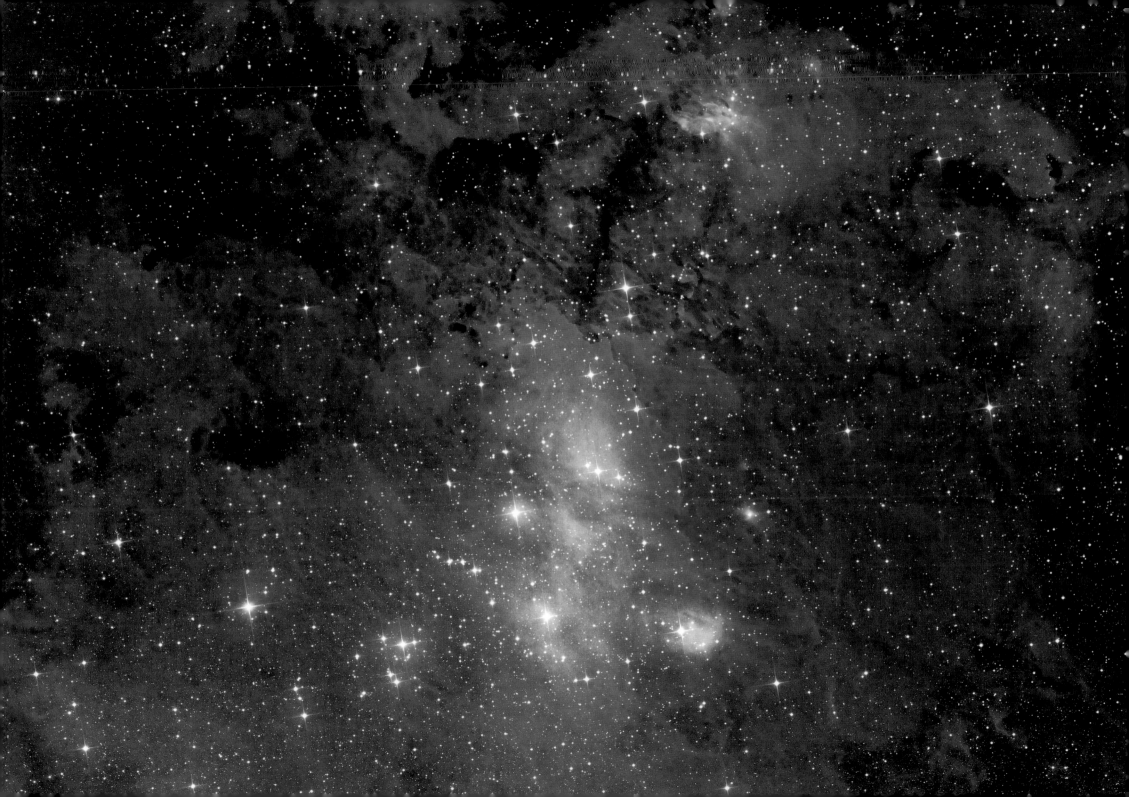

THE PRAWN NEBULA

Just over 1° north of the gorgeous open cluster NGC 6231, approximately mid-way between the lovely pairs μ¹⁺² Sco and ζ¹⁺² Sco, lies IC 4628. Nicknamed the Prawn Nebula, it is a member of the Scorpius OB 1 association, whose young energetic stars cause the Prawn to glow.

IC 4628 was discovered photographically by American astrophotography pioneer E. E. Barnard. It was found independently by R. H. Frost in June 1903 on a photograph, exposed for four hours, with the 24-inch (60 cm) Bruce photographic refractor at Arequipa, Peru. It must have been such an unusual sight that a second photograph was taken specifically to confirm its existence. It was photographed in 1909 at the Transvaal Observatory (Johannesburg, South Africa) and also at Helwan Observatory (Egypt) in 1924, and it was described as a "typical galactic nebula" measuring 30′ × 15′.

Trumpler 24, an extremely large and scattered cluster, lies in the northern part of the association. Barnard noted it on a photograph taken in June 1905, calling it a mass of small stars about 50′ in diameter. He also noted a dark gap in its north side.

In the image on the right, the prominent dark nebula immediately east-southeast of the Prawn is B 48, described by Barnard as "fairly well defined; 40′ long." The small dark nebula just over 2° due west is B 44a, noted as being "irregular; diameter 5′; sharpest on SE side… [a]pparently a real, dark object." Barnard added that it was "remarkable for its smallness and distinctness."

The Prawn is a very young H II region and is the brightest nebulosity in the Scorpius OB1 Association. This association is an extended complex of massive young stars (O and early B-type stars) and glowing gas, some eight million years old and measuring 200 light-years across. On the sky, it spans some 2° north-south, stretching from the Prawn Nebula (IC 4628) in the north to Gum 55 in the south, well-shown in the image to the right.

Compared with other OB associations, Scorpius OB1 is remarkably free of gas and dust despite its young age. Gum 55 to the south is relatively faint, and its intricate shape is best seen in the light of hydrogen-alpha. Colin S. Gum described No. 55 in his 1955 catalogue as a "large roughly semicircular loop, whose ragged appearance is due in part to overlying obscuration." The later H II survey by Rodgers, Campbell and Whiteoak catalogued it as RCW 113, a "large loop of ionization in a region of fainter emission."

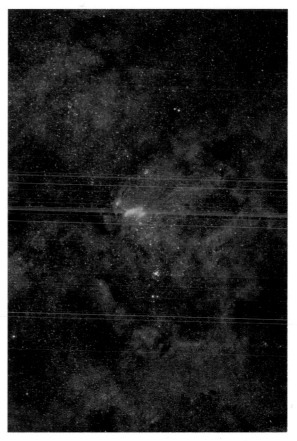

2°

N

E

The Prawn Nebula is the bright cloud in the center of the image. Below it is the compact NGC 6231. The large U-shaped nebula below is Gum 55. RCW 119 is at top-left.

E

N

4′

IC 4628, Cederblad 137b, Gum 56

Bright nebula in Scorpius, 16ʰ 56.9ᵐⁱⁿ, −40° 30′, Size 90′ × 60′

BARNARD'S PECULIAR BLACK SPOT

The graceful curve of the Scorpion is a very recognizable pattern in the mid-southern sky, appearing like a provocative backward question mark. The pale-orange ε Sco (2.3 mag.) is the second star from Antares along the curve of the question mark; and just 2.5° due east, in the direction of the Stinger (Shaula, λ Sco), lies the wonderful dark nebula Barnard 50.

In binoculars, B 50 is easily seen as an elongated black spot, 8′ × 4′, attractively set against a rich star field. It appears to be connected to Barnard 53-1° northeast—by subtle, less-distinct, dark markings.

Barnard's first systematic astronomical observations were of comets, using a 5-inch (13 cm) refractor; he would eventually discover 16 comets in his career. Having gained experienced by working in a photographic studio as a boy, Barnard began photographing comets and the Milky Way soon after he joined Lick Observatory (California, USA) in 1888 as one of its original staff members. He used a relatively fast 6-inch (15 cm) doublet, the Willard portrait lens, to image large portions of the Milky Way. These images showed "wild and mysterious dark markings," which he concluded were starless regions of the sky, the orthodox view favored by, amongst others, William and John Herschel.

Some of his photographs were published in the illustrated scientific magazine *Knowledge* by the English astronomer Arthur Ranyard, bringing Barnard's work to a new, wider audience. Ranyard disagreed with Barnard, arguing that the dark markings were actually physical objects. He wrote: "The dark vacant areas or channels... seem to me to be undoubtedly dark structures, or absorbing masses in space." The matter would not be settled for years to come, and not before Ranyard's death from cancer in 1894.

In 1895 Barnard joined the staff at Yerkes Observatory (Wisconsin, USA), and obtained funding for a 10-inch (25 cm) lens, which was built into the Bruce photographic telescope that was installed in a tin dome on the observatory grounds in 1904. The telescope was moved the following year to Mount Wilson Observatory (California, USA), giving Barnard better access to the southern Milky Way. In just eight months he took 500 photographs, which formed the basis for his masterpiece *A Photographic Atlas of Selected Regions of the Milky Way*. The quality of the images obtained with the Bruce telescope was such that they helped persuade him that the dark markings were, indeed, clouds of obscuring matter and not mere starless regions of space.

The final epiphany came to Barnard on a partly cloudy evening, gazing up at the Milky Way. In a 1916 article in the *Astrophysical Journal*, he wrote: "One beautiful, transparent, moonless night in the summer of 1913, while I was photographing the southern Milky Way with the Bruce telescope... I was struck with the presence of a group of tiny cumulous clouds scattered over the rich star clouds of Sagittarius. They were remarkable for their smallness and definite outlines—some not being larger than the moon. Against the bright background they appeared as conspicuous and black as drops of ink. They were in every way like the black spots shown on photographs of the Milky Way, some of which I was at that moment photographing... One could not resist the impression that many of the black spots in the Milky Way are due to a cause similar to that of the small, black clouds mentioned above—that is, to more or less opaque masses between us and the Milky Way."

The matter was finally settled, and the late Arthur Ranyard's opinion was vindicated.

E ⟍ N ⊦———⊣ 3'

Barnard 50, Sandqvist 30, DCld 350.4+04.4

Dark nebula in Scorpius, 17h 3min, −34.4°, Size 14′

THE GREAT DARK HORSE

Identification chart
p. 169

The Great Dark Horse rides high overhead on spring evenings, standing with its back toward the stream of the Milky Way and looking toward Ophiuchus. This whole region of sky is noticeably lacking in bright blue stars—the view here is toward the center of our galaxy, and the compound effect of all the gas and dust clouds in the line of sight is to redden, or totally extinguish, a great deal of starlight.

The sky's most famous dark horse, the Horse Head Nebula in Orion, is a single dark nebula—Barnard 33—roughly 4′ across. The galactic Dark Horse, on the other hand, is composed of a host of Barnard nebulae arrayed over a 6° × 7° area.

The Great Dark Horse is seen in profile and in the accompanying photograph is shown looking to the right. It is oriented upside down in the Milky Way panorama on p. 10. Individual Barnard nebulae in this complex figure are identified on p. 169.

The most prominent part of the Horse is probably better known as the Pipe Nebula. The bowl of the Pipe is B 78, and its stem is a 5° long, thin, fragmented lane consisting of B 59, B 65, B 66 and B 67 (west to east). The Pipe makes up the rump and hind legs of the Dark Horse, seen in the left half of the accompanying image running more or less vertically. The tail of the Horse starts as a southern extension of B 78, trailing westward to B 256. B 269 is the horse's back, while B 79 and B 270 make up the slanted forehead leading down to the nostrils at B 259. B 276 are the Horse's pointy ears.

Below the belly of the Dark Horse sparkles 3rd magnitude θ Oph, the brightest star in the accompanying photograph. One and a half degrees north-northeast lies the charming Snake Nebula, B 72. Barnard rightly called it "a striking object. It is a thin, curved black marking, the exact form of the letter S or the figure 5, as the imagination or point of view may dictate… Its average thickness is about 2′ to 3′." For a more southerly comparison, see the Black Python (p. 79).

In the neck of the horse (between B 269 and B 268) is the spot where, in October 1604, Kepler's Star appeared. This supernova exploded some 20,000 light-years away from Earth and was visible during the day for almost a month.

The raised hoof of the Dark Horse's front leg is B 63, described as "large, definite, curved figure, convex to the north; the western end abrupt."

The Pipe Nebula is a nearby massive molecular cloud located at the edge of the Sco OB2 association and is seen in projection toward the galactic bulge.

It lies only about 10° from the Ophiuchus cloud complex but in space is roughly 30 light-years farther away from us. Both clouds are similar in size (about 50 light-years across) and contain roughly the same amount of matter (about 10,000 solar masses). However, the Ophiuchus cloud is undergoing intense star formation, while the Pipe Nebula is surprisingly quiescent. In fact, within the whole complex, there is only one active star-formation region, B 59, within which a small cluster of about 20 low-mass stars have recently formed.

The closest massive star to the Pipe Nebula is θ Oph, a B2-type star located about 10 light-years away from it. It is possible that future star formation in the Pipe Nebula could be triggered by the destruction of θ Oph in a supernova explosion. In this scenario, a few thousand years after the explosion, the Pipe is hit by a blast wave that disintegrates the smaller molecular cores. However in the bigger cores (two of 10 solar masses and one of about 20 solar masses are known) the shock triggers collapse and within another few thousand years, new stars are born.

The nickname "Great Dark Horse" was coined in the 1970s by image-processing guru Richard Berry in the pages of *Astronomy* magazine.

E
N 30′

B 59, 65, 66, 67, 78, 77, 72, 75, 63

Dark nebulae in Ophiuchus, 17.3h, −20°, Size 7° × 7°

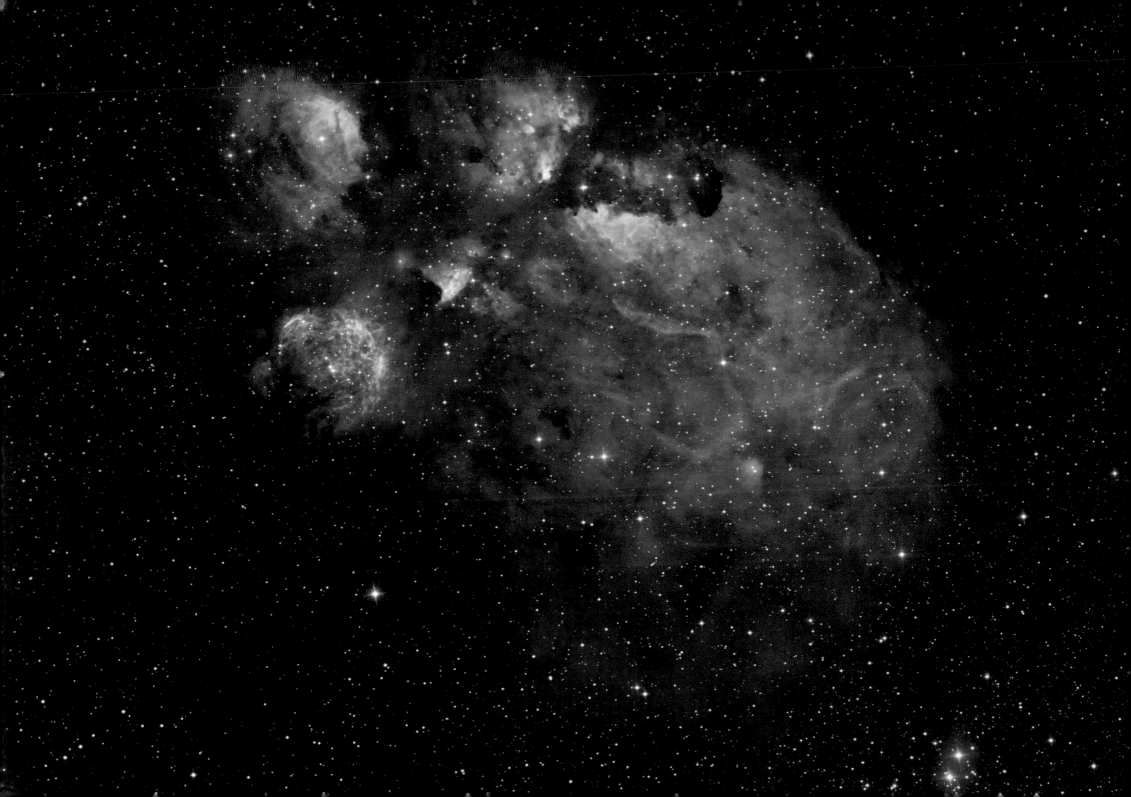

THE CAT'S PAW NEBULA

Looking from Crux toward the Pointers, the richly detailed dark stream of the Milky Way rushes through Norma and Ara, and just before hitting the brilliant stars of the Scorpion's tail, it splits in two. One dark stream cascades westward toward Antares, the other trends eastward, cutting a lane through the Scorpion's tail and plunging on toward Sagittarius. In the tip of the tail lies the stinger, Shaula (λ Sco) and Lesath (υ Sco), poised on the edge of the dark river. About 3° away, in the direction of Antares, is a noticeable dark patch, within which lies two fascinating emission nebulae: the Cat's Paw Nebula and the War and Peace Nebula (NGC 6357).

NGC 6334—which is only the southeastern "toe" of the Cat's Paw and its most prominent visual component—was discovered in 1837 by John Herschel. He recorded a 5′ × 4′ nebula that was "pretty bright, very large, very irregular oval, in which, though excentric, is a star... the densest part of the nebula follows this star...". The star is 9.4-mag. HD 156738.

The rest of this complex area was discovered photographically, with a 1921 account by Milton Humason (Mount Wilson Observatory) being one of the earliest, noting "a remarkable group of gaseous nebulae near [NGC 6334]."

In the 1954 *Catalogue of H(II) Regions in the Milky Way* the authors describe "five small bright condensations of which the south following side is NGC 6334. On the north following side is a somewhat fainter large patch of nebulosity."

The Cat's Paw is a giant complex of molecular clouds and H II regions some 50 light-years across. It has been an active site of star formation for several million years and contains at least ten rich embedded clusters of massive OB stars. These energetic stars are revealed in the infrared and at radio wavelengths, and they appear to be spaced about three light-years apart. They are aligned along a molecular ridge, oriented northeast to southwest and extending for 20′ × 3′, which bisects the optical nebula.

The NGC 6334 complex lies some 5,500 light-years away, at the same distance as the NGC 6357 complex, suggesting that these two star-forming regions are physically related.

The nickname "Cat's Paw" was coined by author and photographer Jerry Lodriguss (Philadelphia, USA) and appeared in print in *Sky & Telescope* in August, 1998.

Two related star-forming regions in Scorpius, the Cat's Paw Nebula to the right, and the War and Peace Nebula near the top. The bright star at lower left is Lesath (u Sco).

1°

N

E

NGC 6334, Cederblad 140, Gum 61–64, RCW 127, Sh 2-8
Bright nebula in Scorpius, 17h 20.8min, −36° 6′, Size 35′ × 20′

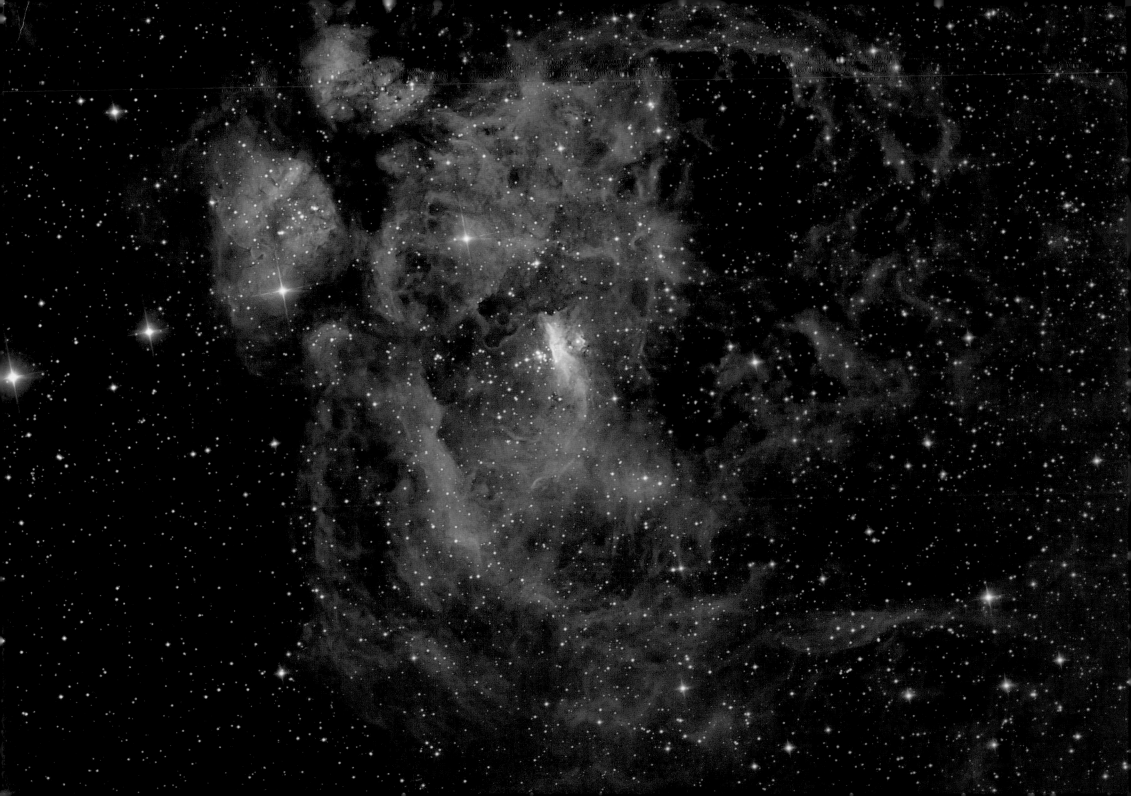

THE WAR AND PEACE NEBULA

Two degrees northeast of the Cat's Paw Nebula lies the remarkable War and Peace Nebula (see the wide-field view on the previous page). These two nebulae lie in a dark stream between two bright ridges of the Milky Way, with the Scorpion's tail curved as if to strike them.

A telescope reveals little more than a faint elongated glow, oriented east-west, with a small patch of faint stars to the south.

NGC 6357 was discovered in June 1837 by John Herschel, who described it as a 2′ long milky nebula, very close to a double star.

Robert Innes at the Union Observatory, Johannesburg, described it in 1916 as a small crescent shaped nebula, partly around an 11th-magnitude star, based on its appearance on photographs made with the 10-inch (25 cm) Franklin-Adams Star Camera.

The first indication of NGC 6357's more extensive nature was revealed five years later when the area was imaged with the 30-inch (76 cm) Reynolds reflector at Helwan Observatory, Egypt. Christopher Gregory, the Chief Assistant at the Observatory, described it as a faint, 4′ long, irregular nebula, looped around two faint stars at the western end. "There are indications of fainter outlying nebulosity," he wrote, "and possibly absorption to the south."

At more or less the same time that the Helwan astronomers were photographing the sky, E. E. Barnard was cataloguing dark nebulae from Lick Observatory in California, USA. The "absorption to the south" that Gregory mentioned is now known as Barnard 258, an "irregular area of dark markings" with a diameter of about 40′.

In 1938, in a review of the photographic work done at Mount Wilson Observatory (California, USA), the director Walter S. Adams commented on Walter Baade's program of red-filtered photography, noting: "For example, NGC 6357, of which only one or two small wisps appear on ordinary photographs, is found on the red plates to be an outstanding object rivaling in size the Orion Nebula and Messier 8."

The accompanying photograph reveals the hidden beauty of this region. The brightest streak of nebulosity in the center of the image is essentially the visual extent of the nebula (although suitable filters dramatically improve the view). Immediately to the left of this streak is the small sparse cluster Pismis 24, catalogued in 1959 by the Turkish-born astronomer Paris Pismis, who has the distinction of being the first formally trained astronomer in Mexico, and one of the first women in Turkey to attend Istanbul University.

The one-million-year-old Pismis 24 contains two very massive O-type stars, one of which is a binary star, with each component weighing in at over 100 solar masses. Most of this cluster's stars reside within a three light-year zone, with the remainder spreading out to a radius of about 15 light-years.

The surrounding nebulosity, more than filling the frame, is ionized by the massive stars of Pismis 24, creating a large (100 × 65 light-years) active star-forming region.

At the top-left of the image are four prominent stars (about 7th magnitude) in a row. Veteran deep-sky observer Steve Gottlieb notes that these are nicknamed "Las Cuatro Juanitas" in Chile, which may be loosely translated as "The Four Stunningly Attractive Ladies." Directly above the third Juanita, within a cloud of nebulosity, is the star cluster AH03 J1725.5–3424, which was first formally announced as such by Brent Archinal and Steven J. Hynes in their 2003 publication *Star Clusters*.

NGC 6357 and its star clusters lie some 5,500 light-years from Earth, in the Sagittarius arm of our Milky Way.

E
N
3′

NGC 6357, Cederblad 142, Gum 66, RCW 131, Sh 2-11
Bright nebula in Scorpius, 17h 24.3min, −34° 20′, Size 25′

123

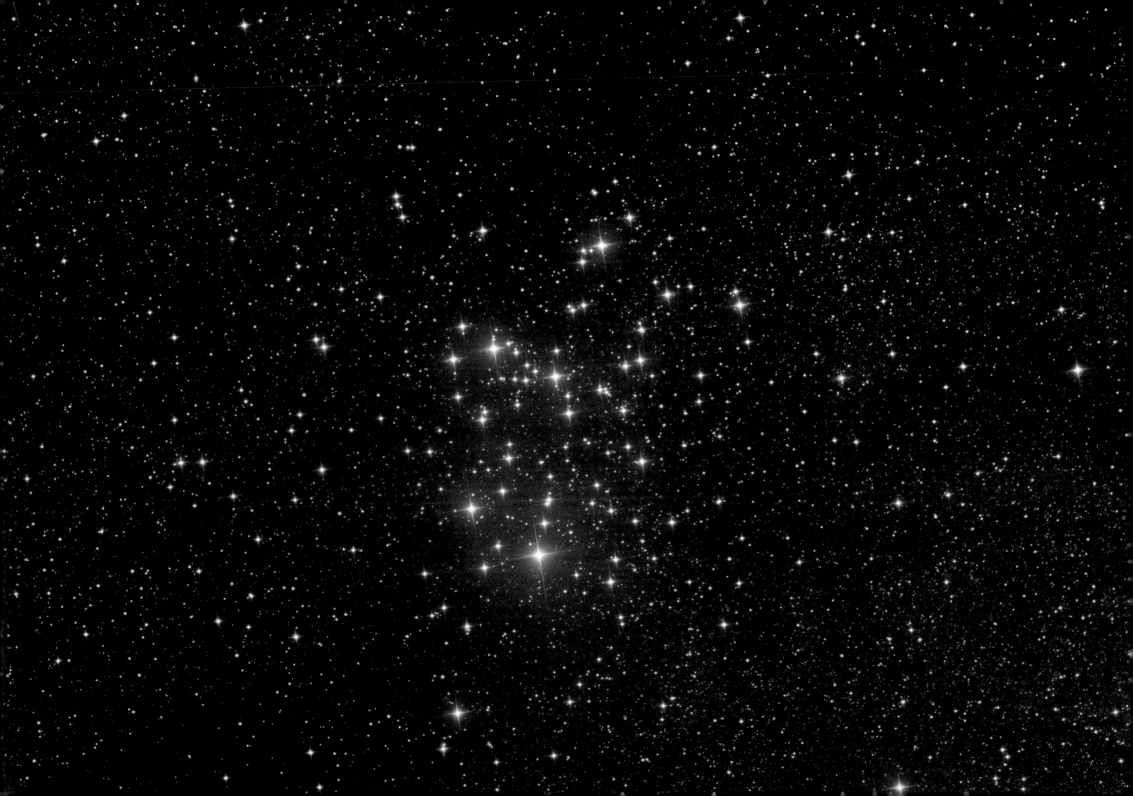

THE BUTTERFLY CLUSTER

Messier 6, along with Messier 7, can be seen with the naked eye as two small fuzzy patches inside the main stream of the Milky Way, midway between the Scorpion's tail and γ Sgr.

Both clusters have been noted since ancient times. The pair are mentioned by the Timurid sultan Ulugh Beg in his "Zij-i Sultani" as "the cloudy ones which follow the sting of the Scorpion." He observed them from his famous astronomical observatory built in 1420 on a rocky hill outside the city of Samarqand, Uzbekistan. Not only was he a skilled observer, but he was apparently able to perform complicated calculations, such as deriving the sun's longitude, while riding on horseback.

The 17th-century Sicilian astronomer Giovan Battista Hodierna gave the first telescopic account of the cluster, counting 18 stars within it. He noted it was "the second and smallest of the two in the Scorpion's stingers, westwards." Hodierna was the first telescopic observer to attempt to compile a list of nebulae, and his 1654 publication listed over 40 nebulous objects.

Lacaille recorded the cluster in 1752 as a remarkable group of faint stars in parallel lines, forming a diamond about 20′ across, filled with nebulosity.

Binocular users are in for a treat when observing Messier 7. Even a small finderscope shows it as a bright band of stars. Six bright stars forming two joined parallelograms make a V-shaped wire-frame box, with a single bright orange star (BM Scorpii) perched on the eastern tip.

The "Butterfly" nickname can probably be attributed to Robert Burnham Jr, American astronomer and author of the classic 1978 work *Burnham's Celestial Handbook*. He called the cluster "a completely charming group whose arrangement suggests the outline of a butterfly with open wings."

The Butterfly lies just 1,600 light-years away in the direction of the Sagittarius arm and is about 90 million years old.

A number of other celestial butterflies are found spreading their wings in the heavens. There is the Southern Butterfly (the globular cluster NGC 4833 in Musca, page 79), the Butterfly Nebula (an alternate name for the Toby Jug Nebula, IC 2220 in Carina, page 41), another Butterfly Nebula (the planetary nebula NGC 650/NGC 651 in Perseus), the Butterfly Cluster (the open cluster NGC 2447 in Puppis) and Minkowski's Butterfly (the planetary nebula M 2–9 in Ophiuchus).

A wide-field view, measuring 4.4°×2.8°, shows Messier 6 at top-right and Messier 7 at bottom-left. The dark nebula near the center, above Messier 7, is Barnard 283.

1°

N
E

N
E 3′

Messier 6, NGC 6405, Lacaille III.12
Open cluster in Scorpius, 17h 40.3min, −32° 12′, Size 20′

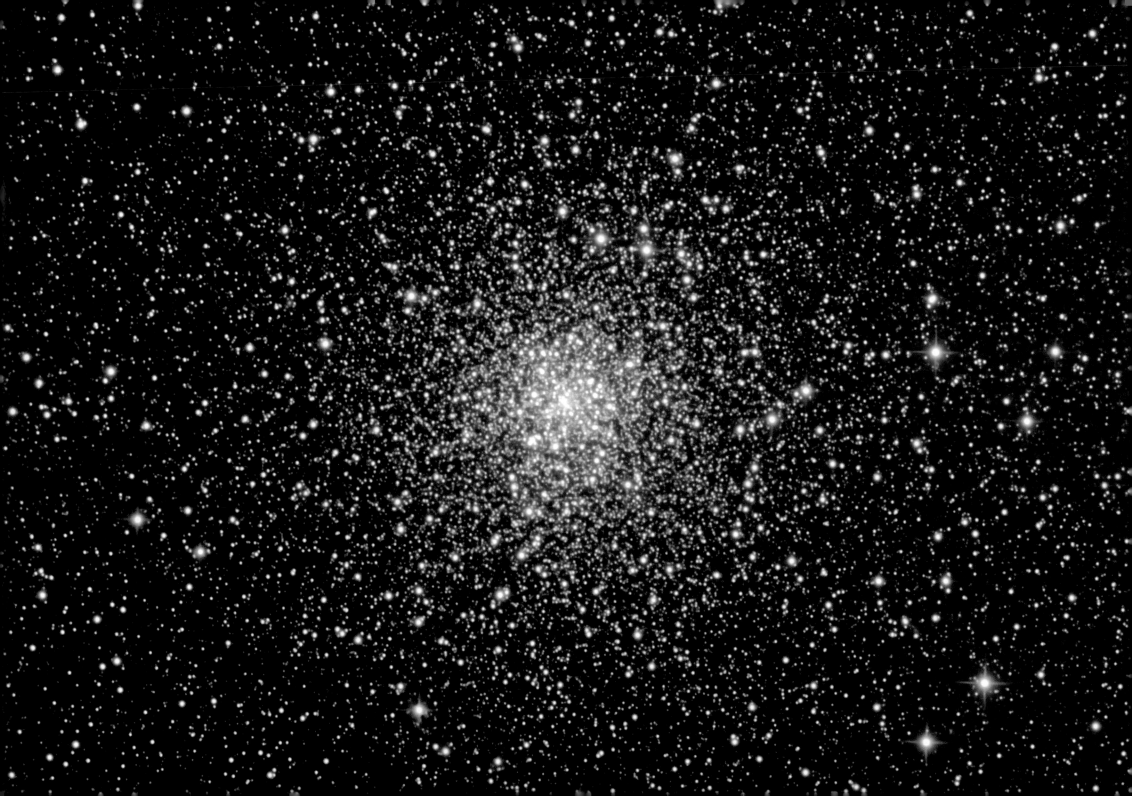

THE GOLDEN NECTAR CLUSTER

The beautiful globular cluster NGC 6397 lies just outside the eastern edge of the Milky Way in Ara, below the base of the altar. If Ara is imagined as a butterfly— flying eastward, with beta and gamma its eyes, and alpha and delta the leading tips of its flapping wings—then NGC 6397 is the tantalizing drop of nectar it is about to enjoy.

It is readily visible with the naked eye as a fuzzy 5th-magnitude glow and is very easy in binoculars, sharing a picturesque field with blue-white γ Ara and orange β Ara. The cluster is some 14′ across, growing gradually brighter to the middle, which appears as a broad, dense, bright disc.

The brightest stars in NGC 6397 are 10th magnitude and the horizontal branch stars are 12.9 magnitude, so a small telescope readily shows its stellar constituents.

Australian deep-sky expert E. J. Hartung, in *Astronomical Objects for Southern Telescopes*, writes: "there are orange stars in it and some of the outliers are in arcs and sprays. This is one of the best globular clusters for small telescopes."

The two 9th-magnitude stars some 10′ southeast of the center of the cluster (see accompanying photograph) shine with a pale-yellow glow in a large telescope and mark the edge of the cluster's halo, giving it a diameter of about 25′. The orange-yellow giant stars that are scattered across the face of the cluster, readily visible in larger telescopes, appear like glistening drops of golden nectar.

The very center of NGC 6397 resists resolution by even a large telescope, with a short bar of stars clumping together in defiance.

The cluster was first recorded by Lacaille from Cape Town as a "faint star in nebulosity."

James Dunlop, observing from Paramatta, Australia, saw "a pretty large nebula, extended nearly in the parallel of the equator, brightest and broadest in the middle; a group of very small stars in the middle give it the appearance of a nucleus..."

John Herschel also noted the compact group of stars in the cluster's nucleus. His 18-inch (46 cm) f/13 speculum mirror telescope revealed a "beautiful globular cluster... somewhat coarse... very much compressed in the middle where, however, the stars are very small, while every where else they are 13th magnitude."

The stars in NGC 6397's center have undergone a process of infalling leading to a rapid shrinking of the cluster core. It is the nearest core-collapsed globular cluster to Earth.

In the solar neighborhood, there is about one star per three cubic light-years, whereas in the core of a collapsed cluster, many millions of stars swarm in the same volume.

NGC 6397 has the brightest known horizontal branch stars (stars fusing helium in the core) of any globular cluster, shining at magnitude 12.9. In comparison, the horizontal branch of Messier 4 (NGC 6121) is at 13.5 mag., the Cartwheel Globular (NGC 6752) is at 13.7 mag and 47 Tuc (NGC 104) is at 14.1 mag.

NGC 6397 lies just 7,500 light-years away, making it the second-closest globular cluster to Earth. Messier 4 in Scorpius is slightly closer, at 7,200 light-years.

The intriguing suggestion has been made that NGC 6397 is the parent of the wonderful open cluster NGC 6231 (see p. 113). When the massive globular cluster impacted the disk of our galaxy, several million years ago, its gravitational field attracted stars and dust, the resulting density increase triggering a sequence of star formation. A similar suggestion has been made that the Vela Globular (NGC 3201, p. 59) created several open clusters when it crossed the galactic disk.

N
E 1′

NGC 6397, Lacaille III.11, Dunlop 366, Bennett 98, Caldwell 86
Globular cluster in Ara, 17h 40.7min, −53° 40′, Size 31′

127

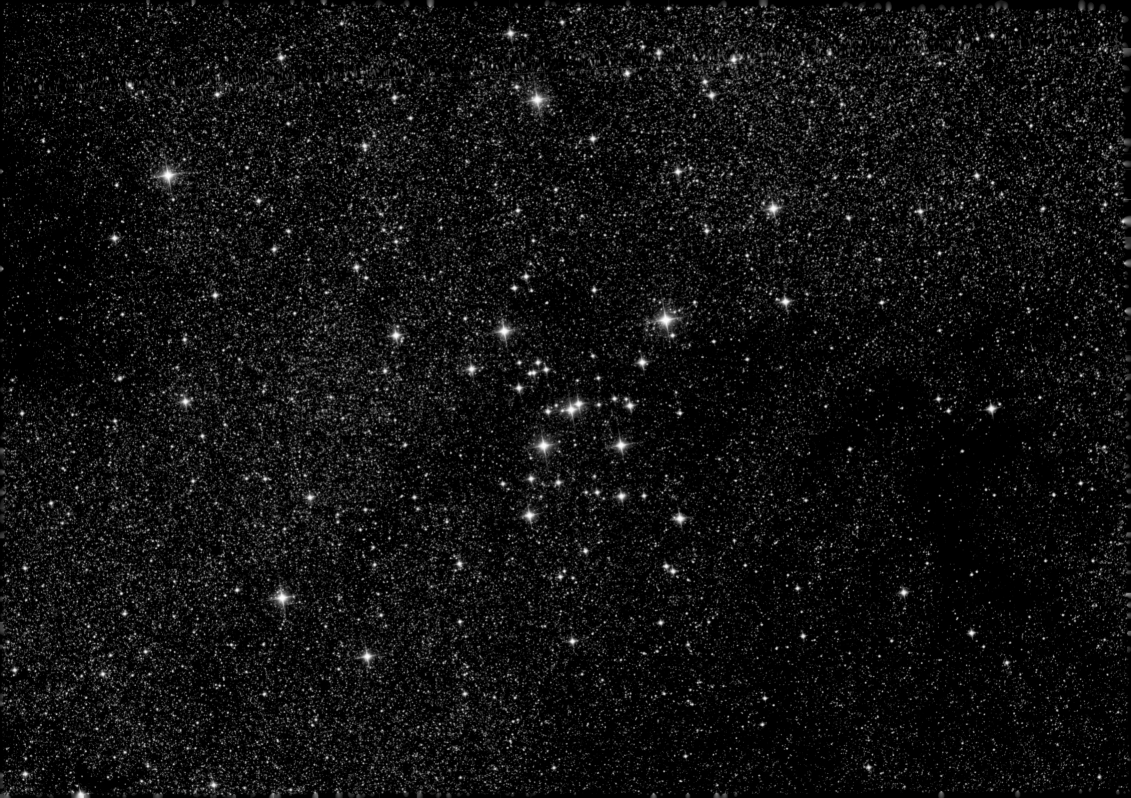

PTOLEMY'S CLUSTER

The bright stars of the Scorpion and the Archer compete with the extensive smokey glow of the Milky Way for the observer's attention. Midway between these two constellations lies a large, fuzzy naked-eye patch. This is the glorious cluster Messier 7, lying northeast of the Scorpion's sting, within a particularly rich part of the Milky Way.

Messier's description is fitting: "It appears to the naked eye as a nebulosity; it is situated... between the bow of Sagittarius and the tail of Scorpius." Incidentally, M 7 is the southernmost Messier object.

Because of its exceptional brightness, M 7 appears in several early star catalogues, including the famous *Almagest*, compiled by the Egyptian astronomer Ptolemy, who flourished in Alexandria, Egypt, in the second century.

Binoculars show it as an excellent, bright and loose cluster, with two obvious curves made up of four stars each arranged more or less in an east-west orientation. The southern curve is tipped by a bright orange star (HD 162587, 5.6-mag., color index $B-V = +1.14$). Users of large telescopes may want to attempt splitting this star, which is a very close binary (See 342, separation 0.6″ in PA 224° as measured in 1991).

The central part of Messier 7 is about 16′ across, so a wide-field telescopic view is essential to enjoy it. This perhaps explains William Herschel's rather blunt description of the cluster as "about 20 small stars (Only seen once)."

The 17th-century Sicilian astronomer Giovan Battista Hodierna gave the first telescopic account of this cluster, assigning 30 stars to it and describing it as "in the stringer of the Scorpion, eastwards."

A century later, Lacaille observed it from Cape Town with his ½-inch (1 cm) 8x magnification telescope, noting it as a group of 15 to 20 stars "arranged in a square."

This linear pattern is remarked upon by several observers, including the Australian deep-sky author Ernst Johannes Hartung, who wrote of it as "a remarkable sight in a large field with its structure of quadrant and straight lines."

The beautifully shaped dark nebula Barnard 287 almost touches Messier 7 on its southern side, its outline reminiscent of a hovering swallow. American astronomer E. E. Barnard described it as an "irregular semi-vacancy" in the bright star clouds of this portion of the Milky Way.

In his description of this region, Barnard noted: "On the southeastern edge of this semi-vacancy is a scattering cluster of smaller stars, 18′ in diameter, with a brighter star ... on its northern edge." This grouping would later be catalogued as Trumpler 30 and is readily seen in smaller instruments as a mottled glow, which at higher magnification is resolved into faint stars arranged in chains.

A short distance farther south lies the ill-defined nebula B 286, with 6th-magnitude HD 162517 within it to the west. The large dark nebula to the northwest of Messier 7, partially seeping in amongst the cluster's stars, is B 283.

Just outside the frame of the accompanying image, about 40′ west of the cluster's center, lies the globular cluster NGC 6453. This soft glow, dazzled by the splendor of its neighbor, is likely to evade all but the largest binoculars.

Under 4° northwest of Messier 7 lies Messier 6, the Butterfly Cluster (see page 125 for a wide-field view). Interestingly, both clusters have an orange-tinged star as their brightest member.

Messier 7 is one of the closest deep-sky objects to Earth, lying just 980 light-years away. It is about 200 million years old, and contains both hot stars (of spectral type A and B, two of which are about 6th magnitude), and evolved red giants (type G and K, two of which are also about 6th magnitude).

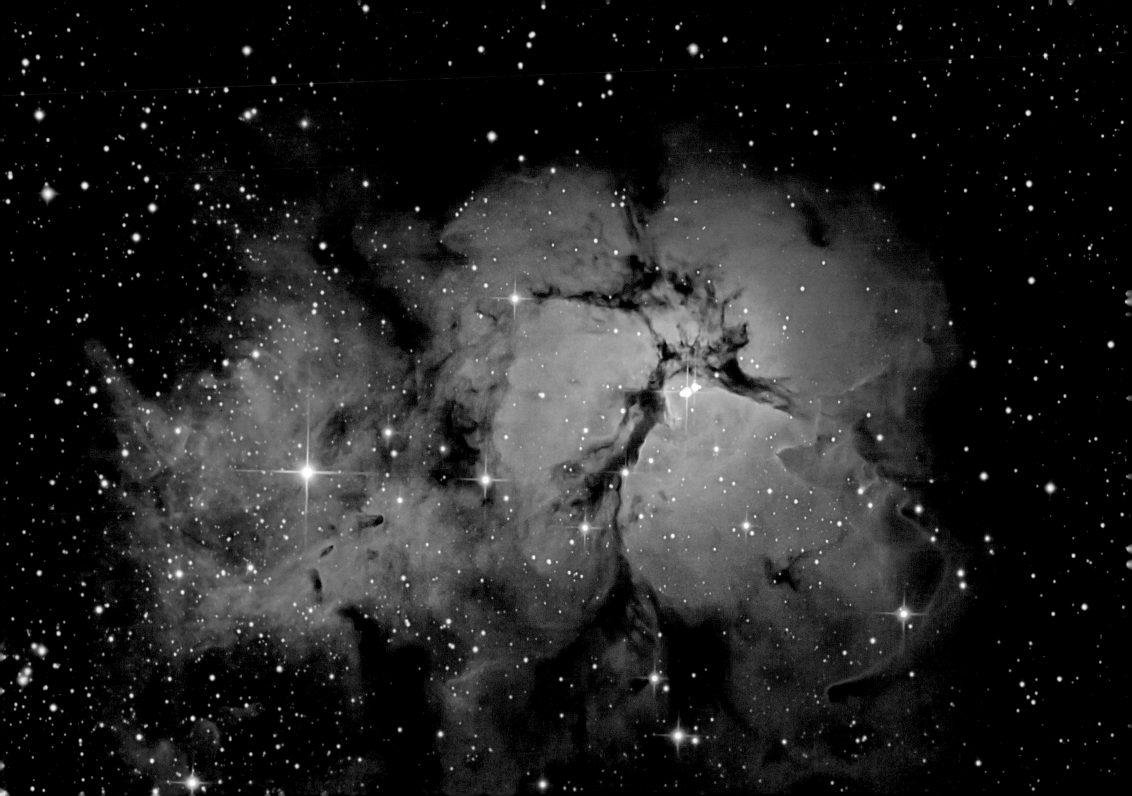

THE TRIFID NEBULA

The delicate and fascinating Trifid Nebula lies about 1° north of the brighter Lagoon Nebula (Messier 8) and can be seen with the naked eye as a dim spot.

Binoculars show it as a fuzzy 8th-magnitude star, one of several in a rough chain leading northeast to Messier 21.

The Trifid is similar to the Horse Head (B 33 in Orion) in that both objects are so famous that one expects them to be obvious in the eyepiece. Yet a small telescope shows the Trifid as only some 10′ across, appearing as a roughly round glow with diffuse edges. Near the center lies a bright star, HD 164492, with two components of magnitude 7.5 and 8.7 about 11″ apart. With some attention a third member of 10.4 magnitude can be seen 6.3″ away from the brightest star.

The Trifid's three wedges, located north, southeast, and west of the central multiple star, can be seen plainly in a modest-sized telescope. With careful attention, the northern wedge is seen as fragmented, with a small slice out of the western tip.

The dark lanes that create the wedges are nominally catalogued as B 85: "the dark markings in this nebula are too well known to insert in this catalogue," wrote American astronomer E. E. Barnard.

Large telescopes give views that compare well to photographs of the Trifid. The dark lanes appear scalloped, and the surface brightness of the wedges is uneven.

The reflection nebula to the northeast, surrounding the pale-yellow star HD 164514 (7.4 mag., B – V = +0.98), can be seen in a small telescope from a dark-sky site, but is challenging in even a modest-size instrument if conditions are not good.

The Trifid's contrasting red-and-blue appearance, beautifully shown in the accompanying image, makes it instantly recognizable on even wide-field (color) photographs of the region.

Recorded by Charles Messier in June of 1764, it was William Herschel who first noticed its characteristic triple nature, describing it as three nebulae vaguely joined together. His son John Herschel dubbed it the Trifid during his early deep-sky observing career in Slough, England. Years later, from Cape Town, he called it "one of the most remarkable nebulae, and must be very carefully delineated. It is very large and has many outlying portions and sinuses."

William Lassell carefully studied the Trifid from the Mediterranean island of Malta in June of 1862.

With his monstrous 48-inch (122 cm) reflector he sketched it and noted: "A most remarkable object, consisting of several bright nebulous patches, sprinkled over with many stars of various magnitudes, distinguished by the brightest two forming a conspicuous and unequal double star in the centre of the brightest part of the nebula."

E. E. Barnard imaged the Trifid in the summer of 1905 with the Bruce telescope at Yerkes Observatory (Wisconsin, USA), revealing for the first time the greater extent seen on modern-day images. "This singular object has faint extensions which I have not seen on any other photographs," he wrote, "the greatest diameter, including the faint outer parts, is 36′ in a south east and north west direction."

The Trifid is an isolated and compact active star-forming region containing a single O-type star, HD 164492, which ionizes the surrounding nebulosity out to about six light-years radius from it. The region has undergone at least two phases of stellar birth since it also contains massive young stars undergoing collapse as well as a population of pre-main-sequence stars.

The Trifid lies 5,400 light-years away in the Sagittarius arm of our galaxy.

N — | E — 1′

Messier 20, NGC 6514, Cederblad 151
Bright nebula in Sagittarius, 18h 2.4min, −23° 2′, Size 28′

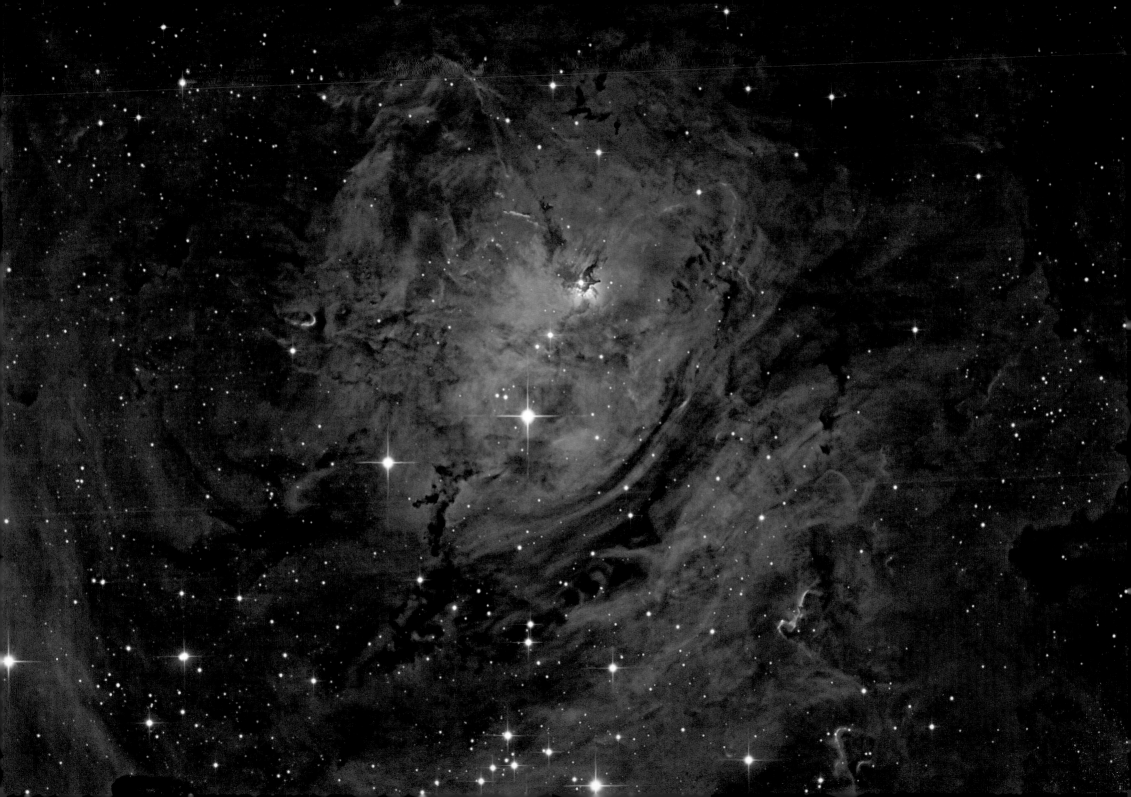

THE LAGOON NEBULA

The brightest part of the Milky Way passes through Sagittarius; and within a prominent dark rift, edged by the "steam" rising from the Teapot of Sagittarius, lies the Lagoon Nebula, visible to the naked eye as a bright patch in the sky. Perched on the northern tip of the Archer's bow, the Lagoon is a magnificent combination of star cluster and nebulosity.

Binoculars show a scattered open cluster, accompanied by a bright star, 9 Sgr, wreathed in gentle nebulosity extending for a full lunar diameter. An obvious dark lane slices it into two uneven halves, immediately calling to mind the Hamburger Galaxy (NGC 5128). Or, as South African deep-sky observer Carol Botha says: "Yes, I can see the lagoon, but it also looks like Mick Jagger's lips!"

Telescopically, this "noble nebula" (as John Herschel referred to it) is an intricate expanse of bright and dark nebulosity. Charles Edward Barns, in his 1927 book *1001 Celestial Wonders as observed with home-built instruments*, saw "wide wastes of incandescent hydrogen and helium, overflung with dark absorbing patches."

Giovan Battista Hodierna, in 1654, was the first to record the star cluster. A century later, Lacaille recorded the region as "three stars in nebulosity,

parallel to the Equator." The 19th-century historian Agnes Clerke, inspired by John Herschel's description of "a collection of nebulous folds and matter surrounding and including a number of dark, oval vacancies" coined the "Lagoon" nickname.

The Lagoon is an extensive star-forming region., and American astronomer Harold Corwin points out that this complex object has several catalogue designations. NGC 6533 refers to the entire area, following William Herschel's description. NGC 6530 is the star cluster physically associated with the complex. A part of the cluster is shown at the bottom edge of the accompanying image, below the bright blue star in the center, 9 Sgr. This latter star is one of the stellar furnaces that ionizes the region. NGC 6523, the Hourglass Nebula, is the brightest nebulous knot above 9 Sgr (3′ southwest in the sky) and is the star-forming nucleus of the Lagoon. NGC 6526 is the southeastern part of the nebula (Mick Jagger's lower lip, so to speak). IC 1271 and IC 4678 are knots in its eastern reaches, noted by Lewis Swift and E. E. Barnard, respectively.

Near the right edge of the image, 11′ south and slightly east of 9 Sgr, is a 1.5′ × 1′ concentration of dark nebulosity, recorded as Barnard 296, a challenging visual target.

0.5°

N

E

Two of the most splendid objects in Sagittarius, the Trifid Nebula (top) and Lagoon Nebula (bottom), about 1° apart.

N
E
1′

Messier 8, Lacaille III.13, NGC 6530 (cluster), 6523, 6533, IC 1271 (nebula)
Open cluster and bright nebula in Sagittarius, 18h 3.2min, −24° 23′, Size 75′ × 45′

HERSCHEL'S HOLE IN THE HEAVENS

Set against an overwhelming Milky Way star field, made up of the inner spiral arms of our galaxy and backed by its central bar, lies this unique combination of fierce white starlight, pitch black night, and a lone orange star. The trio lie about 4° east of the galactic center, at the edge of the cloud of steam rising from the sprout of Sagittarius' Teapot.

The bright orange star near the northern tip of the dark nebula is HD 164562 (6.7 mag, color index B – V = +1.7), a very close (separation 0.2″) double star.

The star cluster NGC 6520, can be seen with attention in binoculars, which show it as a moderately bright spot in the Milky Way. A small telescope reveals little more, as only a handful of its stars are brighter than 12th magnitude. A large telescope reveals it as a tight grouping, rich in faint stars, with a bright orange-red star dominating (HD 164684, 8.8-mag., B – V = +2.2). Two short rows of stars trail off westward from the cluster, and to the imaginative South African deep-sky observer Magda Streicher this resembles the head of an African buffalo with its horns pointing west.

NGC 6520 was discovered by William Herschel in May 1784, a little over a year after he began his epic project to catalogue the heavens. He saw the cluster as a considerably rich, scattered grouping somewhat compressed in the middle.

NGC 6520 lies about 6,000 light-years away, and is approximately 150 million years old.

The striking dark nebula is Barnard 86. Binoculars show it as a small dark spot in a stunning Milky Way field. Veteran observer Steve Coe notes it measures about 5′ and has an hourglass shape. The nebula was recorded in July 1883 by E. E. Barnard, soon after taking up a position at Vanderbilt University Observatory (Tennessee, USA). "On account of its extreme blackness it was one of the most impressive objects in the Milky Way," Barnard wrote, adding that it was known to him since the early 1880s when he was comet-seeking with a 5-inch (13 cm) refractor. He described it as "a small triangular hole in the milky-way, perfectly black, some 2′ diameter, very much like a jet black nebula. A bright orange star on n.p. border. A very remarkable object." Barnard later observed it with the 36-inch (91 cm) refractor at Lick Observatory, noting that its western side was fairly well defined while the eastern half was more diffused. In his seminal *A Photographic Atlas of Selected Regions of the Milky Way* Barnard described it as a "small, dark, triangular spot," inspiring the "Ink Spot" nickname also used for this nebula.

Barnard was not, however, the first to record this nebula. That honour belongs to Angelo Secchi, director of the Collegio Romano Observatory, who observed it some 30 years before Barnard, calling it a perfectly black spot in the shape of a pear.

It is thought, however, that this black spot may have been seen even earlier—by William Herschel! When John Herschel undertook his expedition to the Cape to study the southern heavens, his aunt, Caroline Herschel, asked him to search for a particularly curious object in or near the body of the Scorpion. She noted that William had observed an object on several occasions over the years, that, on his first viewing caused him to exclaim: "Hier ist wahrhaftig ein Loch im Himmel." John Herschel never found the object that so affected his father.

There is some speculation suggesting that NGC 6520 and Barnard 86 share a common origin, with the nebula being the remnants of a star-formation process that ended with the birth of the cluster.

Visible near the bottom of the image, 14.5′ due west of this star, is a small globular cluster, the second of three discovered in 1987 by S. George Djorgovski.

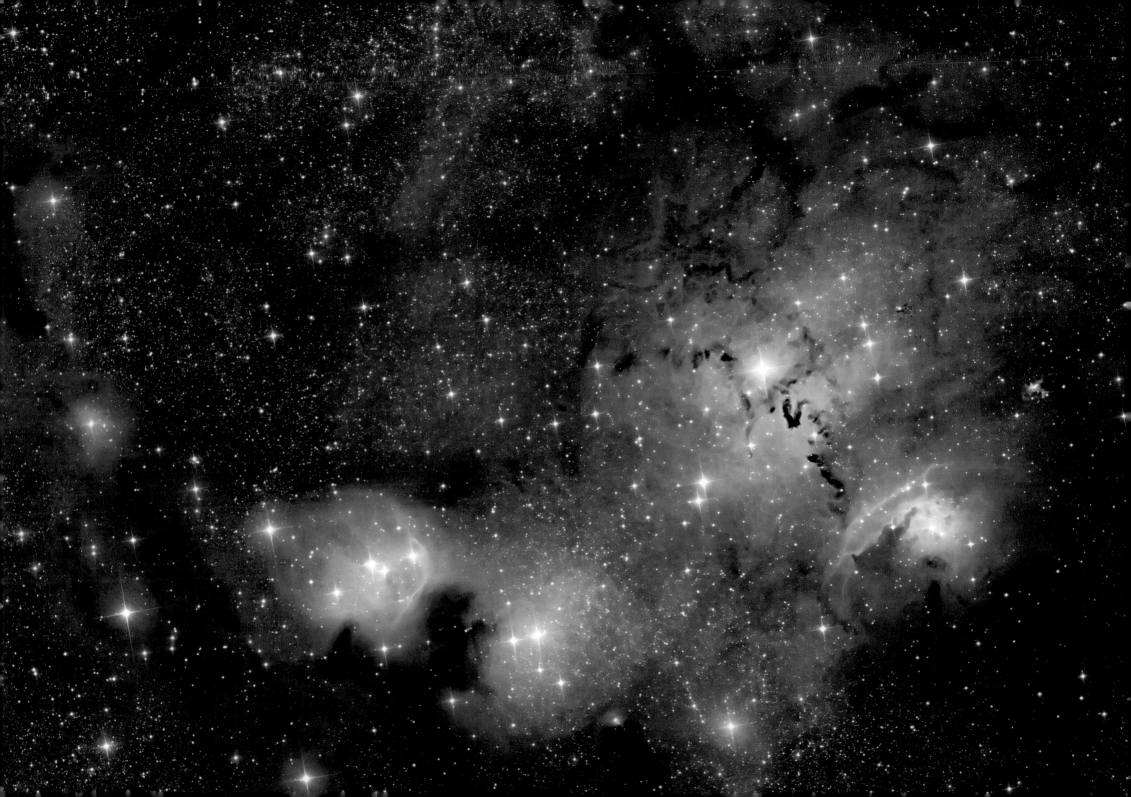

THE PSYCHEDELIC NEBULA

The glorious Lagoon and Trifid Nebulae have a companion nebula that is only revealed as an exceptional object in its own right when photographed. Located east-northeast of the Lagoon Nebula, this complex region of bright and dark nebulae is catalogued as Simeis 188.

Visually, the region appears as only indistinct patches of nebulosity. Australian observer Gerd Bahr-Vollrath notes that a UHC filter helps improve the view, and that the nebulous patches seem associated with groupings of stars.

The very large diffuse pink-colored nebula dominating the accompanying image is the H II region IC 4685. The bright star just above its center is 7.4-mag. HD 165921, an eclipsing binary comprising two main-sequence O stars. The distinct dark spot just to the upper left is B 302. Winding down and to the right of HD 165921 is the sinuous dark nebula B 303. This leads the way to NGC 6559, a reflection nebula with a bright rim running northeast to southwest. At far left is IC 1274, a roundish emission nebula, containing four bright stars, rimmed with blue light. Immediately to its lower-right is the dark cloud B 91. To the right of this lies another roundish emission nebula, IC 1275. The small red-

dish knot to the top-right of NGC 6559, just within the southern fringe of IC 4685, is the planetary nebula Minkowski 1–41.

E. E. Barnard was the first to notice this region, on a photograph exposed at Mount Wilson in 1905 with the 10-inch (25 cm) Bruce photographic telescope. "All the region for several degrees about Messier 8 is covered with a slightly uneven film of nebulosity—especially to the east. The broad, faint extension of nebulosity running eastward from Messier 8 … does not condense about [HD 165921], which seems to be accidently projected upon it."

NGC 6559, the brightest feature within Simeis 188, was discovered by John Herschel in 1826 from Slough, England. From the Cape, he saw it as a very faint oblong glow, about 5′ long and 3′ broad.

The reflection nebulae IC 1274 and IC 1275 were reported by Barnard in 1892, based on photographs taken with the 6-inch (15 cm) Willard lens at Lick Observatory. They formed part of a "singular and isolated group of [unmistakable] nebulous stars" 1.5° following Messier 8. When Barnard later imaged the area with the superior 10-inch (25 cm) Bruce telescope, he noted the "large diffuse nebulosity" that would be catalogued as IC 4685.

From a photograph taken at Mount Wilson, Bar-

nard wrote: "A faint extension of nebulosity from Messier 8, nearly a degree wide, runs east for about 1.5°, where it brightens up and involves a smaller group of nebulous stars. In the eastern part of this nebulosity is an abrupt, dark bay (B 91), open to the east, in which the planet Uranus happened to be located on this date [1905 July 27]."

B 303, nicknamed the "Celestial Dragon" based on its sinuous appearance on modern photographs, was noted by Barnard as being a 1′ wide crescent, bulging to the east, and "very black." B 302 he noted was less definite and smaller than B 303.

This complex region was included in Sven Cederblad's 1946 *Catalog of bright diffuse Galactic nebulae* as No. 154, "the group of nebulous stars following M 8." Simeis 188 was catalogued in the 1950s by Grigory Shain and Vera Gaze during their survey for new emission nebulae carried out at the Simeiz Observatory in the Crimea.

Minkowski 1–41 (PN G006.7–02.2, ESO 521–39) was identified by German-American astronomer Rudolph Minkowski as a planetary nebula in 1946 on a photograph taken with the 10-inch (25 cm) Cooke telescope at Mount Wilson.

Together, the Lagoon, Trifid, and Psychedelic Nebula are known as the Sagittarius Triplet.

N
E
3′

Simeis 188, Gaze-Shajn 188, Cederblad 154, Gum 75, Bernes 7
Bright and dark nebulae in Sagittarius, $18^h 9.3^{min}$, −23° 59′, Size 45′

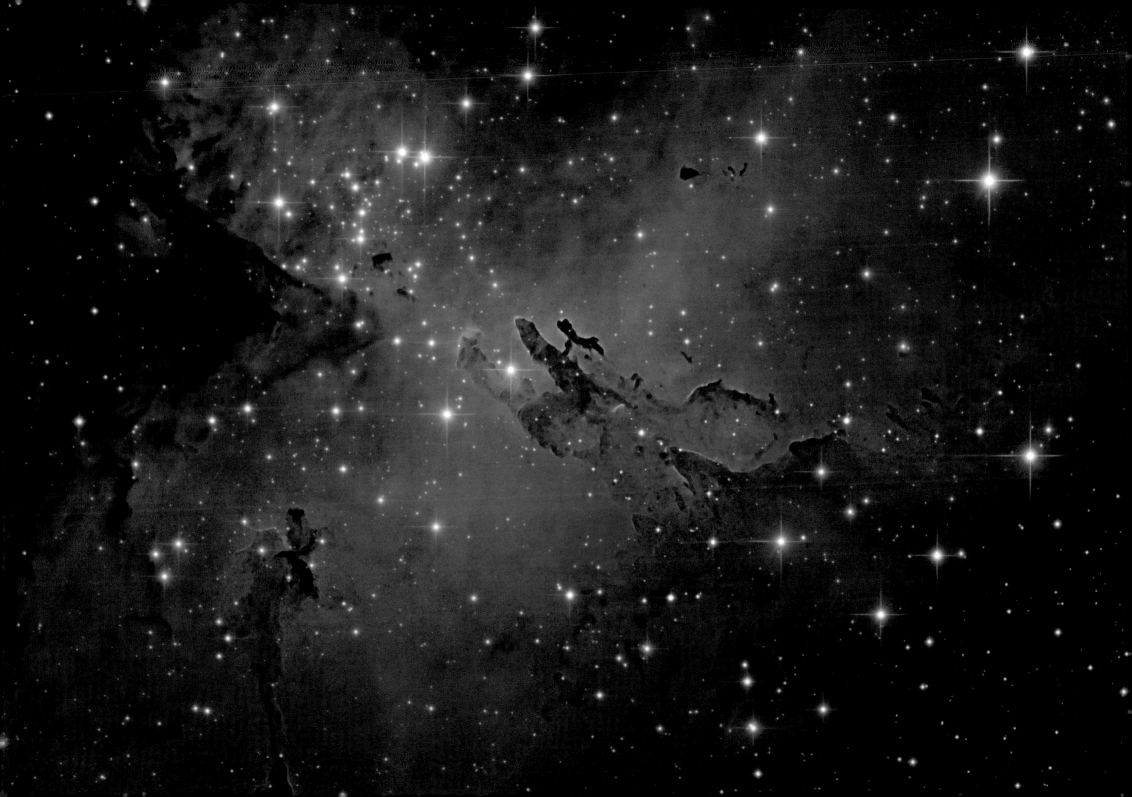

THE EAGLE NEBULA

The Eagle Nebula lies 2.5° west of 4.7-mag. γ Sct and 2.5° north of the Swan Nebula (Messier 17) in the constellation Serpens. Like the Swan it is one of the most active regions of star formation in the Sagittarius arm of our galaxy.

NGC 6611, the cluster of stars near the top-center of the accompanying image, was discovered by the Swiss astronomer Jean-Phillippe Loys de Chéseaux.

The surrounding nebulosity, for which the Eagle is famous, was not discovered visually. It was first noticed on photographs taken by the great American astronomer E. E. Barnard, in 1895. The nebulosity was catalogued as IC 4703, with discovery credit going to the Welsh astrophotography pioneer Isaac Roberts (who photographed it in 1897).

In 1914, Robert Innes of the Union Observatory (Johannesburg, South Africa) observed it, noting: "With the 9-inch [23 cm] refractor the nebula is just visible and it fills the perimeter of the cluster with faint extensions beyond. On the best photographs, the shape is perhaps spiral, but the bright portion forms a thick round ring or disk with a central hole."

The dark features to the right of center in the image are the famous Pillars of Creation, giant molecular clouds containing deeply embedded disk-bearing stars. The Pillars were sculpted by the intense ultraviolet radiation from the massive stars in NGC 6611.

This cluster contains 13 known hot massive O-type stars in a seven light-year wide region. The three most massive stars alone generate about five times the ionizing energy of the O-type stars in the center of the Trapezium in the Orion Nebula.

Simulations suggest that the environment and initial conditions from which our solar system was born, some 4.57 billion years ago, closely resembles the present-day conditions of the Pillars. Recent work has shown that the observed features of our sun and its planetary system can be accounted for by the explosion of a supernova some 16 light-years from a molecular cloud of 10 solar masses.

A wave of star formation has swept through the Eagle Nebula in an ongoing process spanning millions of years. Star formation in the southeast was triggered some 3 million years ago by a series of distant supernovae. These explosions, about 6 million years ago, created a giant, expanding, molecular shell (now some 800 × 550 light-years in size), which reached the Eagle Nebula from the southeast some 3 million years ago. The impact of this shell also triggered star formation in the nearby Swan Nebula. In the north and west of the Eagle Nebula, radiation from the massive stars in NGC 6611 started another phase of star formation less than 1 million years ago. The most recent star formation occurred 400,000 years ago in a deeply embedded cluster in the northeast.

Visually, the Eagle's most obvious feature is the open cluster NGC 6611. Binoculars show a poor, scattered cluster in an approximate A-shape. Modest-sized telescopes only hint at the nebulosity, most noticeably toward the west. Using a UHC filter to bring out the nebulosity, deep-sky observer Donald J. Ware reports seeing the Eagle pattern clearly.

Larger telescopes reveal the two dark Pillars and several smaller dark nebulae, particularly the small dark spot shown to the top-right (southwest) of the Pillars in the accompanying photograph.

There is at least one more Eagle soaring in the sky: IC 2177 in Monoceros. Although commonly known as the Seagull Nebula, it was dubbed the Eagle Nebula by astrophotographer Hans Vehrenberg in his 1978 *Atlas of Deep-Sky Splendors*.

N
E 1'

Messier 16, NGC 6611 (cluster), IC 4703, Cederblad 159, Gum 83 (nebula)

Open cluster and bright nebula in Serpens, 18^h 18.8^{min}, −13° 48', Size 120' × 25'

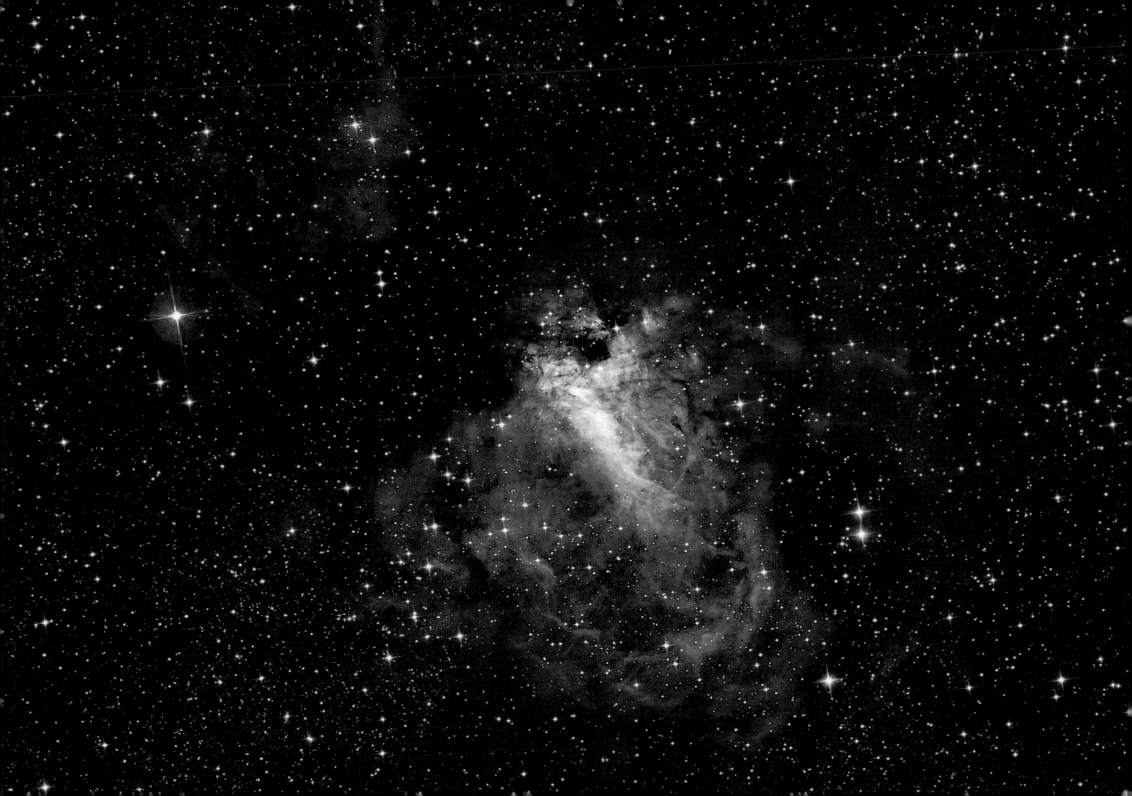

THE SWAN NEBULA

The Swan Nebula can be found near the northern border of Sagittarius at the junction with Serpens and Scutum, about 2° north of the brilliant Sagittarius Star Cloud (Messier 24).

Binoculars show a wonderful region of sky on which is set a well-defined, straight-edged wedge of light, oriented northwest to southeast, with a short hook at its western end, creating a tick-mark figure. Well separated and toward the north is a mottled star patch, containing both bright and faint stars. The duo of nebula and star cluster seem cordoned off to the northwest and southeast by two broad slashes of dark nebulosity. A bright orange star, HD 168415 (5.4 mag., B–V = +1.5), shines to the northwest of the tick. The bright wedge (the body of the graceful Swan) points the way northwest across the dark lane to IC 4706 (Cederblad 160), which can be seen as a very faint nebulous patch in binoculars.

A telescope reveals an impressive level of detail, rivaling that visible in M 42 in the opinion of Tom Lorenzin, author of *1000+: The Amateur Astronomers' Field Guide to Deep Sky Observing*. Veteran observer Steve Coe notes that using a UHC filter "shows off the fact that thin dark lanes cut across the bright nebula in several places" by raising the contrast between the bright and dark parts.

The Swan was first recorded by the Swiss astronomer Jean-Phillippe Loys de Chéseaux in the mid-1740s. "It has the perfect form of a ray or the tail of a comet, 7' long and 2' wide," he wrote, "[i]ts sides are exactly parallel and well terminated." Two decades later, it was seen by Charles Messier, who called it "a train of light without stars, 5' or 6' in extent, in the shape of a spindle, a little like that in Andromeda's belt, but the light is very faint."

William Lassell sketched the Swan using his 48-inch (122 cm) reflector from the Mediterranean Island of Malta in 1862. He called it "a very remarkable nebula in which there is much detail and many stars."

E. E. Barnard's pioneering photography at the turn of the century began to reveal the full glory of the Swan. In a preliminary report on his great Milky Way photographic project, Barnard wrote in 1908: "The Swan or Omega Nebula is a very remarkable object and covers a very much greater space than visual observations would indicate. Its full extent north and south is 42' and it is about 24' broad east and west. Its brightest portion would be comprised within a circle about 15' in diameter. The rest consists of faint diffusions from the south east around to the north."

In the same article, Barnard gave notice of two new nebula: "Preceding the brightest portion of the [Swan] nebula, by about 15', are two small stars involved in a small nebulosity." The two were taken up in the Index Catalogue as IC 4706 and IC 4707. Astronomer Harold Corwin, in his painstaking compilation *History and Accurate Positions for NGC/IC Objects*, notes that Barnard had misidentified the stars in question, and the error lead to incorrect catalogue positions for the nebulae. Furthermore, Corwin notes: "Barnard also claims that two of the stars are involved in nebulosity, where only one [IC 4706] really is (aside from faint, whispy stuff all over the field northwest of M17)."

IC 4706 can be seen in the accompanying photograph as a figure-eight shaped nebulous patch to the top-right of HD 168415, measuring about 8' × 4'. IC 4707 was supposed to surround the two stars immediately below IC 4706.

Messier 17 is a massive star-forming region some 5,000 light-years from Earth, within the Sagittarius arm of our galaxy. The Swan's bright region extends for some 15 light-years and weighs in at about 800 solar masses, making it more massive than the Orion Nebula (M42).

N

E 3'

Messier 17, NGC 6618, Bennett 108
Bright nebula in Sagittarius, 18h 20.6min, −16° 10', Size 20' × 15'

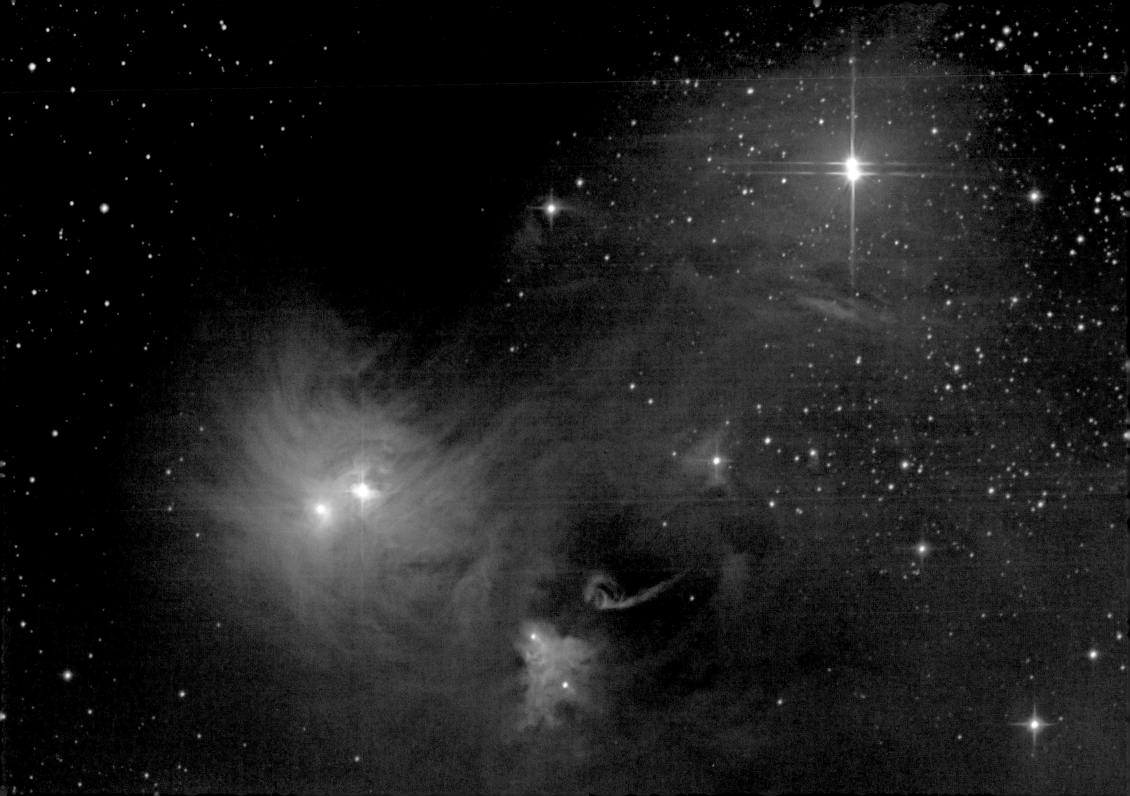

THE R CORONAE AUSTRALIS COMPLEX

Identification chart
p. 169

The beautiful curve of southern stars east of the Scorpion's tail is known as Corona Australis. The |Xam Bushmen of South Africa explain that a group of men were sitting together eating once when a bewitched girl turned them into stars. Perhaps some other form of wizardry holds sway over this constellation because until 2008 (!) the International Astronomical Union still referred to it as "Corona Austrina."

Between ε and γ CrA lies the remarkable Corona Australis cloud complex, one of the closest (420 light-years) active star-forming regions.

In 1861 German lunar expert Julius Schmidt was observing the bright globular cluster NGC 6723 (see right-hand image) with the 6-inch (15 cm) Plössl refractor at Athens Observatory when he discovered the brightest members of this complex. In the accompanying photograph, NGC 6729 is the triangular nebula at bottom-center containing two stars, R CrA (northwest) and T CrA (east). NGC 6726–7 is the large blue northern nebula containing two bright stars near its center, HD 176386 (top-right) and TY CrA (bottom-left). Schmidt may also have seen IC 4812, the diffuse nebula at top-right containing the bright pair HR 7169 and HR 7170, although discovery is usually credited to Harvard astronomer DeLisle Stewart (from a photograph taken in 1899). The NGC objects in this region were independently discovered by Albert Marth, William Lassell's assistant in Malta and discoverer of 563 NGC objects.

This region of sky was unfortunately too far south for American pioneer E. E. Barnard to photograph and catalogue for dark nebulae. Only one object, B 290, lies in Corona Australis, and then just barely, a 3' opal tucked into the northwestern corner of the constellation.

The most massive stars in this star-forming complex are the youthful R CrA and TY CrA. Surrounding R CrA is the compact Coronet protostar cluster, detected in the infrared in 1984. TY CrA is at least a quadruple system with a massive accretion disk. The dark cloud near R CrA is the densest cloud core in the region. Robert Innes at the Cape Observatory wrote in 1910 that the 9-inch (23 cm) refractor with a field of 25' didn't show a single star here, adding "there is probably no other such region in the whole sky." Photometric studies reveal that the visual extinction here is up to 45 magnitudes!

0.5°

N
E

The bright globular cluster NGC 6723 lies to the northwest of the dusty R CrA complex, and proved to be the key to its discovery.

N
E
1'

NGC 6729, Bernes 159, Cederblad 165, Caldwell 68

Bright nebula in Corona Australis, 19h 2min, −37° 0', Size 2' × 2'

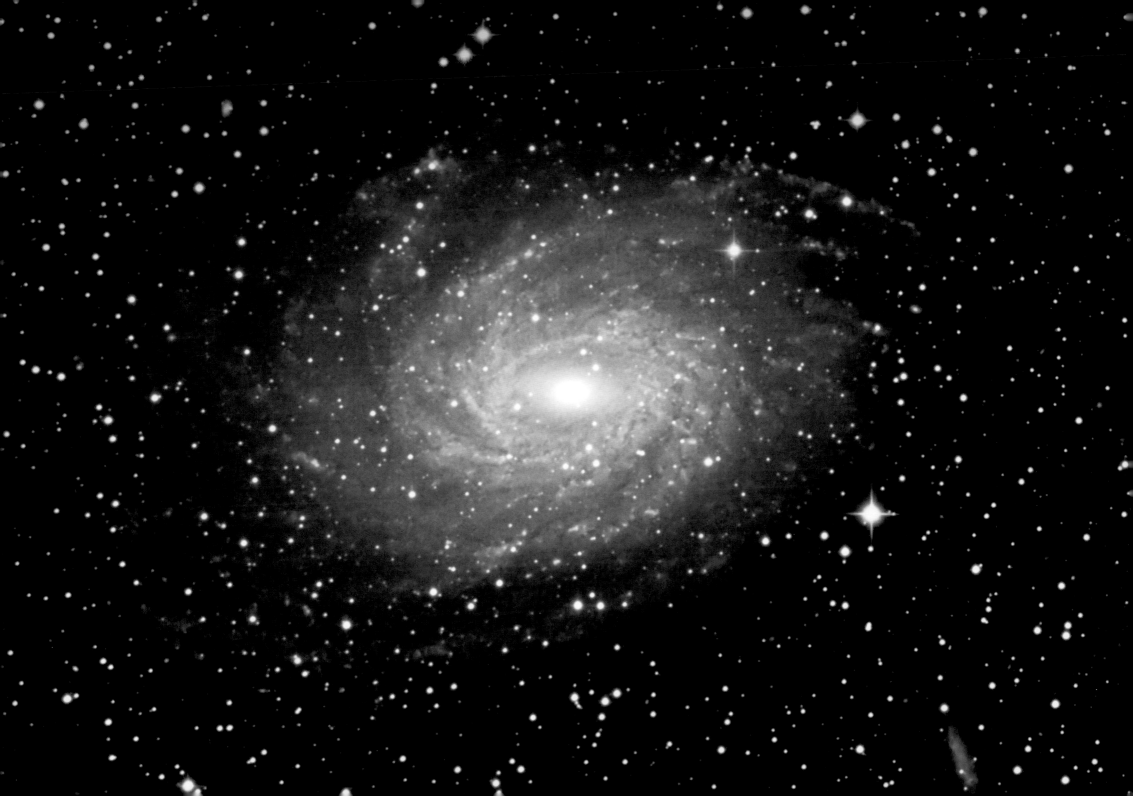

THE FURIOUS DANCER

idway between Atria (α TrA) and Peacock (α Pav), flaunted on the magnificent tail feathers of the Peacock and just 4° south of the naked-eye Cartwheel Globular (NGC 6752), lies the massive galaxy NGC 6744.

Despite its impressive 8.3-magnitude listing in the catalogues, NGC 6744 is a low surface brightness target that is elusive under poor skies. Binoculars show it about 3° northeast of a bow-tie-shaped asterism containing θ Pav. It appears as a large ghostly haze some 10′ across with a 10th-magnitude star pinned to its northwestern edge. With averted vision, binoculars hint at its elongated shape, oriented north-northeast to south-southwest.

Despite being visible in binoculars, the tantalizing details shown in the accompanying photograph essentially elude the telescopic observer. It appears as a large oval glow that is evenly illuminated and grows gradually brighter toward the center, where a small bright nucleus can be seen. At high magnification small stellar points pop into view. Sadly, it does not yield up its multitude of soft graceful arms to the eye easily. Some observers do, however, report seeing "striking detail in the galaxy's arms, including several bright knots of nebulosity and a very obvious spiral pattern."

James Dunlop recorded it three times during his survey of the southern sky, noting a "pretty large, very faint nebula, about 5′ or 6′ diameter, slightly brighter toward the centre," while John Herschel from the Cape of Good Hope noted it was "pretty bright, round…, very much brighter in the middle."

Contemporary observers also note the prominent central region, commenting on its "bright nuclear glow," "sudden bright nucleus" or "a bright, extended nucleus rapidly fading outwards."

However, unlike Dunlop and Herschel, they are unanimous in perceiving it as appearing elongated. Australian observer and author E. J. Hartung called it a "large irregularly elliptical faintly luminous haze more than 5′ across, with some faint stars involved. The center, about 30″ wide, is bright and appears granular."

NGC 6744 is one of the largest and nearest spiral galaxies, located some 30 million light-years away. It is a barred spiral, much like our Milky Way, with several long filamentary arms, and it is inclined about 52° to our line of sight. The bar, oriented north-south, can be seen in the accompanying photograph.

It has at least one "Magellanic Cloud," the irregular galaxy NGC 6744A. This tiny satellite galaxy can be seen in the accompanying photograph as a bright fuzzy streak at bottom-right. At least three other irregular dwarf galaxies are known to accompany NGC 6744.

It is a member of the NGC 6744 galaxy group, a 7° chain of galaxies, that includes NGC 6684, NGC 6684A, IC 4710, IC 4824 and ESO 141–42.

NGC 6744 was one of the four objects imaged for the first-light demonstration of the 9.8-meter (386 inch) Southern African Large Telescope, a facility of the South African Astronomical Observatory (SAAO), the national optical observatory of South Africa.

The nickname "Furious Dancer" is from Gerard Bodifee and Michel Berger's *Catalogue of Named Galaxies*, who describe it as a beautiful whirling galaxy performing a manic celestial dance.

E
N 1′

NGC 6744, Dunlop 262, Bennett 120, Caldwell 101
Galaxy in Pavo, 19h 9.8min, –63° 51′, Size 20.1′ × 12.9′

THE CARTWHEEL GLOBULAR

The Pavo Globular, NGC 6752, lies in the northern part of the Peacock and can be seen with the naked eye as a 5th-magnitude glow 1.5° due east of 5th-magnitude Omega Pavonis.

Binoculars reveal an impressive bright blaze, spilling light out over an area almost 5' in diameter. Embedded in the cluster's fringe, two arcminutes southwest of the center, is a lone 7.4-mag. star, HD 177999. With averted vision one gets the curious impression of the cluster being bi-nuclear! Under dark skies, larger glasses swell the globular out to 13' in diameter.

The brightest stars in NGC 6752 are about 11th magnitude, so even a small telescope shows individual sparks of light sprinkled across its surface. A larger aperture reveals a host of stars in this spectacular object, and probably more so than in any other globular cluster; it is rich in star chains. Many of these chains seem to originate near the nucleus, which is a banana-shaped concentration of unresolved stars. Australian observer Glen Cozens mentions seeing a half-dozen spidery legs emanating from the cluster's center, separated by dark patches. These lines of stars, "like crooked radii" in John Herschel's words, inspired South Af-

rican observer Magda Streicher to call NGC 6752 the Cartwheel Globular, although the nickname "Starfish" is also appropriate.

With a large telescope, two particularly noteworthy loops of stars can be seen. The larger extends from the southeast of the nucleus, and a smaller one curves away toward the northeast. Each loop completely encloses a dark patch and looks rather like a miniature pearl necklace.

Veteran observer Brian Skiff gives an intriguing comparative description: "Try to imagine a cluster as large as M4, as bright as M22, and as rich and structured like M15"!

It is curious that such a bright object was not noticed by Lacaille during his cursory survey of southern deep-sky objects. One object unaccounted for in his list of nebulous objects, Lacaille I.13, lies in Pavo. Astronomical historian Owen Gingerich has suggested that some error crept into Lacaille's records, and that he should be credited with the telescopic discovery of this delightful southern globular cluster. While Lacaille's reported co-ordinates for I.13 do not point to anything special, American astronomer Harold Corwin notes that a pair of 9th-magnitude stars lie nearby and speculates that this might be what

Lacaille saw. "Perhaps," he concludes, "but I like Gingerich's idea a bit better."

James Dunlop was the first to note that the Cartwheel's stars appear to be of two brightness groupings, creating the illusion of an object within an object. "I am inclined to think that this may be two clusters in the same line; the bright parts a little south of the centre of the large nebula."

Several years later, John Herschel recorded the same impression, on several different occasions. His second observation of the cluster showed that "the stars are of 2 magnitudes, the [brighter] run out in lines like crooked radii. The smaller... are massed together in and round the middle," and his fourth observation recorded that the "central mass consists of smaller stars than the outside."

Contemporary observers agree with this testimony—Australian observer Peter F. Williams commented on the "impression of one globular cluster superposed upon another larger and fainter globular cluster... [with] a number of 9th and 10th mag stars overlying innumerable stars of magnitude 12 and fainter."

NGC 6752 lies 13,000 light-years away and is about 13 billion years old.

E N 1'

NGC 6752, Lacaille I.13, Dunlop 295, Bennett 121, Caldwell 93
Globular cluster in Pavo, 19h 10.9min, −59° 59', Size 29'

LACAILLE'S FALSE COMET

Outside the stream of the Sagittarius Milky Way, some 8° east of the Archer's brightest stars, lies the globular cluster NGC 6809, better known as M 55.

It is easy to sweep up in binoculars; a small pair will show it as a grossly unfocused star. Larger binoculars give an impressive view, showing a large cluster with a broad nucleus dominating a rather bland surrounding star field.

Through a telescope, this large (15′ diameter) cluster is a delight. It is well resolved and not at all tightly concentrated in the center, being one of the least compressed bright globular clusters. Even a small telescope shows stars scattered across its surface, "a cloud of faint stars" in E. J. Hartung's words. The impression of dark lanes snaking between the cluster's stars is very strong, reports veteran American observer Steve Coe.

As the accompanying photograph clearly illustrates, NGC 6809 is not a poor cluster. Its brightest stars are 12th magnitude, and the stars on its horizontal branch are at 14th-magnitude, so smaller telescopes will show mainly these stars. A host of 16th-magnitude and fainter stars make up the rest of this beautiful cluster.

Although the Frenchman Nicholas Louis de La-caille could have spotted it from Paris Observatory where he worked, he first saw it from Cape Town, in the early 1750s. He described it as appearing "like the obscured nucleus of a big comet."

Lacaille's fellow countryman and comet-hunter Charles Messier first saw it more than a quarter of a century later, calling it a "whitish spot… [which] does not appear to contain a star." Not many years later, in 1783, it was resolved into stars by William Herschel shortly after he had begun his epoch-making survey of nebulae and clusters.

James Dunlop recorded it as "a beautiful, large, round bright nebula… easily resolvable," while John Herschel wrote that it was "all resolved into separate stars … not so compressed in the middle as to run together into a blaze or nipple."

The 19th-century French observer and champion astronomy popularizer Nicolas Camille Flammarion called it a "huge agglomeration of stars uniformly distributed and immersed in a pale nebulosity. Diam. about 6′ but a little elongated N-S. This cluster should be admirable in the southern hemisphere; for us it is a little pale." Flammarion observed from Juvisy Observatory, some 30 km from Paris, with a 9.5-inch (23 cm) refractor. The late Richard Baum, political scientist and astronomy historian, wrote: "In essence, the observatory was dedicated like a temple, symbolizing Flammarion's dream of finding evidence of extraterrestrial life, and his fascination with the planets, especially Mars."

Messier 55 is a nearby globular cluster, residing in the galactic halo some 20,000 light-years away.

In the course of a long-term survey for variable stars in M 55, a team of astronomers led by Mario Mateo found three RR Lyrae stars in the cluster's vicinity that were not cluster members. Further investigation revealed an excess of other interesting stars that were not cluster members either. It is thought that these stars belong to the Sagittarius Dwarf Spheroidal galaxy (Sgr dSph), located nearly 10° away! These stars lie in an extended tidal tail, a stream of debris strung out along the galaxy's orbital path as it dissolves into our galaxy's halo following a close encounter. If correct, this would imply that Sgr dSph is at least 20° long along its major axis! Thanks to its unusually low central concentration, and proximity to the Milky Way we can see in between its stars to the more distant Sgr dSph, 52,000 light-years from the galactic center.

E

N 1′

Messier 55, NGC 6809, Lacaille I.14, Bennett 122

Globular cluster in Sagittarius, 19h 40.0min, −30° 58′, Size 19′

THE GHOST RING NEBULA

Flying high in the spring skies is Grus the Crane (earlier called the Heron) with its beak reaching for the tantalizing southern fishes, Piscis Australis. Along the neck of the eager water bird lies λ Gru, an orange 4.5-mag. star, and a little over 1° west is the curious annular planetary nebula IC 5150.

A careful observer with large high-powered binoculars should be able to glimpse the nebula, which lies immediately north of two stars (10.4 and 11.2 mag.) 3′ apart and crudely pointing the way. A small telescope reveals it as a surprisingly large but dim glow, round in shape, without an annular appearance. In modest-sized telescopes the characteristic central darkening is obvious. The inner region is not perfectly dark, and it glows with a soft, diffuse light. The ring, which is essentially colorless, has two brighter portions, along the northeast and southwest. In large telescopes the nebula appears mottled, hinting at the delicate structure revealed in the accompanying photograph. The central star glows feebly at 16.2 magnitude.

The nebula was discovered in 1894 by Australian amateur Walter Frederick Gale. Besides being a skilled telescope maker, Gale was also a successful comet hunter, independently discovering seven comets. He discovered his first comet on April 1, 1894, and one can only imagine his excitement when, on June 4 of that year, he came upon "a faint elliptical object in the constellation Grus." Over the next few evenings he realized that it wasn't a comet but "a much rarer object—a ring nebula." His description is a very good account: "The central vacancy, which is rather less than half the diameter, does not appear to be entirely devoid of nebulous matter." When the Danish astronomer John Ludwig Emil Dreyer compiled the second Index Catalogue (1908), Gale's ring nebula was assigned the designation IC 5150.

Three years after Gale's discovery, Lewis Swift, from his lofty observatory in the San Gabriel mountains (California, USA) independently discovered it. Like Gale, Swift was an avid comet hunter, discovering no less than 13 comets in his career. He also discovered 1027 nebulae, making him the most prolific American observer of his era. Swift used a 16-inch (40 cm) Clarke refractor installed at Lowe Observatory on Echo Mountain, then the most southern observatory in the United States. On July 23, 1897 at age 77, he noted a "very faint, large, slightly elongated [nebula]," to which Dreyer assigned the designation IC 5148.

The reason for the duplicate entries is the poor quality of the positions reported by the two observers. Given that Gale's discovery was earlier, the proper designation should be IC 5150.

This planetary is one of the 30 or so bright objects in the IC that were discovered visually, and as Gale noted, it is "remarkable [that] it should have been overlooked by Sir John Herschel and subsequent observers."

IC 5150 is also known as the Ghost Ring Nebula and the Spare Tyre Nebula. The former nickname was coined by deep-sky observer Richard Jakiel, a radio-chemist and environmental scientist from Atlanta, Georgia, USA, and it first appeared in print in *Astronomy* magazine (September 1997, p. 87).

In 1999 the Hubble Space Telescope was used to search for a companion to the central star. However, none was found, leading some to suggest that the progenitor star had one or more substellar, possibly planetary, companions that were destroyed during the formation of the nebula.

IC 5150 is about 2 light-years across and lies 2,900 light-years from Earth.

E
N
1′

IC 5150 (IC 5148)
Planetary nebula in Grus, 21h 59.6min, −39° 23′, Size 2′

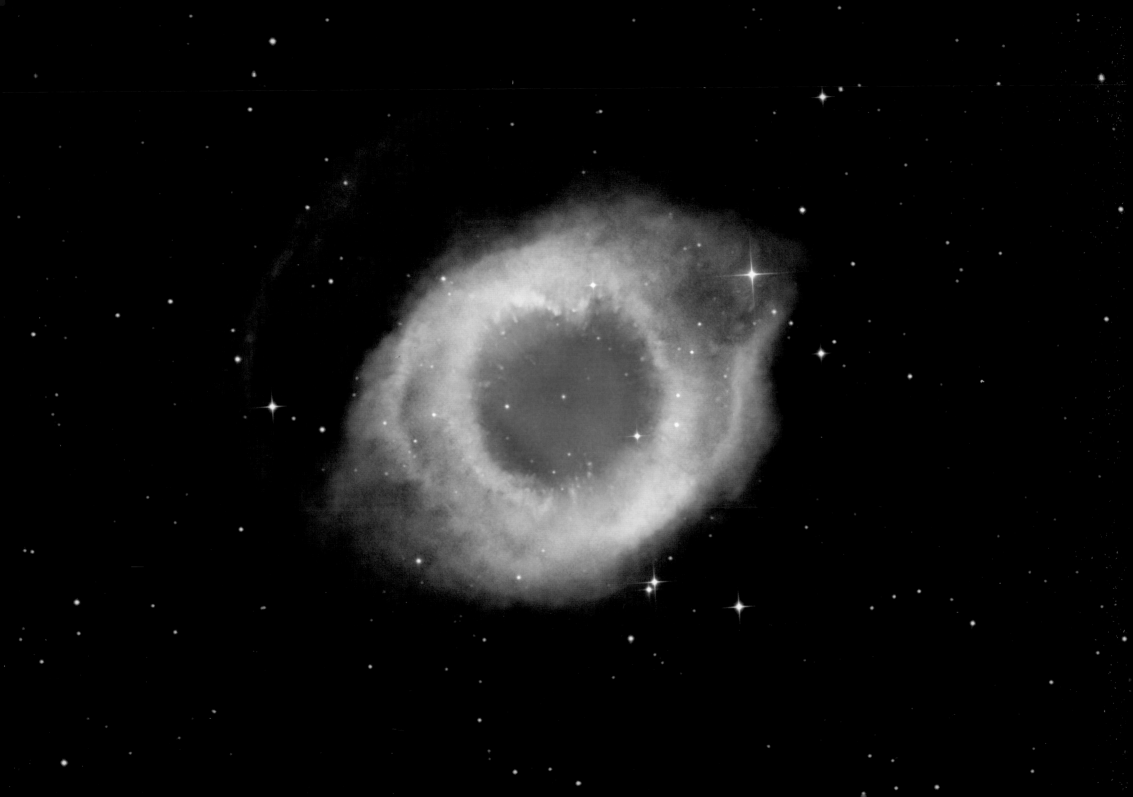

THE HELIX NEBULA

The glorious Helix Nebula lies in southern Aquarius, more or less midway between the eastern tip of Capricorn (δ and γ Cap) and Fomalhaut (δ PsA).

Binoculars show it readily as a round glow some 17' in diameter—an altogether remarkable sight! An instructive exercise is to compare the appearance of the Helix with Messier 33, another famous large, low surface brightness object. In summer, when the two objects are at similar altitudes, it is possible to quickly sweep from one to the other, and evaluate their visibility. In binoculars, the two appear very similar, with M33 being larger.

In a small telescope, this amazing object shows as a large, round, ghostly glow of light that is easy to see, with several small stars enveloped in its nebulosity. There is no hint of its annular shape.

Larger instruments change the appearance quite dramatically. Now it appears irregularly elongated, northwest to southeast, with brighter diffuse edges and a darker but round center. The uneven brightness of the elliptical ring is noticeable. The northeastern arc is the most prominent and the southwestern arc is only slightly less so. The northwestern section, in which lies a 10-mag. star, is the most diffuse. The overall impression is of an elliptical ring with gaps at the extremities.

The charming 11th-magnitude stellar pair resting against the southwestern edge lends a nice touch to this already remarkable object. The 13.0-mag. central star can be glimpsed in a modest-sized instrument, if sufficient magnification is used to set it off against the softly illuminated background.

The Helix was first recorded in 1823 by Karl Ludwig Harding while he worked at the Göttingen University Observatory, probably with the 8.5-inch (20 cm) reflector built and installed by William Herschel. It was independently discovered by with a 7-inch (18 cm) refractor by Ernesto Capocci di Belmonte in 1824, director of the Capodimonte Observatory in Naples, Italy.

R. T. A. Innes, at the Transvaal Observatory (South Africa), wrote in October 1910: "This object was first seen with the 2-inch [5 cm] finder, in which it was so conspicuous that it was further scrutinized through the 9-inch [23 cm] ... [it is] probably variable, for it is not easy to see how such a conspicuous object should have been missed by Messier and the Herschels."

In September 1912, American astronomer Heber Curtis used the 36-inch (91 cm) Crossley reflector at Lick Observatory to photograph NGC 7293. "From the original negative," he wrote, "it is easily seen to be in reality about two turns of a helix.... I would suggest that this interesting object be referred to as 'The Helical Nebula in Aquarius.'"

At Helwan Observatory (Egypt) the Helix was photographed several times, and a 1921 report notes: "A recent plate shows an additional much fainter loop in [northeast] portion, which extends to 15' from the centre of the nebula."

At a distance of only 710 light-years, the Helix is the nearest planetary nebula to the Earth. Its central star is a hot white dwarf with a luminosity only 1/100th that of the sun. Recent Spitzer Space Telescope observations have detected an extensive dust disk, about 115 Astronomical Units wide, around this star.

The bright central nebula, some 3.5 light-years across, features a multitude of cometary knots that have dense cores with long, ionized tails pointing away from the central star. A recent study discovered a 40' diameter mid-infrared halo around the Helix that is invisible at optical wavelengths.

On a closing note, the Helix has the distinction of being the object that sparked the Caldwell Catalogue—a result of the late Patrick Moore wondering why it did not have a Messier number. As some things begin, so others end!

N
E 2'

NGC 7293, PN G036.1-57.1, Bennett 129, Caldwell 63
Planetary nebula in Aquarius, 22h 29.7min, −20° 50', Size 17.6'

LIVES AND DEATHS OF STARS

A star begins its life by condensing out of the tenuous material making up a nebula, a vast cloud of (mainly) hydrogen gas. As the condensing mass increases, a non-luminous globule is formed, which appears dark when seen silhouetted in front of a glowing nebula. Gravity causes the mass to shrink, and the rising pressure near the center begins to heat up the globule from within. When the temperature rises sufficiently, the mass begins to glow. That mass is called a protostar.

If this protostar has a mass less than about one-tenth of the sun's mass, the core never becomes hot enough for nuclear reactions to take place. The stillborn star will merely glow feebly for a very long time before losing all its energy.

If, on the other hand, the protostar has a mass more than one-tenth but less than 1.4 times the sun's mass, it will continue to shrink and its temperature will rise. At this stage its behavior is rather erratic as it fluctuates irregularly, blowing away its original cocoon of gas and dust through a strong stellar wind that develops. This is known as the T Tauri stage and lasts for several million years.

Lifetimes of stars		
Mass (in solar masses)	Lifetime (years)	Star (spectral class)
40	1,000,000	ζ Pup (O5)
18	7,000,000	φ¹ Ori (B0)
6.5	90,000,000	π And-A (B5)
3.2	500,000,000	α CrB-A (A0)
2.1	2,000,000,000	β Pic (A5)
1.3	5,000,000,000	η Ari (F5)
1.0	10,000,000,000	Sun (G2)
0.7	30,000,000,000	61 Cyg-A (K5)
0.5	70,000,000,000	Gliese 185 (M0)
0.2	500,000,000,000	EZ Aqr-A (M5)
0.1	3,000,000,000,000	Van Biesbroecks Star (M8)

Meanwhile, the temperature in the core increases, and once it reaches about 18,000,000°F (10,000,000°C), nuclear reactions are triggered. In the process, hydrogen is converted into helium, and the star is said to be in the main-sequence phase.

For thousands of millions of years these reactions continue until the supply of hydrogen begins to run low. At the core, the star now uses helium to produce carbon, while the remaining hydrogen that is in a shell around the hot core continues to produce energy. Eventually the star becomes unstable and its outer layers expand and cool; it has become a red giant. The star then begins to "dissolve" as its outer layers are thrown off, creating the beautiful and varied objects called (misleadingly) planetary nebulae. Finally, when the outer layers have drifted off into space, the original core is all that remains. The core consists of material incredibly tightly packed together into what is known as a white dwarf. A single teaspoonful of white dwarf matter weighs about 5 tons. The white dwarf continues to radiate its stored energy

into space for billions of years to eventually end up a cold, dead black dwarf.

If the original protostar is more massive than 1.4 times the sun, its evolution is far more rapid and energetic. In the core, temperatures become so high that nuclear reactions create elements heavier than carbon. Eventually, the core consists mainly of iron, at which point the nuclear furnace has reached its limit. The star suddenly and catastrophically collapses, followed by an enormous explosion known as a supernova outburst. This outburst is so bright that for a short while the supernova can outshine its entire host galaxy! Most of the star's material is violently ejected into space during the explosion, leaving a tiny super-dense core made up only of neutrons. A teaspoonful of neutron star stuff weighs about 5 trillion tons.

Truly massive protostars also end their lives in a supernova outburst, but their heavier cores collapse even further to create a black hole—an ultra-compact mass from which not even light can escape.

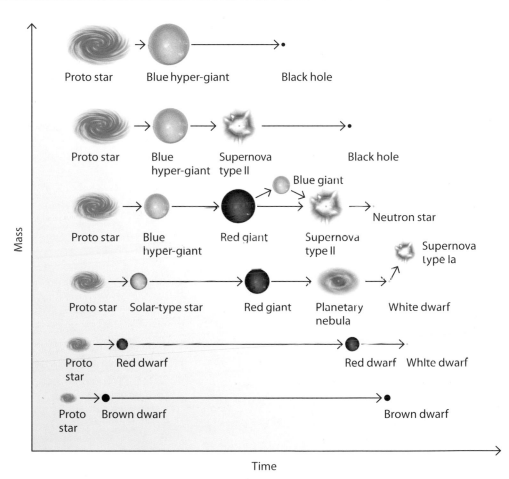

The lifetime of a star is dependent on its initial mass. The larger it is, the shorter the lifespan will be.

OPEN CLUSTERS

An open cluster is a group of stars, numbering anywhere from a few dozen to several thousand, that are born together out of the same cloud of matter. The members of such a stellar system are gravitationally bound, sharing a common spatial motion as they orbit around the galaxy.

Visually, an open cluster appears as an over-density of stars in a star field. Most are under 10 arcminutes in diameter and have fewer than about 20 members.

Amongst the early observers, the most prolific discoverer of open clusters was John Herschel. He discovered 425 clusters, of which 326 were found while observing from Cape Town. His father, William Herschel, discovered 181 open clusters, followed by James Dunlop with 127. Other famous open cluster discoverers include Giovan Battista Hodierna (10 discoveries), Nicolas de Lacaille (15) and Charles Messier (11).

The first detailed examination of the properties of star clusters was made by William Herschel. He noted significant differences in their telescopic appearance, on the basis of which he sorted them into various classes. Herschel used the term "globular clusters" to describe the richest and most dense specimens. The term "open cluster" was first used in the early 20th century to describe all non-globular clusters.

Open clusters were recognized as excellent test beds to probe theories of stellar evolution soon after the first Hertzsprung-Russell diagrams of the Pleiades and Hyades were published, by Ejnar Hertzsprung in 1911. These early investigations coincided with the construction of the first large telescopes, such as the 60-inch (152 cm) Hale Telescope (1908), the 100-inch (254 cm) Hooker Telescope (1917) and the 72-inch (182 cm) Plaskett Telescope (1918), that were capable of studying the brighter star clusters in detail. One of the astronomers who capitalized on this was Harlow Shapley, who used the Hooker Telescope at Mount Wilson to carry out photometry of cluster stars. His results led to the first ideas on stellar physics and introduced concepts like the main sequence and the mass-luminosity relationship well before the source of a star's energy was known. It was only in the late 1930s that hydrogen fusion and the proton-proton chain would be described, paving the way for our current understanding of astrophysics.

Because the stars within an open cluster are born together, they are equally old, equally distant from the Earth and of equal chemical composition (similar to that of the sun). A significant difference between stars belonging to an open cluster is their initial mass. The most massive stars in the younger clusters have masses of about 80 solar masses, while the lower mass limit is below 0.08 solar masses, reaching the domain of brown dwarves. Since mass is the main driver of the rate of stellar evolution, the stars in a cluster spend their lives at different paces. A given cluster might, for example, contain both dwarf (main sequence) and giant stars.

When looking at an open cluster, an immediate problem is recognized: where does the cluster end and the background star field resume? One could even ask if open clusters are just a chance arrangement of stars? As early as 1767, the English astronomer Reverend John Michell argued that star clusters are far too common than would be the case if stars were just randomly scattered. He estimated that there was only about one chance in 496,000 that a random distribution would produce a cluster like the Pleiades, thereby making possibly the first statistical argument in astronomy.

Some 2,000 open clusters have been catalogued in the galaxy. However, most of the open clusters in the galaxy have probably not yet been found: it is estimated that there may be as many as 100,000 open clusters in our Milky Way. Current catalogues of open clusters are only reasonably complete within about 3,000 light-years of the sun. The nearest well-studied open cluster, the Hyades, is located about 150 light-years from the sun. Several other well-known clusters, such as the Pleiades and the Coma Berenices Cluster, have distances on the order of 300 light-years. The most distant open clusters currently known in our galaxy lie over 42,000 light-years from the sun. One of these extreme groupings is the diminutive ESO 093-SC08 in Carina, a one-arcminute patch glowing feebly at magnitude 13.8. The most distant NGC cluster is NGC 3105 in Vela, 28,000 light-years away.

Open clusters are found mainly within or close to the galactic plane (while globular clusters tend to avoid it). Old open clusters are preferentially located in the outer part of the galactic disk. Very few of these ancient groupings lie closer than about 24,000 light-years from the center of our Milky Way. This is most probably due to the disruptive nature of encounters with giant molecular clouds, which themselves are located primarily in the inner galactic disk.

The total amount of star-matter held in an open cluster ranges from just 10 solar masses to as much as 10,000 solar masses. The most massive open clusters, such as NGC 6791 in Lyra, are comparable to the least-massive globular clusters.

The open clusters one observes in the sky are significantly younger than the galaxy, with ages ranging from a few million to ten thousand million years. Young clusters (tens to 1 billion years old) offer an interesting variety of stellar types, including variable stars, emission-line stars and chemically peculiar stars. Well-known young clusters include the Jewel Box (NGC 4755), Southern Pleiades (IC 2602), Pincushion Cluster (NGC 3532), Omicron Velorum Cluster (IC 2391), Galaxy Cluster (NGC 3114) and the Gem Cluster (NGC 3293).

The Trapezium cluster in Orion is the best-studied of all young (embedded) clusters. It is a rich cluster of faint stars embedded within the Great Orion Nebula, with an age of about one million years and a total mass of slightly over 1,000 solar masses. The cluster is about one light-year in diameter, contains approximately 700 stars, and is located in front of, and partially within, an opaque molecular cloud. At its center is the famous Trapezium, a close grouping of four OB stars that excite the nebula.

Very few open clusters are older than 5 billion years old. The oldest are about as ancient as the youngest globular clusters. Berkeley 17 (in Auriga) and NGC 6791 are the oldest known open clusters, about 10 billion years old.

GLOBULAR CLUSTERS

Globular clusters are long-lived, rich collections of stars that are held together by gravity in a more or less spherical shape and found in orbit around a galaxy.

The poorest globular clusters contain only thousands of stars, while the largest are composed of several million stars. The stars are highly concentrated toward the center where thousands are found per cubic light-year (about a million times more dense than in the solar neighborhood). Diameters of globular clusters range from a few dozen to over 300 light-years.

These ancient stellar families are found in orbit around galaxies. The smallest dwarf galaxy may have no clusters at all in orbit around it, while some large galaxies at the center of dense galaxy clusters (such as Messier 87 in Virgo) may have several thousand globular clusters orbiting them. This close association between globular clusters and galaxies suggest that their formation is closely connected to the formation of the parent galaxies.

Our Milky Way has 157 known globular clusters, occupying a halo around the galactic center. The closest globular cluster to the center of the Milky Way is HP 1 (1,600 light-years) while the most distant known is AM 1 (400,000 light-years away). The most distant globular cluster in the New General Catalogue is NGC 2419 in Lynx, lying far beyond the galactic disk at a distance of 290,000 light-years. The current total mass of the Milky Way's globular clusters is about 20 million solar masses, which is about one-ten-thousandth of the mass of the entire Milky Way.

Most of these clusters are orbiting our galaxy in highly eccentric elliptical orbits, with periods longer than 100 million years. Most have a high velocity relative to the sun—some 124 mi/s (200 km/s)—as they do not follow the general rotation pattern of the galactic disk. A globular cluster in an elliptical orbit is carried through the galactic plane and close to the galactic center, with potentially disrupting gravitational effects. Our present-day globular cluster system can be seen as the survivors of a once much more populous system. Simulations suggest that within the next 10 billion years, most of the present globular clusters will have disappeared.

Spectroscopic studies of stars within globular clusters have shown that, overall, they contain very little heavy elements, and are very old. This suggests that globular clusters formed during the early history of our Milky Way Galaxy. Indeed, most of the galactic globular clusters are uniformly old, about 13 billion years, with a few clusters some 2 – 3 billion years younger.

Almost every stage of stellar evolution is present in a globular cluster, including white dwarfs, planetary nebulae, pulsars and neutron stars. The first planetary nebula within a globular cluster was identified in 1928 by American optician and spectroscopist Francis Pease when he discovered Pease 1 in Messier 15. The first ever determination of the radius of a neutron star was made from measurements of an X-ray burst within the globular cluster Terzan 2 (in Scorpius). The X-ray burst is thought to have originated from the surface of a neutron star during an explosive fusion of a thin layer of helium into carbon.

Recent spectroscopic studies with 8 to 10 meters (315–395 in) class telescopes, and precision photometry with the Hubble Space Telescope, have probed the composition of the faint, long-lived, low-mass stars found in globular clusters, showing that multiple stellar populations are found. This contradicts the long-held belief that all stars in a globular cluster are chemically identical. In NGC 2808, for example, three groups

of stars differing in helium content have been found. The current explanation for these chemical differences is that an early generation of massive, rapidly evolving stars ejected processed material into the young cluster medium, from which later stars were born.

The general distribution of globular clusters in the sky, concentrated in the direction of Sagittarius, was first noticed by John Herschel. When variable stars were later identified within these clusters, they were used to estimate the distance to the clusters. American observational astronomer Harlow Shapley's extensive study of globular clusters led him to realize that the center of our galaxy was very far away, and it also enabled him to estimate the size of our galaxy.

American extragalactic observer Edwin Hubble pioneered the search for globular clusters around the galaxies of the Local Group with his discovery of about 100 clusters around Messier 31. Today, about 400 clusters around M31 are known. Messier 33, the Triangulum Galaxy, has some 50 globular clusters, half of which are known to be old (about 13 billion years).

The nearby Magellanic Clouds contain globular clusters with a wide spread of ages, classified as young (less than a billion years), intermediate (less than 5 billion) and old (about 13 billion). Thirteen old globular clusters are known in the Large Magellanic Cloud, while there is only one (NGC 121) in the Small Magellanic Cloud.

The brightest globular clusters		
Designation	Magnitude	Magnitude of horizontal branch
NGC 5139, ω Centauri	3.7 mag	14.5 mag
NGC 104, 47 Tucanae	4.0 mag	14.1 mag
NGC 6656, M 22	5.1 mag	14.2 mag
NGC 6752, Cartwheel Globular	5.4 mag	13.7 mag
NGC 6121, M 4	5.6 mag	13.5 mag
NGC 6397, Golden Nectar Cluster	5.7 mag	12.9 mag

Data from Harris, W. E.: *Catalog of parameters for Milky Way globular clusters* (2010).

PLANETARY NEBULAE AND SUPERNOVA REMNANTS

P lanetary nebulae and supernova remnants are bright nebulae that stand as beautiful memorials to, respectively, peaceful and violent stellar death.

A planetary nebula—so called because some of these bright nebulae look like distant planets seen through a telescope—is formed during the late stage in the life of a low-mass star when it sheds its outer layers as it collapses to form a white dwarf.

When the available hydrogen in the core of a low-mass star (such as our sun) is exhausted, it becomes a red giant. The star swells up as its outer region leaks off into space and creates an expanding atmosphere. When this eventually happens to our sun, in about 5 billion years time, it will expand to beyond the orbit of the Earth. The core of a red giant contracts gravitationally until it is dense and thus hot enough to use helium as a fuel source. When the helium is exhausted, the star becomes a red supergiant. In the case of our sun, its atmosphere will expand beyond the orbit of Jupiter.

The ejected outer envelopes of these stars are a major source of dust in the interstellar medium (ISM). Molecular compounds of hydrogen, carbon, oxygen, and silicon form in the outer parts and are expelled by radiation pressure, creating a stellar wind with a speed of about 6 mi/s (10 km/s).

Eventually the stellar wind carries away all the mass in an evolved star's envelope, leaving a hot core of carbon embedded within a nebula. As this hot core cools down, becoming a white dwarf, it emits large quantities of ultra-violet radiation that is energetic enough to ionize the escaped material, creating a beautiful planetary nebula.

Some 3,000 planetary nebulae are known in our Milky Way, but it is estimated that the total population is around 14,000. In comparison, the Large Magellanic Cloud has 740 planetary nebula, the Small Magellanic Cloud has 139 and the Andromeda Galaxy (Messier 31) is currently known to have 2,766.

The estimated formation rate of planetary nebulae in our galaxy is about one per year. Controversy exists over the mechanism responsible for creating their elaborate shapes. Only some 5% of planetary nebulae are spherical and thought to be descendents of the evolution of a single star. The majority of planetary nebulae are non-spherical, and it is thought that they are shaped by the interaction between the aging star and a stellar companion (or perhaps with its system of planets).

Supernova remnants are the last stages in the lives of high-mass stars. Both planetary nebulae and supernova remnants are the visible signs of processes that enrich the ISM with heavier elements.

Like low-mass stars, high-mass stars first use hydrogen and then helium as fuel in their cores. The nuclear burning processes do not stop, however, when a hot carbon core is generated. Instead, heavier elements such as oxygen, neon, silicon, sulphur and, finally, iron are generated in the core. With the core production of iron, the energy-producing nuclear reactions cease. The iron core contracts gravitationally resulting in a cataclysmic explosion that we see as a supernova eruption.

This incredibly energetic explosion blasts the outer layers of the star into space at speeds of about 6,200 mi/s (10,000 km/s), creating a shock wave moving outward from the doomed central star. The luminosity of the star briefly increases by a factor of about 100 million, or up to 20 magnitudes. For about a month, a brilliant "new" star is seen, with most of the observed luminosity coming from the rapidly expanding gas shell. After several months, the shell cools and becomes invisible to the eye, although it is still very bright in infrared. This expanding shell plows into any

material it encounters, compressing and heating it to eventually form a supernova remnant.

The core of the exploded star becomes either a neutron star (which may be detected at radio wavelengths as a pulsar) or a black hole, depending on the initial mass of the star that erupted. Only the heaviest stars (above 20 solar masses) form black holes.

Within our Milky Way, a star goes supernova about once every 40 years. The most recent supernova erupted about 140 years ago, close to the center of the galaxy. Its remnant was only discovered in 1984. The most recent readily visible supernova in the galaxy was SN 1604 (Kepler's Star) in Ophiuchus, first seen in October 1604. The brightest galactic supernova recorded is SN 1006, near the Centaurus-Lupus border, which reached magnitude −7.5 and may have remained visible for several years.

In 1968, South African comet hunter Jack Bennett discovered a supernova in the Southern Pinwheel (Messier 83), the first visual discovery of a supernova since the invention of the telescope.

In 1987, SN 1987A erupted in the Large Magellanic Cloud. At maximum it was brighter than 3rd magnitude; it is currently around 17th magnitude. Only one other extra-galactic supernova has been seen with the naked eye: SN 1885A in the Andromeda Galaxy (Messier 31).

Some 274 supernova remnants are known within our galaxy, with the Crab Nebula (Messier 1) in Taurus being the most famous.

Selected southern supernova remnants			
Supernova remnant	R.A.	Dec	Size
Puppis A, MSH 08-44	$8^h\ 22^{min}\ 10^s$	−43° 0'	60' × 50'
Vela SNR, Vela (XYZ)	$8^h\ 34^{min}\ 0^s$	−45° 50'	255'
RCW 86, MSH 14-63	$14^h\ 43^{min}\ 0^s$	−62° 30'	42'
SN 1006, PKS 1459-41	$15^h\ 2^{min}\ 50^s$	−41° 56'	30'
Lupus Loop	$15^h\ 10^{min}\ 0^s$	−40° 0'	180'
RCW 89, MSH 15-52	$15^h\ 14^{min}\ 30^s$	−59° 8'	35'
RCW 103	$16^h\ 17^{min}\ 33^s$	−51° 2'	10'
RCW 114	$17^h\ 25^{min}\ 0^s$	−46° 30'	250'
SN 1604, Kepler's SN	$17^h\ 30^{min}\ 42^s$	−21° 29'	3'

Data from Green, D. A.: A revised Galactic supernova remnant catalogue (2003).

Galaxies and Galaxy Clusters

A galaxy is a massive collection of stars (between a few million and 10 million million) and interstellar material (gas and dust) held together by gravitation. There are an estimated 200 billion galaxies in the Universe.

Galaxies can be classified according to their appearance, using the Hubble classification scheme. Elliptical galaxies are spherical or ellipsoidal in shape and are made up mostly of old red stars with very little interstellar gas. Spiral galaxies consists of a central nucleus of relatively closely packed stars, surrounded by a flattened disk-shaped component of stars, gas, and dust. Nebulae and the brightest, youngest stars are gathered into spiral-shaped arms within the mixture and are spread out from the nuclear region. In barred spirals, the central bulge is elongated and the spiral arms spread from either end of the bar. Irregular galaxies display no obvious structure.

The diameters of galaxies range from a few thousand light-years to a few hundred thousand light-years. The largest galaxies, supergiant ellipticals found in the cores of clusters of galaxies, have diameters of up to 5 million light-years.

Our Milky Way is a barred spiral galaxy with relatively loosely wound arms that spread out some 110,000 light-years in diameter. It appears to have four main spiral arms, named after the constellations in which they are most prominent. They are the Perseus, Norma, Scutum-Centaurus, and Carina-Sagittarius Arms. The Orion-Cygnus Arm is a minor spiral arm located between the Carina-Sagittarius Arm and the Perseus Arm. The sun lies within the Orion-Cygnus Arm (which is also known as the Local Arm or the Orion Spur) some 26,400 light-years from the galactic center.

The center of our galaxy is seen in the direction of Sagittarius, at R.A. $17^h 45^{min} 40^s$, Dec $-29° 00' 28''$. The solar system orbits the galactic center in a nearly circular path, taking about 220 million years to complete a single round-trip. It is moving at about 155 mi/s (250 km/s) toward a point in Cygnus with coordinates R.A. $21^h 12^{min}$, Dec $+48° 19'$.

The nucleus of the Milky Way contains a compact source of radio emission called Sagittarius A*, which is believed to be a black hole with a mass of about 2 million solar masses.

Galaxies are preferentially found in galaxy groups, usually containing up to 50 galaxies in a diameter of 5 million light-years. Our Milky Way is a part of the Local Group, which has at least 48 known members spread out over 10 million light-years. The Local Group is essentially a binary system of two massive clumps of galaxies centered on our Milky Way and on the Andromeda Galaxy (NGC 224, Messier 31). The nearest neighbor of the Local Group is the small Antlia Group, and the nearest massive neighbor is the Centaurus Group, which contains the Southern Pinwheel (NGC 5236, Messier 83) and the Hamburger (NGC 5128, Centaurus A). In the distant future, the Andromeda Galaxy will merge with the Milky Way, forming a massive elliptical galaxy with a system of about 700 globular clusters.

The Local Volume is a sphere about 65 million light-years across centered on the Local Group. It includes at least 550 known galaxies, including those in the Centaurus and M81 Groups, the Sculptor Filament and the CVn I Cloud. Recently, Russian astronomer Igor Karachentsev and colleagues have demonstrated that the Sculptor Filament contains distinct clumps of galaxies, one centered on NGC 55 and NGC 300, another centered on NGC 253 and NGC 247.

Collections of galaxy groups form galaxy clusters, containing between 50 and 1,000 galaxies

with diameters of up to 32 million light-years. Galaxy clusters are the largest known gravitationally bound objects in the universe. The nearest and best-studied rich galaxy cluster is the Virgo Cluster, lying some 55 million light-years away. It contains at least 1,300 galaxies in two main concentrations, one around NGC 4486 (M 87) and the other around NGC 4476 (M 49). Other significant nearby clusters include the Coma, Perseus, Hydra I, and Centaurus clusters.

Clusters are organized into larger, non-gravitationally bound collectives called superclusters. The Local Group lies in the outer reaches of the Virgo Supercluster. The Shapley Concentration is a collection of 29 clusters of galaxies about 650 million light-years away.

The vast majority (about 90%) of galaxies in the Universe lie outside of rich clusters. They are found in extensive filaments and sheets, giving the universe an overall bubbly structure. The largest of these sheets of galaxies is the Great Wall, 800 million light-years long, 280 million light-years "high," but only about 20 million light-years "thick." The Coma Cluster forms part of the Great Wall. The dominant large-scale feature of the Universe, however, are voids—large regions of very low galaxy density. The Boötes void has a diameter of about 400 million light-years within which only a few small galaxies are found. In all, voids occupy about 90% of space in our universe.

The first use of the word "galaxy" in its modern context was by the Scottish astronomy popularizer John Pringle Nichol in his 1848 book *The Stellar Universe.* He wrote that "galaxies separated from each other by gulfs so awful that they surpass the distances which divide star from star."

IDENTIFICATION CHARTS

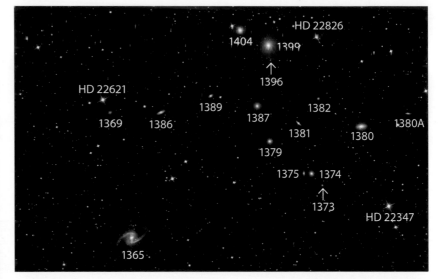

Fornax I (p. 31)

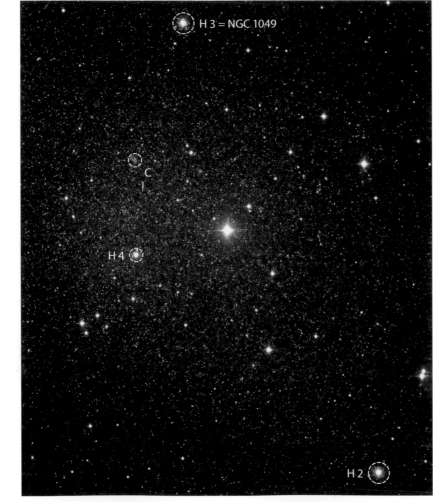

The Fornax Dwarf Galaxy (p. 25)

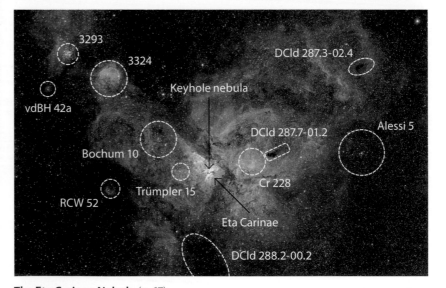

The Eta Carinae Nebula (p. 67)

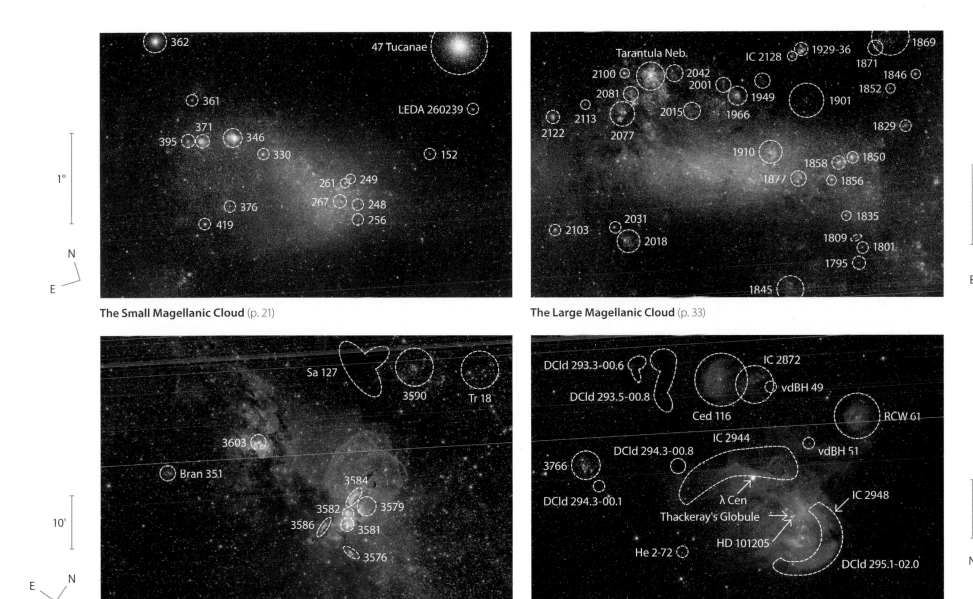

The Small Magellanic Cloud (p. 21)

The Large Magellanic Cloud (p. 33)

The Small Tarantula Nebula (p. 71)

The Running Chicken Nebula (p. 73)

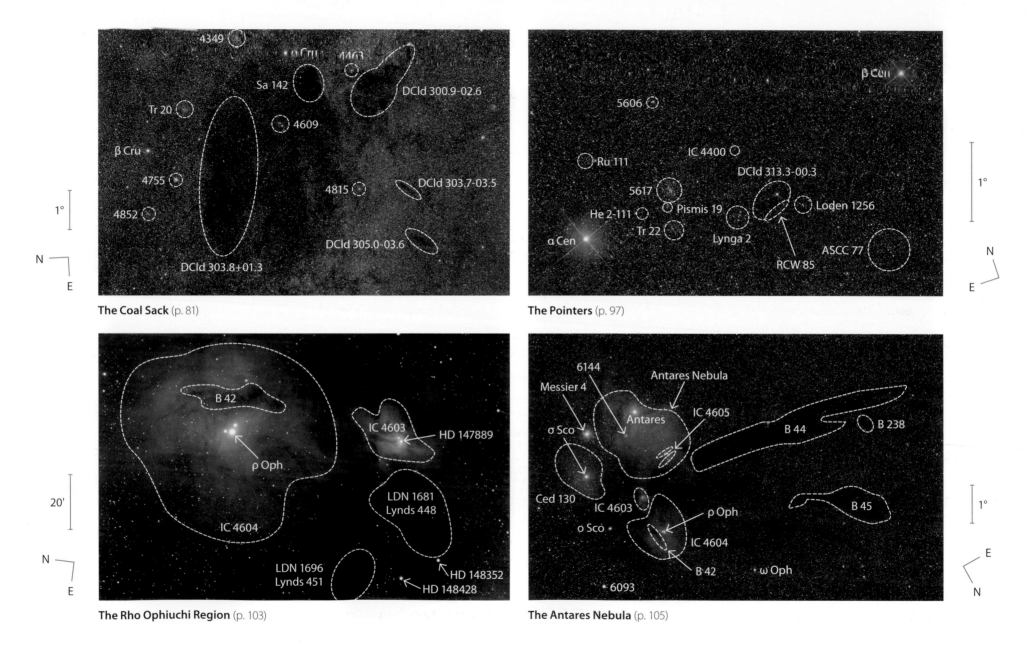

The Coal Sack (p. 81)

The Pointers (p. 97)

The Rho Ophiuchi Region (p. 103)

The Antares Nebula (p. 105)

The Kobold (p. 109)

The Great Dark Horse (p. 119)

The Psychedelic Nebula (p. 137)

The R Coronae Australis Complex (p. 143)

169

Acknowledgments

To name all who have accompanied me during the last years on my way to creating this book would require several extra pages! The information and advice I have received has helped me tremendously, without which I would not have been able to achieve the results presented here. To all of them a grateful "Thank You."

Nevertheless I want to mention Ronald Stoyan, who supported my idea for the book from the beginning and managed its implementation in a professional way.

Special thanks also to the Internationale Amateursternwarte IAS (http://www.ias-observatory.org), which gave me, as a member, the opportunity to work with large telescopes in a friendly location, at Hakos-Farm in Namibia (http://www.hakos-astrofarm.com).

And last but not least, heartfelt thanks and kisses to my wife Hilda, who has accompanied me on all my journeys and excursions without hesitation and provided me with never-ending support.

Dieter Willasch

I would like to thank Bertha Slotegraaf for her loving and steadfast support, and those members of the worldwide deep-sky observing community who freely share their passion for the Universe beyond our solar system. A special word of thanks is due to Magda Streicher, whose dedication as a deep-sky observer sets a fine example.

Auke Slotegraaf

Photographic Details

All the images contained in this book were taken by Dieter Willasch, either in Namibia or South Africa. Besides locations in the field, the majority of the images were taken from his private observatory in Somerset West, close to Cape Town, and at the Internationale Amateursternwarte IAS (http://www.ias-observatory.org) at Farm Hakos in Namibia.

The following optics were used: various Canon and Nikon camera lenses (mainly 50-mm and 200-mm), two apochromatic refractors (Takahashi FSQ 106 ED, TMB 130), a Schmidt-Cassegrain (Meade LX 200) and a Cassegrain reflector (20-inch [50 cm] Keller-Cassegrain).

The cameras used were: DSLRs (Canon EOS 20D and 30D), a CCD color camera (QHY8/ALccd6c) and an SBIG STL-11000M large-format CCD camera. The latter was used for most of the images.

Most deeply exposed deep-sky images require long exposure times. This, in turn, requires subpixel-accurate autoguiding, so good mounts make life substantially easier. In the field, the easily portable Takahashi EM-11 was used, in Somerset West an Astro-Physics 900GTO was used, while at Hakos a heavy German equatorial mount manufactured by Bernd Liebscher was used.

Good astro-images are not possible without extensive image processing. The processing time often equals the total exposure time of the raw images i.e. several hours. For these tasks the processing programs MaxIm DL5 [MI5] and Photoshop [PS] were used, as well as various other pieces of software for special tasks.

In the listing that follows, photographic and processing details for each image are presented and are intended to be of interest to those readers who are also engaged in astrophotography. For further information, please visit http://www.astro-cabinet.com.

Page 12, NGC 55 Keller 20-inch f/3. Liebscher GEM. SBIG STL-11000M. Each 3x5min Baader LRGB filter set. Selfguiding. Processing: MI5, CCDStack, PS. Color Coding LRGB. IAS-Hakos, Namibia.

Page 14, 47 Tuc Keller 20-inch f/3. Liebscher GEM. SBIG STL-11000M. Each 3x5min Baader LRGB filter set. 1min RGB for center. Selfguiding. Processing: MI5, CCDStack, PS. Color coding LRGB. IAS-Hakos, Namibia.

Page 15, 47 Tuc TMB 130 f/6 with Field Flattener. Astro-Physics 900GTO. SBIG STL-11000M. 6x5min L, each 3x5min RGB Baader filters. Selfguiding. Processing: MI5, PS. Color coding LRGB. Somerset West, South Africa.

Page 16, NGC 247 Keller 20-inch f/3. Liebscher GEM. SBIG STL-11000M. Each 6x5min Baader LRGB filter set. Autoguiding: StarlightXpress Lodestar and Schneider OAG. Processing: MI5, PS. Color coding LRGB. IAS-Hakos, Namibia.

Page 18, NGC 253 Keller 20-inch f/3. Liebscher GEM. SBIG STL-11000M. Each 3x5min Baader LRGB filter set. Selfguiding. Processing: MI5, CCDStack, PS. Coding LRGB. IAS-Hakos, Namibia.

Page 20, SMC Takahashi FSQ 106 ED f/3.7. Astro-Physics 900GTO. SBIG STL-11000M. 20min Baader Ha filter, each 3x5min Baader LRGB filter set. Selfguiding. Processing: MI5, CCDStack, PS. Color coding L, R/Ha, G, B. Somerset West, South Africa.

Page 22, NGC 300 Keller 20-inch f/3. Liebscher GEM. SBIG STL-11000M. Each 3x5min Baader LRGB filter set. Selfguiding. Processing: MI5, CCDStack, PS. Coding LRGB. IAS-Hakos.

Page 24, Fornax Dwarf Keller 20-inch f/3. Liebscher GEM. SBIG STL-11000M. 6x10min L, each 3x5min RGB, Baader filters. Autoguiding: StarlightXpress Lodestar and Schneider OAG. Processing: MI5, CCDStack, PS. Color Coding LRGB. IAS-Hakos, Namibia.

Page 26, NGC 1291 Keller 20-inch f/3. Liebscher GEM. SBIG STL-11000M. Each 3x5min Baader LRGB filter set. Selfguiding. Processing: MI5, CCDStack, PS. Color Coding LRGB. IAS-Hakos, Namibia.

Page 28, NGC 1365 Keller 20-inch f/9. Liebscher GEM. SBIG STL-11000M. 10x10min L, each 3x10min RGB Baader filters. Autoguiding. StarlightXpress Lodestar and Schneider OAG. Processing: MI5, PixInsight, PS. Color Coding LRGB. IAS-Hakos, Namibia.

Page 30, Fornax I TMB 130 f/6 with Field Flattener. Astro-Physics 900GTO. SBIG STL-11000M. 5x10min L, each 3x10min RGB Baader filters. Selfguiding. Processing: MI5, PS. Color coding LRGB. Somerset West, South Africa.

Page 32, LMC Takahashi FSQ 106 ED f/3.7. Astro-Physics 900GTO. SBIG STL-11000M. 3x20min Baader Ha filter, each 3x5min Baader LRGB filter set. Selfguiding. Processing: MI5, CCDStack, PS. Color coding L, R/Ha, G, B. Somerset West, South Africa.

Page 33, LMC Canon EF 200mm 1:2.8 @ f/3.5.Takahashi EM-11. SBIG STL 11000M. 6x10min Baader Ha filter, each 6x5min Astrodon RGB filter set. Selfguiding. Processing: MI5, PS. Color coding L: Ha, R, G, B. Sutherland, South Africa.

Page 34, NGC 2070 Keller 20-inch f/3. Liebscher GEM. SBIG STL-11000M. 3x10min Ha, each 3x5min RGB, Baader filters. Selfguiding. Processing: MI5, PixInsight, PS. Color coding L: Ha, R: R/Ha, G, B. IAS-Hakos, Namibia.

Page 35, NGC 2070 Keller 20-inch f/9. Liebscher GEM. SBIG STL-11000M.Each 3x10min RGB Baader filters. Selfguiding. Processing: MI5, CCDStack, PS. Color coding RGB. IAS-Hakos, Namibia.

Page 36, NGC 2207 Keller 20-inch f/9. Liebscher GEM. SBIG STL-11000M. 3x10min L, each 3x5min RGB (bin 2x2), Baader filters. Autoguiding: StarlightXpress Lodestar and Schneider OAG. Processing: MI5, PS. Color coding LRGB. IAS-Hakos, Namibia.

Page 38, CG 4 Keller 20-inch f/3. Liebscher GEM. SBIG STL-11000M. 3x10min Ha, each 8x10min RGB, Baader filters. Autoguiding: StarlightXpress Lodestar and Schneider OAG. Processing: MI5, PixInsight, ImagesPlus, PS. Color coding L:Ha,R:R/Ha,G,B. IAS-Hakos, Namibia.

Page 39, CG 4 TMB 130 f/6 with Field Flattener. Astro-Physics 900GTO. SBIG STL-11000M. 6x20min Ha, 18x10min L, each 6x10min RGB, Baader filters. Autoguiding: Meade DSI Pro II and Skywatcher ED 80. Processing: MI5, CCDStack, PS. Color coding L: L/Ha, R: R/Ha, G, B. Somerset West, South Africa.

Page 40, IC 2220 Keller 20 inch f/9. Liebscher GEM. SBIG STL-11000M. Each 3x10min LRGB Baader filters. Autoguiding: StarlightXpress Lodestar and Schneider OAG. Processing: MI5, CCDStack, PS. Color coding LRGB. IAS-Hakos, Namibia.

Page 42, NGC 2547 Keller 20-inch f/9. Liebscher GEM. SBIG STL-11000M. Each 3x10min RGB, Baader filters. Selfguiding. Processing: MI5, CCDStack, PS. Color coding RGB. IAS-Hakos, Namibia.

Page 44, Gum Nebula Canon EF 50mm f/1.8 @ f/4.5 for Ha, [OIII], f/6.3 for RGB. Astro-Physics 900GTO. SBIG STL-11000M. 9x20min Ha, 7x20 [OIII], each 3x5min RGB, Baader filters. Autoguiding: StarlightXpress Lodestar and Skywatcher ED 80. Processing: MI5, PixInsight, PS. Color coding R/Ha, G/[OIII], B/[OIII], RGB stars as overlay. Somerset West, South Africa.

Page 46, Vela SNR Takahashi FSQ 106 ED f/3.7. Astro-Physics 900GTO. SBIG STL-11000M. Each 10x20min Ha, O[III], 5x5min RGB, Baader filters. Autoguiding: StarlightXpress Lodestar and Skywatcher ED 80. Processing: MI5, Registar, PS. Color coding R/Halpha, G/[OIII], B/[OIII]. RGB stars as overlay. Somerset West, South Africa.

Page 47, Vela SNR Takahashi FSQ 106 ED f/3.7. Astro-Physics 900GTO. SBIG STL-11000M. 4 image mosaic: 2 images each 10x20min, 2 images each 5x20 min Ha, O[III], 5x5min RGB, Baader filters. Autoguiding: StarlightXpress Lodestar and Skywatcher ED 80. Processing: MI5, Registar, PS. Color coding R/Halpha, G/[OIII], B/[OIII], RGB stars as overlay. Somerset West, South Africa.

Page 48, NGC 2736 Keller 20-inch f/3. Liebscher GEM. SBIG STL-11000M. Each 3x5min LRGB, Baader filters. Autoguiding: StarlightXpress Lodestar and Schneider OAG. Processing: MI5, CCDStack, PS. Color coding LRGB. IAS-Hakos, Namibia.

Page 50, NGC 2899 Keller 20-inch f/9. Liebscher GEM. SBIG STL-11000M. 2x10min L, each 4x10min RGB, Baader filters. Selfguiding. Processing: MI5, PS. Color coding LRGB. IAS-Hakos, Namibia.

Page 52, NGC 2997 Keller 20-inch f/9. Liebscher GEM. SBIG STL-11000M. 6x10min L, each 3x10min RGB, Baader filters. Autoguiding: StarlightXpress Lodestar and Schneider OAG. Processing: MI5, CCDStack, PS. Color coding LRGB. IAS-Hakos, Namibia.

Page 54, NGC 3132 Keller 20-inch f/9. Liebscher GEM. SBIG STL-11000M. 2x10min L, each 2x5min RGB (2x2 binning), Baader filters. Selfguiding. Processing: MI5, CCDStack, PS. Color coding LRGB. IAS-Hakos, Namibia.

Page 56, NGC 3199 Keller 20-inch f/9. Liebscher GEM. SBIG STL-11000M. Each 3x10min LRGB, Baader filters. Autoguiding: StarlightXpress Lodestar and Schneider OAG. Processing: MI5, PS. Color coding LRGB. IAS-Hakos, Namibia.

Page 57, NGC 3199 Keller 20-inch f/3. Liebscher GEM. SBIG STL-11000M. 3x10min Ha, each 4x5min RGB, Baader filters. Autoguiding: StarlightXpress Lodestar and Schneider OAG. Processing: MI5, PixInsight, ImagesPlus, PS. Color coding L:Ha,R:R/Ha,G,B. IAS-Hakos, Namibia.

Page 58, NGC 3201 Keller 20-inch f/9. Liebscher GEM. SBIG STL-11000M. Each 3x10min RGB, Baader filters. Autoguiding: StarlightXpress Lodestar and Schneider OAG. Processing: MI5, PS. Color coding RGB. IAS-Hakos, Namibia.

Page 60, NGC 3247 Keller 20-inch f/3. Liebscher GEM. SBIG STL-11000M. 3x10min Ha, each 3x5min RGB, Baader filters. Autoguiding: StarlightXpress Lodestar and Schneider OAG. Processing: MI5, PixInsight, ImagesPlus, PS. Color coding L:Ha,R:R/Ha,G,B. IAS-Hakos, Namibia.

Page 61, NGC 3247 TMB 130 f/6 with Field Flattener. Astro-Physics 900GTO. SBIG STL-11000M. 6x20min Ha, each 3x10min RGB, Baader filters. StarlightXpress Lodestar and

Skywatcher ED. Processing: MI5, PS. Color coding L: Ha, R: R/Ha, G, B. Somerset West, South Africa.

Page 62, NGC 3293 Keller 20-inch f/9. Liebscher GEM. SBIG STL-11000M. Each 2x5min RGB, Baader filters. Selfguiding. Processing: MI5, CCDStack, PS. Color coding RGB. IAS-Hakos, Namibia.

Page 63, NGC 3293 TMB 130 f/6 with Field Flattener. Astro-Physics 900GTO. SBIG STL-11000M. 2x20min Ha, each 3x10min RGB, Baader filters. StarlightXpress Lodestar and Skywatcher ED. Processing: MI5, CCDStack, PS. Color coding L: Ha, R: R/Ha, G, B. Somerset West, South Africa.

Page 64, IC 2602 Takahashi FSQ 106 ED f/3.7. Astro-Physics 900GTO. SBIG STL-11000M. Each 3x5min RGB, Baader filters. Selfguiding. Processing: MI5, CCDStack, PS. Color coding RGB. Somerset West, South Africa.

Page 66, NGC 3372 Takahashi FSQ 106 ED f/3.7. Astro-Physics 900GTO. SBIG STL-11000M. 6x20min Baader Ha filter, each 10x5min Astrodon RGB filter set. Selfguiding. Processing: MI5, Registar, PS. Color coding L: Ha, R: R/Ha, G, B. Somerset West, South Africa.

Page 67, NGC 3372 Keller 20-inch f/9. Liebscher GEM. SBIG STL-11000M. 2x20min Ha. Each 3x10min RGB, Baader filters. Selfguiding. Processing: MI5, CCDStack, PS. Color coding L: Ha, RGB. IAS-Hakos.

Page 68, NGC 3532 Keller 20-inch f/3. Liebscher GEM. SBIG STL-11000M. Each 5x3min RGB, Baader filters. Autoguiding: StarlightXpress Lodestar and Schneider OAG. Processing: MI5, PixInsight, ImagesPlus, PS. Color coding RGB. IAS-Hakos, Namibia.

Page 69, NGC 3532 Takahashi FSQ 106 ED f/3.7. Astro-Physics 900GTO. SBIG STL-11000M. Each 3x5min Baader RGB filter set. Selfguiding. Processing: MI5, CCDStack, PS. Color coding RGB. Somerset West, South Africa.

Page 70, NGC 3576, 3603 Keller 20-inch f/3. Liebscher GEM. SBIG STL-11000M. 3x10min Ha, each 3x5min RGB, Baader filters. Autoguiding: StarlightXpress Lodestar and Schneider OAG. Processing: MI5, CCDStack, PS. Color coding L: Ha, R: R/Ha, G, B. IAS-Hakos, Namibia.

Page 72, IC 2944 Takahashi FSQ 106 ED f/5. Astro-Physics 900GTO. SBIG STL-11000M. 3x20min Ha, each 3x10min RGB, Baader filters. Autoguiding: Meade DSI Pro II and Skywatcher ED 80. Processing: MI5, PS. Color coding: L: Ha, R:R/Ha,G,B. Somerset West, South Africa.

Page 73, IC 2944 Takahashi FSQ 106 ED f/3.7. Astro-Physics 900GTO. SBIG STL-11000M. 3x20min Ha, each 6x5min RGB, Baader filters. Autoguiding: StarlightXpress Lodestar and Skywatcher ED 80. Processing: MI5, CCDStack, PS. Color

coding L: Ha, R: R/Ha, G, B. Somerset West, South Africa.

Page 74, Thackeray's Globule Keller 20 inch f/9. Liebscher GEM. SBIG STL-11000M. 3x20min Ha, each 2x10min RGB, Baader filters. Autoguiding: StarlightXpress Lodestar and Schneider OAG. Processing: MI5, PixInsight, ImagesPlus, PS. Color coding L:Ha,R:R/Ha,G,B. IAS-Hakos, Namibia.

Page 75, Thackeray's Globule Keller 20-inch f/3. Liebscher GEM. SBIG STL-11000M. 2x10min Ha, each 3x5min RGB, Baader filters. Autoguiding: StarlightXpress Lodestar and Schneider OAG. Processing: MI5, CCDStack, PS. Color coding L: Ha, R: R/Ha, G, B. IAS-Hakos, Namibia.

Page 76, NGC 3766 Keller 20-inch f/9. Liebscher GEM. SBIG STL-11000M. Each 2x5min RGB, Baader filters. Selfguiding. Processing: MI5, CCDStack, PS. Color coding RGB. IAS-Hakos, Namibia.

Page 78, Black Python Canon EF Tele lens 200mm 1: 2.8 @ f/3.5.Takahashi EM-11. SBIG STL 11000M. Each 6x5min Astrodon RGB filter set. Processing: MI5, PS. Color coding R, G, B. Sutherland, South Africa.

Page 80, Coal Sack Canon EF Tele lens 200mm 1: 2.8 @ f/3.5. Astro-Physics 900GTO. SBIG STL 11000M. Each 6x5min Astrodon RGB filter set. Autoguiding: Meade DSI Pro II and Skywatcher ED 80. Processing: MI5, PS. Color coding RGB. Somerset West, South Africa.

Page 81, Coal Sack Canon EF Tele lens 200mm 1: 2.8 @ f/3.5. Astro-Physics 900GTO. SBIG STL 11000M. Each 6x5min RGB, Baader filters. Autoguiding: Meade DSI Pro II and Skywatcher ED 80. Processing: MI5, PS. Color coding RGB. Somerset West, South Africa.

Page 82, NGC 4755 Keller 20-inch f/9. Liebscher GEM. SBIG STL-11000M. Each 3x10min RGB, Baader filters. Selfguiding. Processing: MI5, CCDStack, PS. Color Coding RGB. IAS-Hakos, Namibia.

Page 84, NGC 4945 Keller 20-inch f/9. Liebscher GEM. SBIG STL-11000M. 3x10min L, each 3x5min RGB(2x2 binning), Astrodon filter set. Selfguiding. Processing: MI5, CCDStack, PS. Color coding LRGB. IAS-Hakos, Namibia.

Page 86, NGC 5128 Keller 20-inch f/9. Liebscher GEM. SBIG STL-11000M. 6x10min L, each 4x10min RGB, Baader filters. Selfguiding. Processing: MI5, CCDStack, PS. Color coding LRGB. IAS-Hakos, Namibia.

Page 87, NGC 5128, 5139 Takahashi FSQ 106 ED f/3.7. Astro-Physics 900GTO. SBIG STL-11000M. Each 3x5min LRGB, Baader filters. Autoguiding: StarlightXpress Lodestar and Skywatcher ED 80. Processing: MI5, CCDStack, PS. Color coding RGB. Somerset West, South Africa.

Page 88, NGC 5139 Keller 20-inch f/9. Liebscher GEM. SBIG

STL-11000M. Each 3x5min LRGB, Baader filters. Selfguiding. Processing: MI5, CCDStack, PS. Color Coding LRGB. IAS-Hakos, Namibia.

Page 89, NGC 5139 Keller 20-inch f/3. Liebscher GEM. SBIG STL-11000M. Each 3x2min RGB, Baader filters. Autoguiding: StarlightXpress Lodestar and Schneider OAG. Processing: MI5,PixInsight,ImagesPlus,PS. Color coding RGB. IAS-Hakos, Namibia.

Page 90 , NGC 5189 Keller 20-inch f/9. Liebscher GEM. SBIG STL-11000M. 3x10min L, each 3x5min RGB(2x2 binning), Astrodon filter set. Selfguiding. Processing: MI5, PS. Color coding LRGB. IAS-Hakos, Namibia.

Page 92, NGC 5236 Keller 20-inch f/9. Liebscher GEM. SBIG STL-11000M. 5x10min L, each 3x10min RGB, Baader filters. Selfguiding. Processing: MI5, CCDStack, PS. Color coding LRGB. IAS-Hakos, Namibia.

Page 94, Circinus Galaxy Keller 20-inch f/9. Liebscher GEM. SBIG STL-11000M. Each 3x5min LRGB(2x2 binning), Baader filters. Selfguiding. Processing: MI5, CCDStack, PS. Color coding LRGB. IAS-Hakos, Namibia.

Page 96, Pointers Takahashi FSQ 106 ED f/3.7. Astro-Physics 900GTO. SBIG STL-11000M. Each 6x5min Baader RGB filter set. Autoguiding: StarlightXpress Lodestar and Skywatcher ED 80. Processing: MI5, CCDStack, PS. Color coding RGB. Somerset West, South Africa.

Page 98, NGC 6067 Keller 20-inch f/3. Liebscher GEM. SBIG STL-11000M. Each 3x5min Baader RGB filter set. Autoguiding: StarlightXpress Lodestar and Schneider OAG. Processing: MI5, CCDStack, PS. Color coding RGB. IAS-Hakos, Namibia.

Page 100, Messier 4 Keller 20-inch f/9. Liebscher GEM. SBIG STL-11000M. Each 3x10min Baader RGB filter set. Autoguiding: StarlightXpress Lodestar and Schneider OAG. Processing: MI5, CCDStack, PS. Color coding RGB. IAS-Hakos, Namibia.

Page 102, Rho Ophiuchi TMB 130 f/6 with Field Flattener. Astro-Physics 900GTO. SBIG STL-11000M. 6x10min L, each 3x10min RGB, Baader filters. Selfguiding. Processing: MI5, PS. Color coding LRGB. Somerset West, South Africa.

Page 104, Antares Nebula Canon EF Tele lens 200mm 1: 2.8 @ f/3.5. Astro-Physics 900GTO. SBIG STL 11000M. 3x10min L, each 3x5min RGB, Astrodon filter set. Autoguiding: Meade DSI Pro II and Skywatcher ED80. Processing: MI5, PS. Color coding LRGB. Somerset West, South Africa.

Page 106, NGC 6164, 6165 Keller 20-inch f/9. Liebscher GEM. SBIG STL-11000M. 3x20min Ha, each 3x10min RGB, Baader filters. Autoguiding: StarlightXpress Lodestar and Schneider OAG. Processing: MI5, CCDStack, PS. Color coding L: Ha, R: R/Ha, G, B. IAS-Hakos, Namibia.

Page 108, LBN 24 Nikkor 50mm lens f/1.4 @ f/3.5. Takahashi EM-11. SBIG STL-11000M. 5x20min Astronomik Ha filter, each 4x10min RGB, Astrodon filter set. Selfguiding. Processing: MI5, PS. Color coding L: Halpha, R: Ha/G, B.

Page 110, NGC 6188 Takahashi FSQ 106 ED f/3.7. Astro-Physics 900GTO. SBIG STL-11000M. 6x20min Ha, 9x20min O[III], each 6x5min RGB, Baader filters. Autoguiding: StarlightXpress Lodestar and Skywatcher ED 80. Processing: MI5, Registar, PS. Color coding L:Ha, R:R/Ha, G:G/[OIII], B. Somerset West, South Africa.

Page 111, NGC 6188 Canon EF Tele lens 200mm 1:2.8 @ f/3.5. Takahashi EM-11. SBIG STL 11000M. 3x20min Astronomik Ha filter, each 6x5min RGB, Astrodon filter set. Autoguiding: Meade DSI Pro II and Skywatcher ED80. Processing: MI5, PS. Color coding L:Ha, R:Ha/R, G, B. Sutherland, South Africa. and Somerset West, South Africa.

Page 112, NGC 6321 Keller 20-inch f/9. Liebscher GEM. SBIG STL-11000M. Each 2x10min RGB, Baader filters. Selfguiding. Processing: MI5, ImagesPlus, PS. Color coding RGB. IAS-Hakos, Namibia.

Page 114, IC 4628 Keller 20-inch f/3. Liebscher GEM. SBIG STL-11000M. 3x10min Ha, 3x10min [OIII], each 3x5min RGB, Baader filters. Autoguiding: StarlightXpress Lodestar and Schneider OAG. Processing: MI5, PixInsight, ImagesPlus, PS. Color coding L:Ha, R:R/Ha, G:G/[OIII], B:B/[OIII]. IAS-Hakos, Namibia.

Page 115, IC 4628 Canon EF Tele lens 200mm 1:2.8 @ f/3.5. Astro-Physics 900GTO. SBIG STL 11000M. 3x20min Baader Ha filter, each 3x10min RGB, Astrodon filter set. Autoguiding: Meade DSI Pro II and Skywatcher ED80. Processing: MI5, Registar, PS. Color coding L:Ha, R, G, B. Somerset West, South Africa.

Page 116, Barnard 50 Keller 20-inch f/3. Liebscher GEM. SBIG STL-11000M. Each 3x5min Baader RGB filter set. Autoguiding: StarlightXpress Lodestar and Schneider OAG. Processing: MI5, CCDStack, PS. Color coding RGB. IAS-Hakos, Namibia.

Page 118, Dark Horse Canon EF Tele lens 200mm 1: 2.8 @ f/3.5. Astro-Physics 900GTO. SBIG STL 11000M. 2 image mosaic: Each 3x10min L, each 3x5min (2x2 binning) RGB, Astrodon filter set. Autoguiding: Meade DSI Pro II and Skywatcher ED80. Processing: MI5, Registar, PS. Color coding LRGB. Somerset West, South Africa.

Page 120, NGC 6334 Keller 20-inch f/3. Liebscher GEM. SBIG STL-11000M. 3x10min Ha, each 3x5min RGB, Baader filters. Autoguiding: StarlightXpress Lodestar and Schneider OAG. Processing: MI5, PixInsight, ImagesPlus, PS. Color coding L:Ha, R:R/Ha, G, B. IAS-Hakos, Namibia.

Page 121, NGC 6334 Takahashi FSQ 106 ED f/3.7. Astro-Physics 900GTO. SBIG STL-11000M. 3x20min Ha, each 4x5min RGB, Baader filters. Autoguiding: StarlightXpress Lodestar and Skywatcher ED 80. Processing: MI5, CCDStack, PS. Color coding L:Ha, R:Ha/R, G, B. Somerset West, South Africa.

Page 122, NGC 6357 Keller 20-inch f/3. Liebscher GEM. SBIG STL-11000M. 3x10min Ha, 3x5min RGB, Baader filters. Autoguiding: StarlightXpress Lodestar and Schneider OAG. Processing: MI5, CCDStack, PS. Color coding L: Ha, R: Ha/R, G, B. IAS-Hakos, Namibia.

Page 124, Messier 6 Keller 20-inch f/3. Liebscher GEM. SBIG STL-11000M. Each 3x3min RGB, Baader filters. Autoguiding: StarlightXpress Lodestar and Schneider OAG. Processing: MI5, ImagesPlus, PS. Color coding RGB. IAS-Hakos, Namibia.

Page 125, Messier 6 Takahashi FSQ 106 ED f/3.7. Astro-Physics 900GTO. SBIG STL-11000M. Each 2x5min RGB, Baader filters. Autoguiding: StarlightXpress Lodestar and Skywatcher ED 80. Processing: MI5, CCDStack, PS. Color coding RGB. Somerset West, South Africa.

Page 126, NGC 6397 Keller 20-inch f/9. Liebscher GEM. SBIG STL-11000M. Each 3x10min RGB, Baader filters. Selfguiding. Processing: MI5, CCDStack, PS. Color coding RGB. IAS-Hakos, Namibia.

Page 128, Messier 7 Keller 20-inch f/3. Liebscher GEM. SBIG STL-11000M. Each 3x3min RGB, Baader filters. Autoguiding: StarlightXpress Lodestar and Schneider OAG. Processing: MI5, ImagesPlus, PS. Color coding RGB. IAS-Hakos, Namibia.

Page 130, Messier 20 Keller 20-inch f/9. Liebscher GEM. SBIG STL-11000M. 3x20min Ha, each 3x10min RGB, Baader filters. Selfguiding. Processing: MI5, CCDStack, PS. Color coding L: Ha, R, G, B. IAS-Hakos, Namibia.

Page 132, Messier 8 Keller 20-inch f/9. Liebscher GEM. SBIG STL-11000M. 2x20min Ha, each 2x10min RGB, Baader filters. Selfguiding. Processing: MI5, CCDStack, PS. Color coding L: Ha, R, G, B. IAS-Hakos, Namibia.

Page 133, Messier 8 TMB 130 f/6 with Field Flattener. Astro-Physics 900GTO. SBIG STL-11000M. Each 3x10min RGB, Astrodon filter set. Selfguiding. Processing: MI5, PS. Color coding RGB. Somerset West, South Africa.

Page 134, Barnard 86 Keller 20-inch f/3. Liebscher GEM. SBIG STL-11000M. Each 3x5min RGB, Baader filters. Autoguiding: StarlightXpress Lodestar and Schneider OAG. Processing: MI5, CCDStack, PS. Color coding RGB. IAS-Hakos, Namibia.

Page 136, Psychedelic Nebula Keller 20-inch f/3. Liebscher GEM. SBIG STL-11000M. 3x10min Ha, each 3x5min RGB, Baader filters. StarlightXpress Lodestar and Schneider OAG. Processing: MI5, PixInsight, ImagesPlus, PS. Color coding L:Ha,

R:R/Ha, G, B. IAS-Hakos, Namibia.

Page 138, Messier 16 Keller 20-inch f/9. Liebscher GEM. SBIG STL-11000M. 5x20min Ha, each 3x10min RGB, Baader filters. Selfguiding. Processing: MI5, CCDStack, PS. Color coding L: Ha, R, G, B. IAS-Hakos, Namibia.

Page 140, Messier 17 Keller 20-inch f/3. Liebscher GEM. SBIG STL-11000M. 1x10min Ha, each 3x5min RGB, Baader filters. Autoguiding: StarlightXpress Lodestar and Schneider OAG. Processing: MI5, CCDStack, PS. Color coding L: Ha, R: Ha/R, G, B. IAS-Hakos, Namibia.

Page 142, R CrA Keller 20-inch f/9. Liebscher GEM. SBIG STL-11000M. Each 4x10min RGB, Baader filters.Autoguiding: StarlightXpress Lodestar and Schneider OAG. Processing: MI5, CCDStack, PS. Color coding RGB. IAS-Hakos, Namibia.

Page 143, R CrA TMB 130 f/6 with Field Flattener. Astro-Physics 900GTO. SBIG STL-11000M.Each 3x10min RGB, Astrodon filter set. Selfguiding. Processing: MI5, PS. Color coding RGB. Somerset West, South Africa.

Page 144, NGC 6744 Keller 20-inch f/9. Liebscher GEM. SBIG STL-11000M. 8x10min L, each 3x10min RGB, Baader filters. Autoguiding: StarlightXpress Lodestar and Schneider OAG. Processing: MI5, PS. Color coding LRGB. IAS-Hakos, Namibia.

Page 146, NGC 6752 Keller 20-inch f/3. Liebscher GEM. SBIG STL-11000M.Each 3x5min RGB, Baader filters. Autoguiding: StarlightXpress Lodestar and Schneider OAG. Processing: MI5, CCDStack, PS. Color coding RGB. IAS-Hakos, Namibia.

Page 148, Messier 55 Keller 20-inch f/9. Liebscher GEM. SBIG STL-11000M.Each 3x10min RGB, Baader filters. Autoguiding: StarlightXpress Lodestar and Schneider OAG. Processing: MI5, CCDStack, PS. Color coding RGB. IAS-Hakos, Namibia.

Page 150, IC 5150 Keller 20-inch f/9. Liebscher GEM. SBIG STL-11000M.Each 4x10min RGB, Baader filters. Autoguiding: StarlightXpress Lodestar and Schneider OAG. Processing: MI5, PixInsight, PS. Color coding RGB. IAS-Hakos, Namibia.

Page 152, NGC 7293 Keller 20-inch f/3. Liebscher GEM. SBIG STL-11000M. 3x10min Ha, each 3x5min LRGB, Baader filters. Selfguiding. Processing: MI5, CCDStack, PS. Color coding L: L/Ha, R: Ha/R, G, B. IAS-Hakos, Namibia.

Name Index

OBJECT INDEX: CATALOG DESIGNATIONS

OBJECT INDEX: PROPER NAMES